Small Town Baltimore

ALSO BY GILBERT SANDLER

Jewish Baltimore: A Family Album

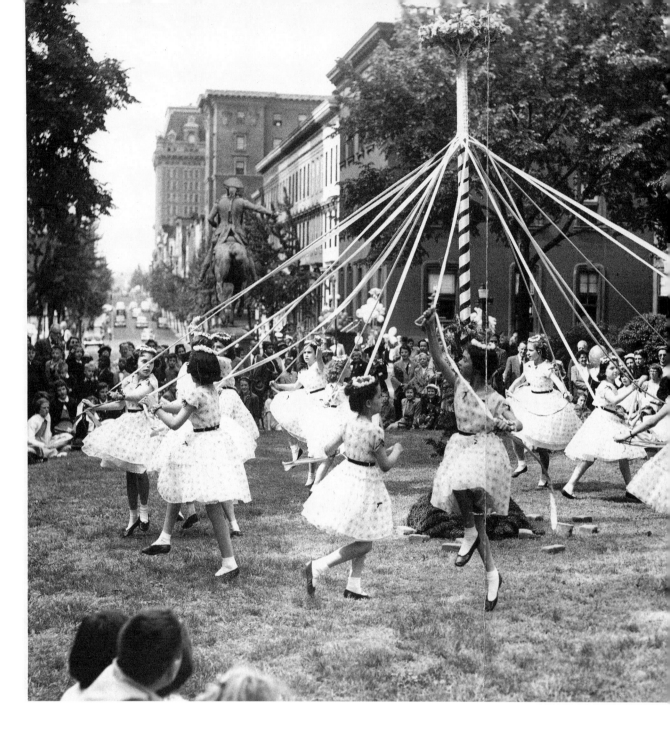

In Association with the Marylandia and Rare Books Department

UNIVERSITY OF MARYLAND LIBRARIES

SMALL

GILBERT SANDLER

An Album of Memories

TOWN BALTIMORE

THE JOHNS HOPKINS UNIVERSITY PRESS · *Baltimore and London*

© 2002 The Johns Hopkins University Press

All rights reserved. Published 2002

Printed in the United States of America on acid-free paper

9 8 7 6 5 4 3 2 1

The Johns Hopkins University Press

2715 North Charles Street

Baltimore, Maryland 21218-4363

www.press.jhu.edu

Library of Congress Cataloging-in-Publication Data will be
found at the end of this book.

A catalog record for this book is available from the British Library.

ISBN 0-8018-7069-0

For Joan,
and to the rest of my gang:
Joe and Karen, Marie and John,
Skip and Judy; and Nora and Eli,
Elizabeth and Eric, and Alex,
Lucy and Noah, and to all the
people who, when asked where
they're from, say "Baltimore!"

CONTENTS

PREFACE AND ACKNOWLEDGMENTS

These stories originally appeared, in different form, in the *Baltimore Sun,* the *Evening Sun,* and the *Sunday Sun,* and I am grateful to my editors through the years, who provided me with so much support, discipline, instruction, and inspiration. The list includes James H. Bready, Mike Bowler, Harold Williams, Gwinn Owens, and the late Dudley Digges. I thank, too, for their ideas and camaraderie, *Sun* writers Carl Schoettler, Dan Berger, Ted Lippman, Joseph Sterne, Michael Olesker, Dan Rodricks, Rich O'Mara, and Ray Jenkins.

Valued friends served as sounding boards and fact-checkers: Efrem Potts, Irv Lansman, Sol Snyder, Herb Shofer, Eddie Snyder, Sander Wise, Walter Sondheim, Reuben Shiling, Robert C. Embry, Robert C. Embry Jr., my brother Irving and my late brother Eddie, Sarajane Greenfeld, and Gene Raynor. I owe a special thanks to Fred Rasmussen of the *Sun,* who is willing to walk with me through the minefield of Baltimoriana; he has read the manuscript not once but twice. I am indebted to him for his invaluable edits and, in particular, for his strong feelings that this book had to be written and that I was the one to write it. Jeff Korman, head of the Maryland Department, Central Branch, Enoch Pratt Free Library, provided continuing and ready research and fact-checking.

Dr. Robert J. Brugger, history and regional books editor at the Johns Hopkins Press, has been unerring in his judgment and painstaking in his guidance; Celestia Ward of the press has provided formidable editing; noted Baltimore photographer Morton Tadder always seemed to know where the best pictures lay hidden; and Baltimore historian Wayne Schaumburg read the manuscript and made several excellent suggestions. And I shall always be grateful to my old gang from Cottage Avenue, who hung out and came of age with me in Sussman's drug store at Park Heights

and Ulman Avenue, back in my old neighborhood, where this book really began.

Jeff Korman and his staff also helped to search and gather printed ephemera at the Pratt. The archivist at the *Baltimore Afro-American*, Leah Lakins, was extremely helpful in preparing artwork for the book, as was David Prencipe at the Maryland Historical Society. Elizabeth Schaaf, Peabody Institute Archives, generously shared material from her growing collection of musical Marylandia. Special and warm thanks to Douglas P. McElrath, Joanne Archer, and Ann Hudak, Marylandia and Rare Books Department, University of Maryland Libraries, for their steady cooperation in putting together and preparing the illustrations that make up a large part of this book.

And most of all, I am indebted to all of the people who have lived a lifetime in Baltimore and talked to me about what they had seen and heard and felt, and who were so willing to share their impressions of the Baltimore experience with me. Notwithstanding their lapses of memory, if there are mistakes in this book, they are mine and mine alone.

And speaking of mistakes: Some time back there was this guy who called me often about what he thought were errors of omission in my columns. In one call, frustrated, he snapped, "Sandler, when are you going to learn something about Baltimore?"

I worry about that.

INTRODUCTION

Henry "Grandpa" Snow was ninety-two when I interviewed him some ten years ago. Born and bred in Baltimore, he had spent the last decade of his life sitting on his porch in Roland Park, telling "Baltimore stories" to friends. In his earlier years, he had been active in business and in the life of the city.

He remembered the great Baltimore Fire of 1904, how the town rebuilt itself, and how it lived, worked, and played before, between, and after the Great Wars. He spoke wistfully of the difference the years have made in the life of the city. "Back then, you see, there was a feeling among Baltimoreans that they *owned* Baltimore—the way it was." It was, Mr. Snow went on to explain, life in a "small town." He was talking about the years from the 1930s through the 1970s.

He recalled baseball at Oriole Park on Greenmount Avenue, when a capacity crowd was fourteen thousand; family excursions down the river and across the bay to Tolchester; streetcar rides to amusement parks like Bay Shore, Carlin's Park, and Gwynn Oak. "We felt these things were ours. But it's different today. The National Aquarium, Harborplace, Science Center, the big new Baltimore zoo—that's all big business now, the stuff of Baltimore gone big-time.

"So all of those places no longer belong to Baltimoreans. They belong to the tourists and, I guess, the world. We had concerts on the lawn in Druid Hill Park and rowing on Druid Park Lake, Thanksgiving Day Toytown Parades, and Easter parades—and, in that segregated Baltimore, the white on Charles Street, the black on Pennsylvania Avenue. And the movies like the Century, the Valencia, the Royal—where we worked and where we played, all of the shops and the attractions and the factories—they were ours.

"Why, before Harborplace took Baltimore into the big time you could be standing on the curb watching a parade and strike up a conversation with the guy next to you, and you'd ask where he was from and he'd tell you— Hamilton, or Pimlico, or Highlandtown, or Roland Park. Now you stand in line at the Aquarium and you find out that the guy next to you is from Switzerland. Or Jakarta. Or Chicago. Nobody blinks. That's the way it is. And it's all a good thing, too. It brings industry. Jobs. Good times. Big times. But, still, I miss the Baltimore that was ours, when Baltimore—think how we lived!—was like a small town."

Henry Snow would like this book. It's a collection of stories that bring the times, the places, the names, and the events of his small-town Baltimore to life—the ones that in later years he grew to miss. The sketches have been drawn from a collection of newspaper columns that I wrote, first for the *Evening Sun* and then for the *Sun* over more than twenty-five years, beginning in 1975, under the rubric "Baltimore Glimpses." The columns were the idea of *Evening Sun* editor Bradford Jacobs, who felt at the time that we were witnessing epochal changes in the history of Baltimore City but had no ready record of what the city had been before it began changing. Hence, he got the idea of publishing remembrances of who we were from the 1920s into the 1970s. At the time, neither he nor I, nor the readers, had any idea that we would look back at the Baltimore City of that era and call it "small town." That observation could only come with the inevitable perspective that is the legacy of the Baltimore Renaissance, which began, by my calculation, in 1970.

The popularity of the columns proved to me what I have always suspected: that, at least for many, recollection of who we were, and are, lies close to home and the habits of the neighborhood. It was simple things like the movies we went to, the restaurants we ate in, the stores where we shopped, the streets where we played, the factories and shops where we worked. I discovered the truth of this when I wrote in a column that the No. 25 streetcar had run to Bay Shore Park. The big story at the time was the national trucking strike, which threatened to shut the country down. Nobody wrote to the paper about *that*, but dozens wrote and raised holy hell because I had the wrong number streetcar going to Bay Shore! If there is a collective point at all in these pieces, it is that what defined life for many in those earlier days is not so much how we felt about the presidential election of 1948 but where we danced to Rivers Chambers in 1954.

The theory is reinforced by the number of letters people sent following particular columns, always supplying new information (or correcting my

own). After I wrote a piece about the brassy Block character and queen of the Tenderloin life here in Baltimore, Betty Mills, who owned the Stork Club, I received an anonymous call telling me that Betty's considerable earnings from her strip joint went to keep her daughter in one of Baltimore's prestigious private schools. (I checked it out, the story is true.) And there were these guys who formed a club in an East Baltimore bar and who, for months, would call me Friday nights to chastise me in strong language about what I had left out of the week's column or where I had erred. They called themselves the "Baltimore Glimpsers."

Certain columns seemed to put many people back in touch with warm and half-remembered moments in their lives, and they responded to these stories with enthusiasm, raising the question: Why do we so cherish our Baltimore nostalgia? I've heard it said that the essence of nostalgia is that what has been will never be again. Exactly: Baltimore has moved so fast that there is *so much* that will never be again. It is the speed of the city's change that lends such rich currency to its yesterdays.

It is important to note that this book is not a history. I make no attempt here to tell the big story of what happened to Baltimore during these years. That insufficiency is made obvious not so much by the people, times, and places I have included but by those that I have not.

I am always hearing from people who came from somewhere else, readers who like to share with me what it was like growing up in Philadelphia, or Los Angeles, or Chicago. Their point is that Baltimore is no different, that every city has a culture peculiar to itself—its own sense of what it is and what it was. And so, these transplants say, they have their own stories of small-town wherever. Maybe so. But I have mine. And here they are, glimpse by glimpse.

Regardless of Baltimore's kicking and screaming as it confronted change, in the end the city not only accepted change, it embraced it. And, in its own quirky way, while reveling in the new life, Baltimore did not let go of the old. Memories of who we were are forever sharpening the picture of who we have become. The Inner Harbor summons memories of the old waterfront; the ongoing crab feasts bring up stories of how big the crabs used to be; the new cheers for the home team recall the same cheers in seasons past. It is as if an artist has painted a new work over an old one, only to discover that the old one has a way of showing through. In Baltimore's remembered history, and in the stories parents tell children, small-town Baltimore still shows through.

I recognize that a collection of such stories may not be popular among

a generation born and raised in the bright light of Renaissance Baltimore. But I like to think there is a small lesson here for these younger people: If you want to know where you're going, it helps to know where you've been.

This book is about where some Baltimoreans have been.

■ A NOTE ON THE ILLUSTRATIONS The work of several Baltimore photographers of note appears in these pages—I. Henry Phillips, who for many years worked at the *Baltimore Afro-American,* ably covering local but also national news; Thomas C. Scilipoti, who has captured the flavor of Baltimore, especially of Little Italy, over a long and productive career; and James P. Gallagher, photographer of the Pacific air campaign in World War II, Maryland railroads, and local life in the 1950s. The illustration legends credit these valuable sources, along with the *Afro-American,* the Maryland Historical Society, and the Peabody Institute, Johns Hopkins University. Some pieces came from the private collections of the author's friends. Many came from the rich print and ephemera collection of the Maryland Department, Enoch Pratt Free Library. Most of them, however, came from the Marylandia and Rare Books Department, University of Maryland Libraries, and its unsurpassed photo files from the old *Baltimore News-American.*

The illustrations appear as a researcher finds them—examining them carefully, wearing white-cotton gloves for the sake of preservation. The scratches, folds, tears, and—on the *News-American* photos—crop marks maintain the scrapbook appeal of these archival photographs and the found-in-the-attic character of the material from the Pratt's ephemera collection.

Small Town Baltimore

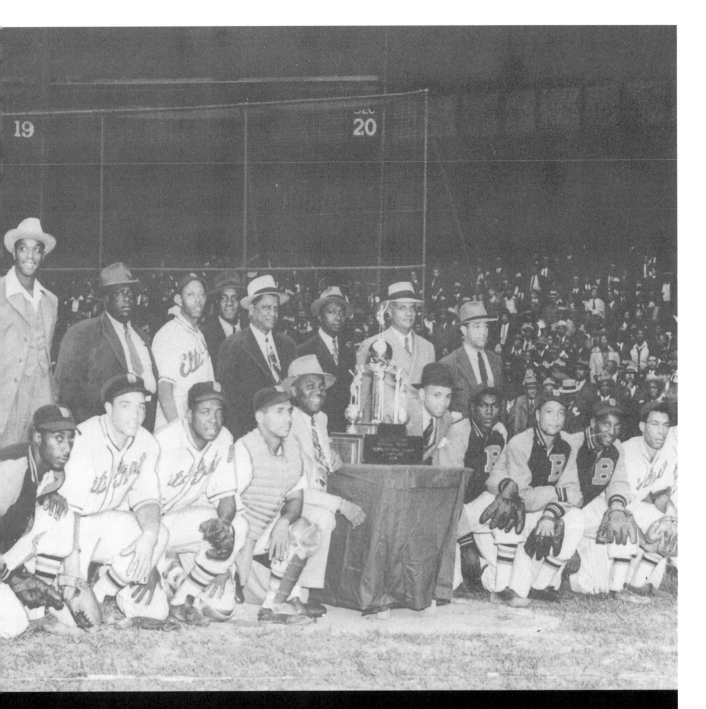

Part I ARTIFACTS

1 | Look Up There!

■ THE FAMOUS BLUE BOTTLE, ABOUT TWENTY STORIES UP

The skyline of small-town Baltimore had an extremely distinctive look: atop what is now the Emerson Tower at 308 West Lombard Street, there was a four-story-high, twenty-foot-wide bottle of Bromo-Seltzer.

That monster of a Bromo-Seltzer bottle was, in every way except size (it was fifty-one feet high), an exact replica of the familiar "blue bottle" of Bromo-Seltzer headache powder you could buy at the drugstore. The inventor of Bromo-Seltzer, a Baltimore pharmacist named Isaac Emerson, built the tower in 1911 as his Emerson Drug Company's headquarters. Emerson made so much money curing headaches that he went on to build the Emerson Hotel downtown at Calvert and Baltimore Streets, the Emersonian Apartments at Eutaw Place near the Druid Park Lake, and Emerson's Farm out on Greenspring Valley Road at Falls Road. He also owned any number of homes and yachts.

The big blue bottle weighed twenty tons and was lit up by 596 electric bulbs, which made the writing on the label legible through the night. It revolved continuously and was so high and so bright in the Baltimore sky that on clear nights it could be seen from Tolchester Beach, twenty miles across the Bay.

Then one day in the mid-1930s Baltimoreans looked up, expecting to see the familiar revolving bottle, only to discover that it wasn't there. Quietly, with no announcement and almost no press coverage, it had been removed.

Edward "Ed" Knauff Jr. said his father had been put in charge of removing the bottle. Ed was always told that the bottle's removal had been or-

Walking along West Lombard Street in the 1920s and early 1930s, Baltimoreans could look up and see, at the top of the Emerson Tower, a twenty-ton, revolving replica of a bottle of Bromo-Seltzer headache powder.

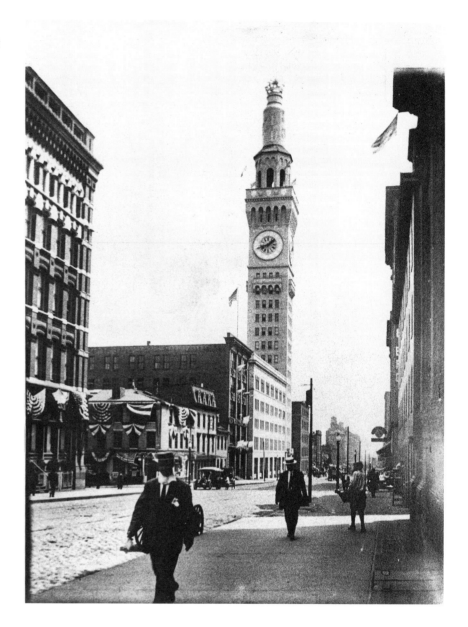

dered by engineers who began to discover cracks throughout the structure of the entire building. "The bottle was to blame," Ed said. "It revolved twenty-four hours a day, and this revolving was creating vibrations that were, in turn, causing very dangerous cracks to appear. The job of taking the bottle down was given to Consolidated Engineering." (A Mr. James Gallon said, in contradiction to Mr. Knauff, that it was his grandfather, Harold Cummins, who had been "in charge of removing the bottle.") At any rate, Knauff said, "The bottle was steel, and Consolidated elected to cut it apart piece by piece with a blowtorch into three-foot-by-six-foot sections and to

take each section down on the elevator." Each of those sections, according to Gallon, was moved to a scrap yard in Walbrook. Ed Knauff recalled that it took at least six months to get the entire bottle cut up in sections and removed. Leaders in the scrap metal industry agree that in 1936 the three-by-six steel sections were sent to Sparrows Point for recycling and that the steel found its way into the automotive industry.

When exactly did the giant bottle come down? Collective memory yields varying reports, but research turns up a column of March 10, 1936, in the *News-American*. "Today," Lou Azrael wrote, "was the day the bottle came down."

■ BALTIMORE, FLAGPOLE-SITTING CAPITAL It remains one of the unexplained mysteries in the history of Baltimore that in 1929 the city became a national center for flagpole-sitting. We don't know why, but we do know how: Late in the afternoon of July 19, 1929, a fifteen-year-old boy named Avon ("Azey") Foreman climbed to the top of an eighteen-foot sapling in the rear of his home at 5704 Ethelbert Avenue and, in a special seat which he had constructed earlier, sat down. He promptly announced that he was going to stay up there until he'd set a record no one could match.

Azey had been inspired by an ex-boxer named Shipwreck Kelly, who had been traveling around the country for years sitting on hotel-top flagpoles as publicity stunts. Local newspapers recounted Azey's effort, and in a matter of days the fifteen-year-old was a city celebrity. Crowds by the thousands descended on the Foremans' modest backyard in the Pimlico section; boys and girls, even adults, throughout the nation began to compete with him. Daily reports of Azey's life in his treetop seat were cabled to Europe and South Africa.

The fad led to unusual situations. On the morning of July 22, 1930, Dr. Samuel Shipley Glick, then a practicing pediatrician, took a phone call from a worried parent, Mrs. Evelyn McGruder. Mrs. McGruder said her thirteen-year-old daughter, Ruth, was sitting in the top of a tree in the back of their house in the same Pimlico neighborhood. She said Ruth had scarlet fever, and, despite her parents' pleas, steadfastly refused to come down. Could Dr. Glick come right away? Dr. Glick, accustomed to making house calls, promptly drove over. He recalled, "I arrived at the house and found that someone had placed a ladder for me to climb up to the limb of the tree where Ruth was sitting. While standing on the ladder, and balancing myself—I had to carry my doctor's bag up with me—I managed to examine her. I found that she was in excellent health. I, too, tried to talk her into coming down. She wouldn't do it."

In 1929, caught up in the flagpole-sitting fad then all the rage, young Avon "Azey" Foreman climbed to the top of a sapling in his backyard and went for the world's record. He descended after ten days. No one knows whether he set a record.

On July 29, 1929, exactly ten days, ten hours, and ten minutes after Azey had ascended to his treetop seat (the timing was Azey's idea), he came down to the cheers of more than four thousand well-wishers. Mayor William Broening paid him a personal visit and issued this open letter to the press: "The grit and stamina evidenced by your endurance from July 19 to 29, a period of ten days, ten hours, ten minutes, and ten seconds atop the 18-foot pole in the rear of your home shows that the old pioneer spirit of early America is being kept alive by the youth of today."

Azey had suddenly become like the best gunfighter in a town; he had to be taken on. Dozens of Baltimoreans began to flagpole-sit in the hopes of knocking off his record. During one week in 1929 Baltimore had no fewer than twenty flagpole sitters—seventeen boys and three girls.

■ "PRATT AND LIGHT CARRIED THE SECOND-HIGHEST VOLUME OF TRAFFIC IN THE WORLD" This is the story of a traffic policeman named Bill, who was the brother of a governor; a horse named Bob, who became a median strip; and the passing into history of Baltimore's traffic kiosks—those on the ground and those in the air.

It begins in the 1930s, when traffic in Baltimore was controlled by policemen standing in traffic kiosks strategically placed in the middle of busy intersections. A traffic kiosk was a four- or six-sided, telephone-booth-sized structure, with glass on all sides and either a "stop-and-go" semaphore or a set of red, yellow, and green lights mounted at the roof line. Policemen were isolated from the passing vehicles in an enclosed kiosk either at ground level or on a six-foot-high platform.

For many years kiosks remained in use at Lombard and Charles, Baltimore and Paca, Saratoga and Eutaw, North and Charles, Lombard and South, and Light and Pratt—this last intersection being the scene of Bill and Bob. "In those days," recalled Thomas Keyes, who was then deputy commissioner of traffic, "Pratt and Light carried the second-highest volume of traffic in the world. One intersection in London may have had a denser flow. Well, Bill McKeldin, who was Governor McKeldin's brother, ran Pratt and Light like a general running a battle. Standing in front of his kiosk, he shouted orders all day long, and he could whistle through his teeth louder than anybody could through a metal whistle. While Bill was working the kiosk, he had Bob tied up. Bob was trained to shift positions with the traffic. When the signal changed, Bob would move his body, paralleling himself with the oncoming traffic. Bob was a live median strip. Darndest thing you ever saw."

In 1939, the city began doing away with the kiosks, removing them

one after another, including the kiosk at Charles and Chase, which had long been occupied by Patrolman John Thierauf. Shortly after its removal, a reporter asked him, "What's it like without your kiosk?" Said Officer Thierauf: "This corner's colder."

Officer Raymond Miles recalled his last day working the kiosk at Lombard and South Streets: "Every morning before I could get into the kiosk I would have to clean it out. People would throw trash into them all night long. Then I'd wheel it into the center of the intersection. And in the summer! Talk about hot in there; they were like steam baths. But those of us who worked the kiosks, we had a trick to beat that heat. You'd lay an ice-cold, dripping wet cabbage leaf on top of your head, inside your hat. You'd be surprised at how an ice-cold cabbage leaf on the head could keep you working at that job."

■ UP IN THE AIR In the early 1940s, Municipal Airport replaced little Logan Field as Baltimore's hub for air travel. Both fields occupied acreage in Dundalk that abutted Broening Highway—about where Colgate

For many years, policemen in enclosed kiosks operated "stop-and-go" signs, often atop a raised platform—in all kinds of weather despite boredom and discomfort. This officer directs traffic at North Avenue and Charles Street in the late 1920s or early 1930s.

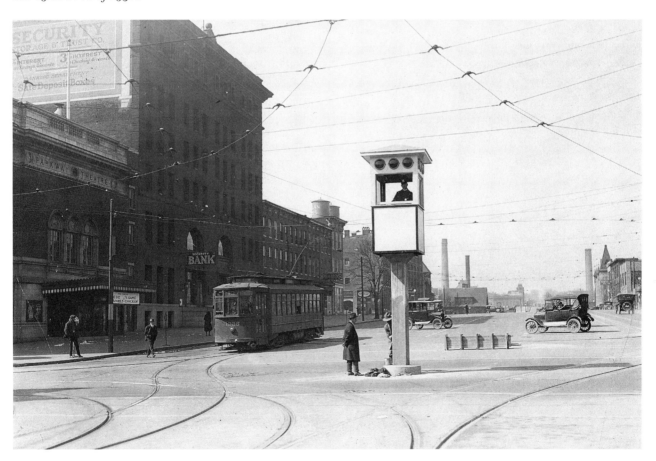

Named for Patrick Logan, an army pilot who died there in an airplane crash, Logan Field, the pride of Baltimore, opened in 1921. The New York Sun *chastised New York City for "letting Baltimore take the lead in East Coast aviation." Executives of the Bethlehem Steel Company and a few aviation enthusiasts, veterans of the Great War, led the movement to establish the airfield, and in 1929 the U.S. Department of Commerce made Logan headquarters for all Maryland-Delaware aviation. Amelia Earhart landed there the following year; Lindbergh praised it when he visited in 1933.*

Here a biplane takes off in September 1935, with the increasing menace of poles and wires on the western edge of the field very much in evidence. "The lines," said the News-American, *"with a 26,000 volt current feed the great industrial plants at Sparrows Point and are strung along 43-foot poles. Beneath them is a network of trolley poles and wires." Pilots also had to negotiate 85-foot-tall steel electricity towers to the east and a telephone line to the southeast.*

Creek met the Patapsco River, Logan on one side, Municipal on the other—and both served just a small number of people. Most travelers in those days naturally chose the train.

Municipal Airport's backers, and the airlines that flew into it, including American, Eastern, United, Pan Am, and British Overseas Airways, shared a wild dream. They bet that travel by airplanes (including seaplanes) would help shape the world of tomorrow. As a matter of fact, in 1936 Pan Am designated Municipal as the hub of its trans-Atlantic seaplane operations. Glenn L. Martin, whose company manufactured the famous Clipper seaplanes, said at the time: "Baltimore will face a golden opportunity of becoming a world port." But World War II made seaplanes obsolete and dashed Baltimore's dream of becoming the leading seaplane port of the world.

Guests who visited Municipal's terminal rhapsodized about it. "It's smaller, but more tastefully designed and decorated than New York City's LaGuardia," one passenger noted. "Sunlight streams into the rotunda from a dozen high narrow windows. The floor is covered with quarry tile in a pastel red; the baseboard is deep blue, the walls are beige tile. The woodwork is a pale blue pastel."

Albert Sehlstedt Jr., who covered aviation for the *Sun*, often flew out of Municipal on assignment, usually to Florida. It reminded him of the "Lucky Lindbergh" era of the 1930s. "It had one of those chain-link fences around it, protecting passengers from the tarmac," Sehlstedt recalled. "The terminal was a domed, art deco building. I remember it as small and sort of intimate. They had maybe twenty or so arrivals and departures a day. Thinking back on it, the pace of the place seemed so slow."

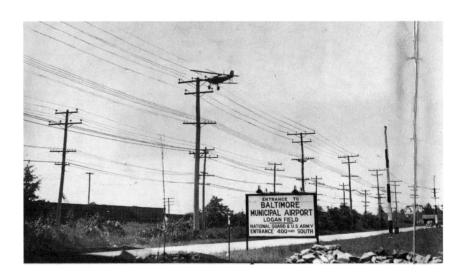

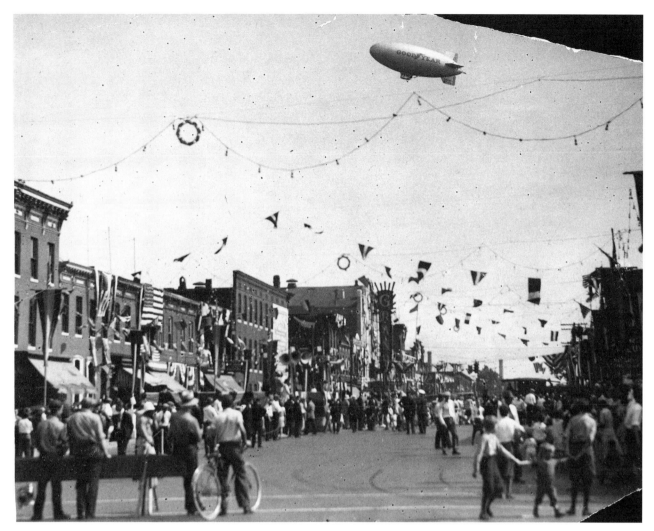

Young and old in the streets of Highlandtown devote spellbound attention to the flight of an early Goodyear blimp, which was in town to salute Baltimore during its 1929 bicentennial celebration.

Bob Rappaport used the airport to fly to Syracuse University, where he was a student. "I flew Eastern," he said. "They gave you a box lunch for a dollar. Hard-boiled egg, a chicken sandwich, and an apple. Maybe a cookie."

Along with its near-miss at becoming a world center for seaplane travel, Baltimore also came close to being a world center for zeppelins and futuristic lighter-than-air travel. The famous zeppelins were slated to become a major presence in worldwide air travel, beginning in the mid 1930s.

Before the war Baltimore enjoyed a tiny but thrilling taste of the lighter-than-air ships, many the length of three football fields and complete with staterooms, elegant dining, and decor that featured walls covered in silk tapestry. On Saturday afternoon, August 8, 1936, Baltimoreans looked

up in wonder at the magnificent sight of the Hindenburg, showpiece of the German zeppelin industry.

The airship had been scheduled to land at Lakehurst, New Jersey, but windy conditions forced a delay. The Hindenburg's captain decided to kill time by detouring to Washington, then fly back over Baltimore and return to Lakehurst a few hours later when the winds would be more favorable. Right on schedule, the ship passed over Atlantic City, then over Centreville on the Eastern Shore, and finally, at 2:13 that afternoon, it soared majestically over the Capitol dome—advertising Germany's technological triumph to the United States and the world. Some twenty minutes later it reached the outskirts of southwest Baltimore, and shortly afterward the Hindenburg appeared in the sky over downtown Baltimore.

Newspaper reports of the event described throngs of the curious gathered at windows, on rooftops, and in every open space to gaze up at the huge zeppelin, or dirigible. It glided at a leisurely pace over Sun Square and the Baltimore and Charles Streets intersection and then drifted off to the northeast, headed for Lakehurst and calmer winds.

The very next year, on May 6, 1937, while making a routine landing at Lakehurst, the Hindenburg burst into flames, crashing to the ground and killing all thirty-six passengers and crew. As it turned out, more than the future of lighter-than-air travel went up in the flames of that crash. In those early stages of the industry, Baltimore had been proposed as a site for a permanent zeppelin terminal in the United States. Dr. Horst K. A. Schirmer, a leading authority on the history of lighter-than-air travel, told the *Sun:* "There was a plan—all trans-Atlantic dirigible service would have been based in Baltimore."

2 | REMINDERS OF THE 1930s

■ YOU STAND WHENEVER YOU HEAR
"THE STAR-SPANGLED BANNER" Efforts of presidents, senators, members of Congress, and public servants at every level to defend Old Glory must forever pale beside the record of Baltimore's Virginia Houck Holloway, known through the 1930s as Mrs. Reuben Ross Holloway.

She was born at 10 Front Street in 1862, next door to the Shot Tower. She said this circumstance accounted for her wearing her tall "shako" (a hat about a foot-and-a-half high that she insisted recalled the Shot Tower), which became her trademark and distinguished her in any assembly. At her death in 1940, obituary writers eulogized Holloway as "an authority on the

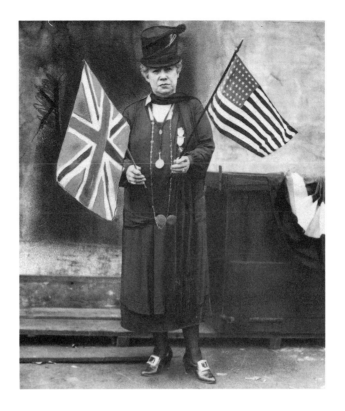

Mrs. Reuben Ross Holloway, authority on flag etiquette and champion of "The Star-Spangled Banner," demonstrates the proper way to enter Canada, carrying British colors and Old Glory at the same time.

proper use of the American flag and instrumental in having Congress adopt 'The Star-Spangled Banner' as the national anthem." At one time she held the imposing title of Chair of the Committee on the Correct Use of the Flag of the United States of the Daughters of the War of 1812.

Holloway was more than an authority on how the flag was to be displayed; she fiercely condemned any display of the American flag on articles of clothing and on items like pocketbooks, ashtrays, and lapel pins. She was especially incensed at the use of flags on birthday cakes and ice cream molds. She thought that every adult and child should start the day by saluting the flag before breakfast. "The flag should be hung in the dining room," she said. "It will start not only the children, but their elders, too, off to the day with patriotic stimulus."

Her fight to have "The Star-Spangled Banner" adopted as the National Anthem started in 1918, when she persuaded J. Charles Linthicum (Democrat, Md.) to introduce such a bill in Congress. Thirteen years later she succeeded. She was also particularly zealous about one's duty to stand wherever and whenever one heard the anthem.

A mischievous friend of Mrs. Holloway, aware of how she felt about one's duty to follow that dictum, once asked her what she would do if she

Boys and girls at Carlin's Park in the late 1920s or early 1930s make ready to fly the "Lindy" planes, just one of the many thrill rides at the amusement park at Park Circle, where Park Heights Avenue met Reisterstown Road. At one point in their "flight," the Lindy planes soared out over the nearby A&W Root Beer franchise, to the delighted squeals of the young flyers and passengers.

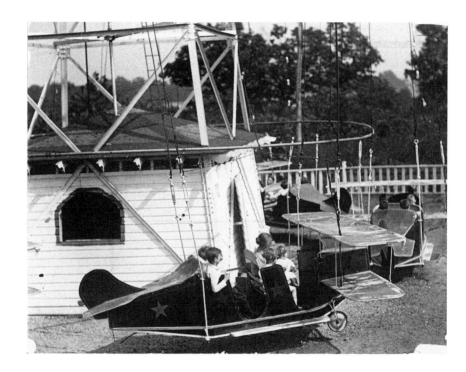

Riding "the Whip" at Carlin's Park. Each car whipsawed back and forth while lurching erratically forward, forcing young riders to hold on for dear life.

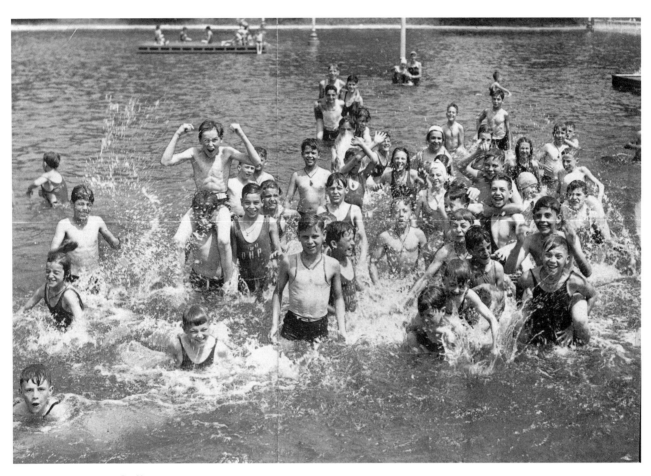

*Young swimmers cool off at opening
day of the Druid Hill Park
swimming pool, 1938.*

heard the anthem while taking a bath. "Young man," she snapped, "whenever and wherever I hear 'The Star-Spangled Banner,' I stand!" She died in 1940 at age seventy-eight, fittingly, at the Marine Hospital in Wyman Park in Baltimore.

■ DISCOVERING ARTHUR GODFREY Radio station WFBR always enjoyed a special place among Baltimore radio stations, not only because it was the first radio station to go on the air in Baltimore (as WEAR in 1922) but also because in 1929 an unknown, red-haired Coast Guardsman stationed in Curtis Bay got his start in radio on that station. He could sing a little and play a little ukulele. His name was Arthur Godfrey. Helen Weyner, then Helen Meeks ("Baltimore's Personality Girl"), used to sing with Godfrey and remembered some good stories about him.

"I had a show on WFBR at the time," she recalled. "Fifteen minutes, three times a week. My sponsor was Read's Drug Stores. I sang the popular songs of the day, like 'The Man I Love,' and 'I've Got A Crush On You.' Anyway, one evening when I had finished my show I got a call over the loud speaker from the station manager. 'Helen, please come to my office right away.' My heart sank. I was scared."

Her fears were misplaced. What the manager wanted was her opinion of a new singer who had just applied for a job at the station. "Listen to this audition, Helen," he said. "Tell me what you think. This guy wants to be on our amateur show." The manager turned a few knobs at the control at his desk and then through the speaker Helen heard this "deep, gravelly voice with ukulele accompaniment."

> I'm Alabammy bound,
> There'll be no heebie jeebies
> Hanging 'round.

The manager looked at me and I looked at him. I said, "This boy is going to make it."

On the strength of Helen's hunch, WFBR put Arthur Godfrey on Meeks's show and from there on out called the show *Me and My Boyfriend*. The "boyfriend" was Godfrey. They sang together,

> Me and my boyfriend
> My boyfriend and me
> We stick together
> Like coffee and tea . . .

Listeners seemed to like the redheaded singer and ukulele player ("I

Crooner and all-around radio personality Arthur Godfrey started his career in Baltimore, earning five dollars a program. This later promotional photograph shows orchestra leader Ray Sinatra coordinating Godfrey's musical accompaniment for a network program that aired on WBAL Mondays, Wednesdays, and Fridays from 5:00 to 5:15 P.M. and featured Lilian Lane and the Barbasol Singers. "It's fun and music with the inimitable Godfrey touch."

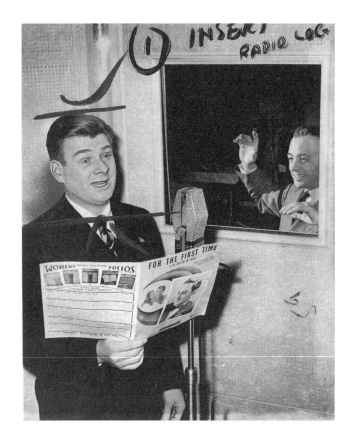

always called him Reds," Helen said), and he got another break when a staff announcer took sick. Arthur asked to sit in for him, not just reading script but writing it, too. The combination of Helen Meeks and Arthur Godfrey began to do well—too well, it would turn out.

Meeks explained: "One day Godfrey got a call from a Washington radio station, a big one. They made him an attractive offer and off he went. Then an *absolutely incredible* thing happened: just by chance, Walter Winchell was in Washington at the time, and heard him, and in his column, which in those days was the most widely read and most influential in the country, raved about him. That sent Godfrey off to big-time national radio and television. Who that has seen it can forget Godfrey broadcasting from Hawaii, wearing those huge flowered shirts and plunking his ukulele?"

■ IT WAS A PUNISHMENT METED OUT, BUT ONLY
 FOR WIFE-BEATING. Flogging in Baltimore dates back to the early eighteenth century, when the punishment was meted out quietly and without much fanfare, but in 1926 a supposedly enlightened and certainly circulation-minded Baltimore press saw the punishment as good copy. Reporters' accounts of the floggings soon sharply heightened community

Another Baltimore landmark dating back to the Depression was the thirty-four-story Baltimore Trust Building on the southwest corner of Baltimore and Light Streets. Dedicated March 6, 1929, the towering structure soon had its troubles. Before it had signed its first tenant, construction workers went on strike, and when the building was just a year old the stock market crashed, leaving the new downtown showpiece—along with the rest of the country—feeling empty. Interest did pick up on August 7, 1930, when a large crowd formed on the corner, everybody looking up at the ledge on the twentieth floor of the building. They saw a man fishing; rod and reel in hand, Irwin Sperry, manager of the building, was fishing for his hat, which had blown off his head and out an open window to the ledge below. While the sidewalk crowd cheered, Sperry deftly maneuvered his pole, hooked the hat, and reeled it in.

A reorganized Baltimore Trust held onto the property until 1942, when it became the O'Sullivan Building, named after the famous rubber-heel manufacturer.

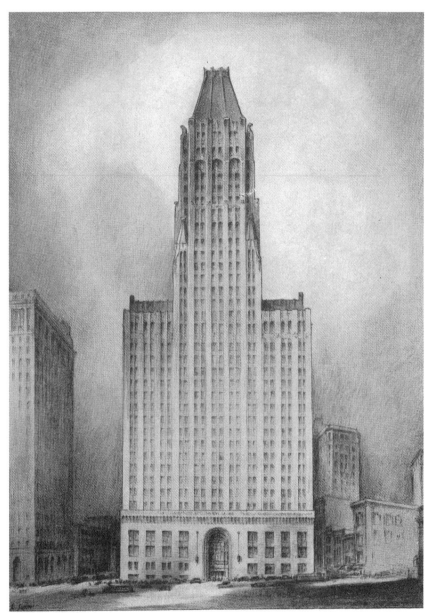

THE BALTIMORE TRUST BUILDING
Baltimore, Light and Redwood Streets

Carlin's Park sported an incongruous Chinese pagoda entrance. Sprawling across seventy acres, Carlin's flourished from the mid-1920s until after World War II. John J. Carlin, who lived only a few blocks away, opened the park as a family place. It offered a midway with carnival-style games of chance, rides named "the Bug" and "the Caterpillar," a merry-go-round, a roller-coaster (known as the Mountain Speedway), an Old Mill (featuring boat rides through a dark tunnel popular with the teenage set), a modest Ferris wheel, a fun house, and a penny arcade where a boy with five or six pennies could get "cowboy cards" featuring the likes of Ken Maynard, Tom Mix, or Buck Jones.

The fun house was one of Carlin's most popular attractions. Kids couldn't stop talking about it, even days after they'd been through the place. The building itself was large, shapeless, and barnlike, but inside was the stuff of childhood and ado-

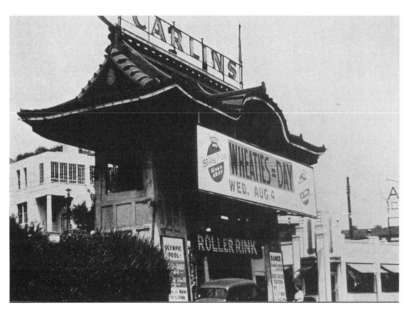

lescent joy. Odd attractions included a revolving disk about fifteen feet across that spun faster and faster until all of the kids clinging for dear life were thrown off; a sliding board two stories high; a rotating tunnel in which it was impossible to remain standing; mirrors that made the viewer outrageously fat or thin or short or tall. And, as a titillating diversion, there was this built-in device that could lift up the skirts of unsuspecting females. As the girls walked through the fun house, they would unknowingly pass over tiny holes in the floor. Through these holes came blasts of air, perfectly timed to billow a girl's skirt like a parachute. The embarrassed victim would grab at her skirt to hold it down—but always too late. That was the genius of John Cypulski, the operator of the device: "Pressing this button," he said, pointing to the control, "is an art." He explained how the air blast would appear a few seconds after the button was pushed, so he had to take into account how far the victim was from the air hole and the speed of her approach. It was a calculus Cypulski was proud of: "I never miss. I have perfect timing."

In the winter, depending on the year, the park offered boxing, wrestling, and ice skating; in the summer, patrons danced at Forest Gardens or swam in Carlin's Olympic pool. There really was a circle in the Park Circle, to the east of the park's entrance, which was crowded and full of city sights and sounds—balloons and popcorn in summer giving way in winter to hot roasting peanuts and, at twilight, the glow of newsboys' fires.

There were other popular amusement parks in small-town Baltimore; among them were Gwynn Oak, Riverview, Bay Shore, Electric Park, and the all-black Brown's Grove.

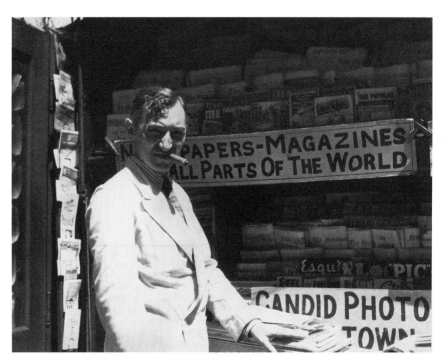

Decorated war hero and newsstand entrepreneur Abe Sherman stands in front of his wares in 1934. He opened his stand on the northeast corner of Battle Monument park (Fayette and Calvert Streets) in 1919 after returning from France. Sherman carried newspapers and magazines from all over the world, advertising at one point that all forty-eight states were represented among his printed inventory. Baltimoreans grew to love the stand and came to rely on it—many of them routinely driving by, grabbing a paper, and paying for it on the fly.

When, years later, city fathers decided to dress up the grounds of the Battle Monument, they argued that the stand was dangerous and impeded traffic flow at one of the city's major intersections. Forced to move to the northwest corner, Sherman complained that he "got more business there from the pigeons" than the people. He wanted his old spot back. Finally, with official blessing, local architects sponsored a contest for the best newsstand design. It would be back at the old place, but it would be "aesthetically pleasing." Schaefer Beer came up with $11,000 to build it, and so, about a year later, a glass and aluminum Abe Sherman's came into being. Mayor Ted McKeldin, borrowing money from a bystander to buy the first paper sold at the stand, called it "the Taj Mahal of newsstands." Sherman responded grumpily. City comptroller Hyman Pressman then read one of his poems: "This is truly beautiful, Abe, / Treat it tenderly, like a babe. / Protect it from all passing trucks, / It cost eleven thousand bucks." Besides Abe, others were not so happy. The Society of 1812 called Sherman's new presence near the monument "rank commercialism." Flag House devotees described it as "a desecration of our war dead."

awareness of the custom. In March of that year, Judge Eugene O'Dunne sentenced James H. Kingsmore to five lashes for wife-beating and ordered Sheriff John F. Potee to lay them on. Potee, it turned out, was part sheriff and part showman, and he chose the main corridor of the City Jail to carry out the sentence. He handed out hundreds of admission cards. As cameras flashed, the prisoner was led into the noisy, churning scene. Handcuffed, stripped to the waist, he turned to the guard and said, "I don't mind taking my medicine, but I don't think you ought to make a circus out of it."

Circus it was, and the press had a field day. The next day a grisly picture of Kingsmore, tied spread-eagled with the cat-o'-nine-tails lying right on his bare back, appeared in the *Sun*. The public and Judge O'Dunne were furious at the "vulgarity of such journalism." In 1931, when Judge O'Dunne ordered wife-beater Charles Lamley to the whipping post for five lashes, he issued a warning to the press: "The orderly processes of the court are being daily subjected to the undesirable publicity of a low order by pictorial display in certain publications. They. . . are offensive to the administration of justice." He forbade the newspapers to take pictures; they could only report the event.

In 1938, when Judge J. Abner Saylor sentenced Clyde Miller to twenty lashes, the press forgot its prior restraints and went completely tabloid: "Miller sags at knees, stays conscious as 6-foot, 200-pound sheriff wields whip." The Jail Board, livid, passed a new regulation: "Hereafter, press representation at such will be limited to two reporters from each local newspaper," and "no cameras will be allowed."

The last flogging in Baltimore took place in 1939, when Judge Emory Niles ordered Sheriff Joseph Deegan to give Louis Woolschlager five lashes for wife-beating. Witnesses were "strictly limited"; press coverage turned out to be nothing more than a buried four-inch story—with no pictures.

■ THE FIRST TOYTOWN PARADE Late in the afternoon of November 22, 1936 (the day before Thanksgiving), Benjamin "Ben" Posen, advertising manager of Hochschild, Kohn's department store at Howard and Lexington Streets, was beside himself with anxiety. Here it was, only about thirty hours before Baltimore's first Toytown Parade was to begin, and, though just about all other things (bands, Santa's helpers, mailboxes, floats) were in place, the huge balloon characters, which had been advertised as the big draw of the parade, had not arrived. They had been expected to arrive by 5:00 P.M. via trucks out of Binghamton, New York, about two hundred miles north of Baltimore. When that didn't happen, Posen, suspecting trouble, got on the phone. His fears were confirmed: the trucks were snow-

bound in Binghamton. Worse, even if they could leave early in the morning, it was not likely they could arrive soon enough to allow time for inflating the balloons before the 9:30 A.M. parade start.

Thanksgiving morning, November 23, 1936, Charles Street near University Parkway: It is a big, wide, noisy parade, filling the street curb to curb, and the huge balloon characters are larger and taller than any that parade watchers had ever seen (they have been billed as "the largest in the world"). The bands are playing "Santa Claus Is Coming To Town," with the drum majorettes strutting to the beat, and Santa's helpers are wheeling their "mailboxes" along the curb so the kids can mail their letters to Santa.

Posen gets assurances that the trucks will leave as soon as the roads are clear. If they leave Binghamton by 2:00 A.M. they can arrive in Baltimore by 7:00 A.M. But can the Hochschild crew get all those balloons inflated in two hours using the commercial pumps supplied by the manufacturer? Posen realizes that they can't; the pumps work much too slowly.

Here comes a towering Cinderella balloon, so big it takes six Hopkins students to pull it along with ropes. Next, a giant Mickey Mouse; then Goldilocks; then Noah and his Ark. Wild cheers break out as each of the balloon spectaculars makes an appearance before another group of watchers, lined six deep along the curb.

Posen has an idea, and it's a desperate one: To get the balloons inflated fast he commandeers every vacuum cleaner in the store ("including," he later recalled, "some right off the sales floor!"). Miraculously, the balloons arrive about 7:00 the next morning, and a crew of porters, using the commandeered vacuums, work like dervishes to fill them. The idea works! By 9:30 A.M. the big balloons are moving down Charles Street. More than two hundred thousand see the parade this Thanksgiving Day.

For the next twenty years the Hochschild, Kohn Toytown Parade would be a tradition, its immense presence helping to define Thanksgiving in Baltimore. But Ben Posen, viewing the passing parade in the sunshine of that long-ago morning, could not know that. He was too busy thinking that this first Toytown Parade had been only a couple of vacuum cleaners away from establishing no tradition at all.

Every spring, dozens of organ grinders like this one—carrying a crank-operated music box balanced on a pole and holding a prancing monkey on a leash—appeared on the streets of downtown Baltimore.

■ HOW YOU COULD TELL IT WAS SPRINGTIME

IN BALTIMORE This story begins long ago and far away in the French Quarter of New Orleans in, oh, say 1939; we can't be sure. It is early March, and Luciano Ibolito (or "Louisiana Ibolito," it depends on which account of his life and times you read) is standing on a corner. With one hand he is cranking out "Whispering" on a barrel organ (called a "hurdy-gurdy"— a portable, miniature organ in a square-foot box, resting on a pole and operated with a hand crank), and with the other he is holding a leash, at the end of which is his dancing, romping, somersaulting monkey, Julia.

Julia is busy collecting coins from children and stashing them in her pocket, but Luciano is looking up at the sky. Some ancient calendar deep within him tells him it is spring back home in Baltimore now and he should be going there. We next see Luciano and Julia on a sun-drenched spring afternoon on the corner of Howard and Lexington Streets, or on Baltimore and Charles Streets, or on the grassy slopes in front of the flowering shrubs in Mt. Vernon Place. Luciano is again grinding out "Whispering" on his

hand organ, and Julia is again busy with the children gathered around her. She clashes symbols, smokes a pipe, picks up her hat with her tail, dons spectacles, combs her hair, salutes men in uniform, preens before a mirror. Between these stunts, she is dutifully collecting coins and putting them carefully into the deep pockets of her red jacket.

Luciano Ibolito, who lived at 712 Duker Court, was one of dozens of such "monkey grinders," as they called themselves, who were seen and heard on the street corners of downtown Baltimore. Every year, after the dark ice of February and March had melted, they suddenly appeared in the sunshine of Baltimore's glorious April. It was how you could tell it was springtime.

■ "HANDLE POLITICIANS WITH KID GLOVES,

BUT HAVE A ROCK IN YOUR MITT" Marie Oehl von Hattersheim Bauernschmidt's life and times were as formidable as her name. She came out of South Baltimore in the 1920s like a sputtering firecracker, married a beer baron, and became, easily, the most controversial name in Baltimore public life in her day. She stormed into the offices of mayors, governors, city officials, and politicians demanding—and always getting—a hearing. She was ready for them. "Handle politicians with kid gloves," she advised, "but have a rock in your mitt."

She carried her fight for reform into newspapers and onto radio. She never let up. "Mrs. B.," as headline-writers dubbed her, at one time or another waged war against Mayors Broening, Jackson, McKeldin, and D'Alesandro Jr., Comptroller R. Walter Graham, and Democratic faction boss Jack Pollack. ("That lady," Pollack averred, "wants nothing less than to be dictator of this city.") The list of Mrs. B.'s targets even included certain schoolchildren who, she said, were "leaving school to go out to the racetrack and sell dope sheets."

But the focus of her relentless campaign was on those whom she accused of standing in the way of her battle to improve public schools. On her way to many successes, she seemed to enjoy the fight. "Look here, big boy," she roared at one of the prominent politicians of the time, "bigger boys than you have tried to stop me, and they've never succeeded."

Marie Bauernschmidt, scourge of politicians, steps from a voting booth with a characteristically determined look on her face (right) and gives the Public Park Board a piece of her mind in December 1939 (below). The board was considering a proposal to allow midget auto racing in Municipal Stadium. Speaking as executive secretary of the Public School Association, Mrs. Bauernschmidt declared that midget auto racing and, for that matter, all races "draw an undesirable element of people."

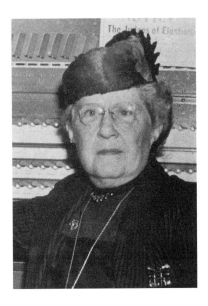

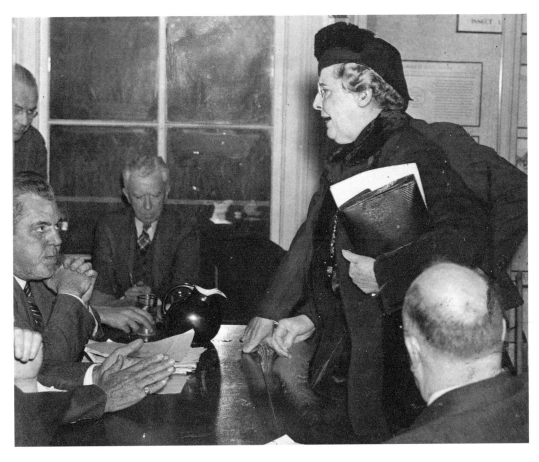

3 | They're Off and Running at Pimlico

■ **THE BALTIMOREAN WHO CHANGED ON-TRACK BETTING WORLDWIDE** On the cloudy and chilly afternoon of October 22, 1933, something highly unusual occurred at the Pimlico Racetrack. It was Sunday, not a racing day at Pimlico, and yet more than seven thousand fans filled the stands. Stranger still, there were no horses running. It nonetheless proved to be a historic day. When it was all over, racing at Pimlico (and around the world) would never again be the same.

The Maryland Jockey Club had invited guests to watch the first test of the "totalizator" (later to be known as the "tote board"), a revolutionary innovation that racing officials described as "the new betting machine that flashes official odds and total amount of money wagered in electric lights every sixty seconds."

Until that Sunday afternoon, odds at race tracks had been displayed manually and could only be approximate. "Before the tote board," Jack Mahony, son of one of the original members of the team that developed the totalizator, recalled, "there was this big signboard with rows of three-sided slots, each about a foot square. Boys working the board would get instructions from the office over the telephone. Then, carrying signs with numbers painted on them, they'd climb the ladders and insert the right signs into the right slots on the board. It took maybe five boys and five minutes to handle each change." Mahony had been one of those boys.

But from that Sunday on, beginning with the first race at the formal opening of the Pimlico fall season in 1933, the exact amount of money a horse would pay could be known by the bettor at every stage of the wagering. "The tote makes no mistakes," the club management announced, "and cannot be tampered with."

A crowd gathered immediately at the $50 window. Fans bet phantom money from a simulated entries card in a test that used the names of famous horses who had run at Pimlico, including Preakness and Glenelg. The first fan bet $1,000 on Preakness, and for twenty minutes every window was busy. Up in the control rooms, officials watched closely. The machines started clicking, changing the odds board every sixty seconds. Bets kept coming in until the bell rang. The judges and stewards were in their usual places, and the crowd settled into seats and along the rail. The timing was perfect. The judges allowed time for the horses to parade to the gate and then run the race.

Of course, no horses paraded and no race was run that day. What the

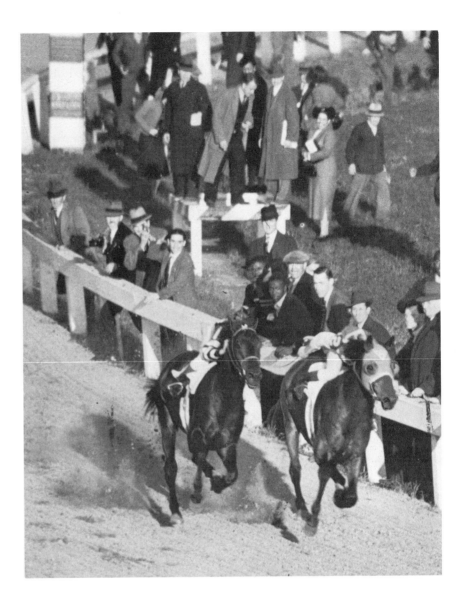

fans watched instead was the tote board, which displayed the order of the finishers. It named the winner: Preakness, paying $10.20.

"A good day," officials at Pimlico stated for the record. "The fans bet their bankrolls. A satisfactory figure is around the $400,000 mark for an entire afternoon for a card of seven races. The ghost money of $147,480 for this ghost race was more than one-third of that."

The totalizator was the brain child of Baltimore engineer, sportsman, entrepreneur, and Johns Hopkins graduate Harry Straus, who was born in 1896 at 2303 Madison Avenue into an upper-middle-class Jewish family. After the turn of the century, streetcar lines were extended outward and the family was able to move out to the suburbs, to 4007 Penhurst Avenue, at the

The venerable home of the Maryland Jockey Club provided the cover art for the program commemorating the race between War Admiral and Seabiscuit, a rather expensive souvenir at fifty cents.

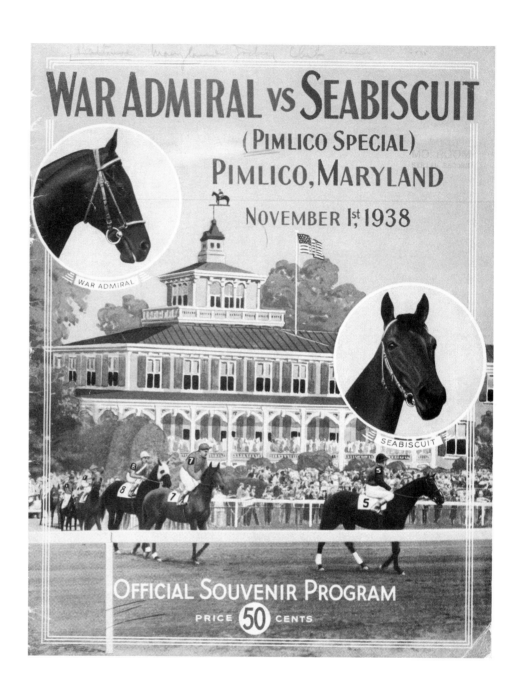

corner of Granada Avenue in Northwest Baltimore, in the neighborhood of Arlington. The young Harry attended P.S. 64 at Garrison and Maine Avenues through the eighth grade. He spent his boyhood days with neighborhood friends, biking out to nearby Electric Park, crabbing on the Patapsco, and cycling over to the Pimlico Racetrack.

He then moved on to Baltimore City College High School at Howard and Centre Streets, from which he was graduated in 1910 at age fourteen. In 1912 the Johns Hopkins University, renowned for its School of Arts and Sciences, announced that it would open a School of Engineering. Harry Straus applied to enter the 1913 freshman class and was accepted. The university, which had been located in the Howard and Monument Streets area since its founding, moved to Homewood in 1915, a year before Straus graduated. Like most Hopkins students in those days, he lived at home, for a while riding the same streetcar that he had taken to high school.

According to John C. Schmidt, who wrote *Win, Place, Show* (Whiting School of Engineering, Johns Hopkins University, 1989), a biography of the inventor, "Harry Straus's success was harnessed to a passion for sport," and his electrical device "was instrumental in elevating thoroughbred horse racing to a billion-dollar-a-year industry and making it one of the country's most popular and most honest spectator sports. At the tragic end of his life, which came three decades after his graduation from Johns Hopkins, he had still not reached his prime. His insight had led him to support the early development of a strange new electronic contrivance in which only a handful then saw promise. We know it today as the computer."

■ MATCH RACE! WAR ADMIRAL VERSUS SEABISCUIT Small-town Baltimore laid fair claim to being a racetrack town, so when they talked sports in Valley drawing rooms and Highlandtown taverns, they talked about horse racing.

At 8:30 on the damp morning of November 1, 1938, Jervis Spencer Jr., chairman of the Maryland Racing Commission, stepped onto the track at Pimlico and slowly walked the entire mile oval. When Mr. Spencer finally crossed the finish line thirty-three minutes later, he turned to the officials and gave them and the world the word: "This track," he said, "will be ready by post time. The race is on."

"The race" he referred to was a rivalry that had been building for two years, between a Cinderella horse, Seabiscuit, the nation's undisputed handicap king, and War Admiral, the turf aristocrat who had won the Triple Crown.

Shortly after Spencer made his pronouncement, the gates were

thrown open and forty thousand people jammed the grandstand, clubhouse, and infield. Tension mounted through the morning, and by post time the sun was shining, the crowd was on its feet, and the horses—War Admiral the favorite—were walking to their start.

When the gates opened, Seabiscuit broke suddenly with a tremendous burst of speed and moved ahead by a length. He and War Admiral ran indecisively for most of the way, then, coming into the backstretch, the favorite's nose showed in front. Seabiscuit's jockey used the whip and brought the horses head-to-head. Charley Kurtsinger, who was riding War Admiral that day, had stated before the race that so far he had never had to ask War Admiral for his best. Now he did, begging War Admiral to give it all he had. But War Admiral could give no more; he had met a better horse. Seabiscuit drew away and won by four lengths.

4 | "Separate but Equal," So They Said

■ **WHEN BLACK CATERERS DOMINATED THE BUSINESS** In the elegant days when Baltimore society lived in stately mansions bordering the parks of Monument and Charles Streets, every sophisticated party, wedding, cotillion, or symphony was handled by one of four caterers: Waters, Young, Shipley, or Hughes. All of them were in demand, all of them enjoyed excellent reputations, and all of them were black. "As a matter of fact," said Howard Murphy, grandson of James Hughes, who founded Hughes Catering in 1882, "up until 1930 or so there were few white caterers in Baltimore."

Murphy recalled working for Hughes Catering at 12 East Centre Street, a row house on the north side of the block between Charles and St. Paul Streets and close to the Mt. Vernon mansions. Mary Frances, a granddaughter of James Hughes, felt that Hughes Catering's success was due in no small measure to their specialty—chicken croquettes. "We had a chef, David Bruce, who was with Hughes fifty-five years, and he made those croquettes taste *different;* it was the Hughes's secret. In the best homes along Mt. Vernon Place, including the Jacobs Mansion; at the home of Mayor Jackson, the Government House in Annapolis, Goucher College; in Roland Park and out in the Valley, the hit of the party was always Hughes's chicken croquettes."

The era of flourishing black catering services started coming to an end in the 1930s. By then the patrician families had left Mt. Vernon Place behind and, worse, the big hotels downtown—the Emerson, Stafford, Southern,

and Belvedere—had established their own catering services. Even so, Hughes Catering continued offering its famous chicken croquettes and excellent catering services until 1955, when the family decided to close down the business.

As far as the secret to Mr. Hughes's chicken croquettes, Mary Frances herself said. "I *know it,* but I'm not *telling* it!"

■ DRUID HILL AVENUE, THE BEST ADDRESS The area was called "Druid Hill Avenue" because the avenue was the best-known thoroughfare running through it. It was roughly a ten-block-square area, centered on Druid Hill Avenue and North Avenue, offering the relative luxury of the broad, green open spaces of Druid Hill Park and splendid views of Druid Park Lake. The section was recognized as the most prestigious of Baltimore's black communities. According to Gaines Lansey, a banker familiar with the neighborhood, some of the households had cooks, maids, butlers, and housemen. The men often dressed in elegant jackets for dinner.

William H. Murphy knew the area well. He recalled residents in the neighborhood enjoying the services of chauffeured limousines and house servants. "They had their own coming out parties and debutante balls, so their children could meet the right people. And these children went to the best colleges in America: Lincoln University, yes, as did Justice Marshall, and Howard University, yes, but also to Vassar, Smith, Penn, Yale, and Harvard. This was in the 1920s, too, remember."

Although Justice Thurgood Marshall was born at 1632 Division Street, he grew up in these same blocks of Druid Hill Avenue. There is disagreement among Marshall biographers over whether his family was wealthy, but there were certainly many wealthy families in the area. Among the prosperous residents was well-known political figure Harry Cole, a member of the state legislature and eventually a judge in the state Court of Appeals. He lived at 1534 Druid Hill Avenue. Truly Hatchett, a prominent real estate investor and member of the state legislature, lived at 2026 Druid Hill Avenue. And Dr. Louis Harman, a successful physician, lived at 2024 Madison Avenue. Emanuel Chambers, who made a fortune in the stock market, lived close by, at the corner of Madison Avenue and Wilson Street. A resourceful and highly valued member of the Maryland Club staff, he listened carefully to the conversations of downtown brokers and modeled his own investments, very successfully, after theirs.

This elegant community was responsible for an annual cotillion known as the Half-Century Ball. "It took that name," according to Elizabeth McCard Shipley, a 1928 graduate of Smith College, "because the families in-

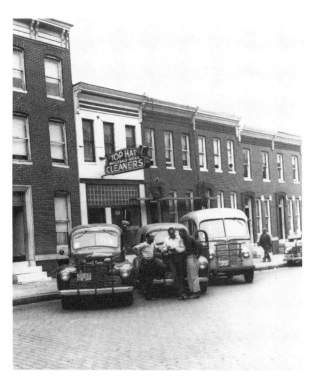

Above: *Drivers for the Top Hat Cleaners, 1808 West Lanvale Street, take a break in about 1940. A leading African American–owned business, Top Hat served the neighborhoods of West Baltimore. Courtesy of the I. Henry Phillips Collection.*

Right: *A lovely Sunday scene near St. James Episcopal Church, Arlington and Lafayette Avenues, in one of the fashionable neighborhoods of Northwest Baltimore in the 1940s. Courtesy of the I. Henry Phillips Collection.*

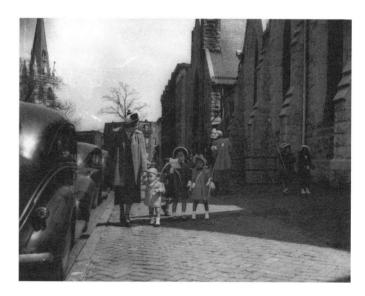

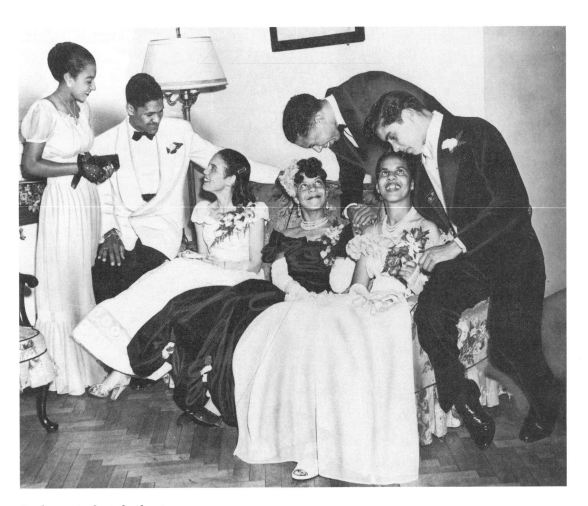

Students mingle at the dean's reception, Morgan State College, June 1949. "Pretty girls, charming chaps, flashing smiles, and party frocks," reported the Baltimore Afro-American, *made the event "an outstanding end-of-the-year affair." Courtesy of the* Afro-American *Archives.*

vited into membership were members of the Half-Century Club." The ball was reminiscent of white Baltimore society's Bachelor's Cotillion—replete with similar taffeta and tuxedos, soft music, champagne, corsages, polite introductions and warm embraces, and Ivy League and "Seven Sisters" college ambiance.

Because none of the downtown hotels—not the Emerson, the Southern, the Belvedere, or the Lord Baltimore—was open to blacks, the Half-Century Balls were held at either the Odd Fellows Hall (on McCulloh and Lanvale Streets) or the Elks Club (on McMechen Street and Madison Avenue). The families in the membership of the now-defunct Half-Century Club included the Hawkins, Wrights, Youngs, Masons, McCards, and Fitzgeralds. They were professionals for the most part—doctors, lawyers, educators. Many if not most of the families lived in the area of Druid Hill Avenue near North Avenue.

Jessie Fitzgerald Lemon, a 1938 Wellesley graduate, recalled hearing about the traditional ceremony at the Half-Century Ball. "First, the father would dance with his daughter, in an exclusively father-daughter dance. Then, the young men would be invited to cut in, and there would be a young people's dance. Then, the fathers and mothers would join as couples, and all, daughters and partners and parents, would dance together. It was the loveliest of occasions and in the best of taste."

The grand days of the black community's debutante parties and the Half-Century Balls are gone; the last such ball was held in the early 1930s. "The Depression was partly responsible," Elizabeth McCard Shipley said. "But black society, like white, was in turmoil, and the young people were in rebellion against the idea of class. They have long rejected the idea as elitist."

■ PROTEST ON THE AVENUE The nation was deep in the national Depression on December 8, 1933, when more than 150 African Americans congregated on the streets and sidewalks of the 1600 and 1700 blocks of Pennsylvania Avenue in one of Baltimore's first civil rights demonstrations.

Pennsylvania Avenue in the 1930s was the heart of Baltimore's African American community. Not only were those 1000 to 1800 blocks the community's shopping center, but they were also the center of its social life. The Royal Theater was at 1329; the Regent Theater, 1619; the Comedy Club, 1414; the Diane Theater, 1429; New Albert Theater, 1320; and Penn Hotel, 1631.

The protestors carried signs reading: "Don't Shop Where You Can't Work!"

In July 1933, when it was fifty years old, Weber Brothers Poultry opened a new outlet at 624 North Chester Street. Chester ran north and south a few blocks west of Patterson Park. The firm had two stalls at the Northeast Market, "with poultry sold under rigid sanitary conditions."

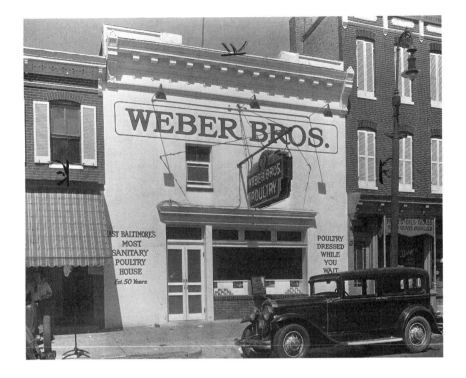

This demonstration was not about segregation of schools, restaurants, or movies. It was not about drugs, crime, or police brutality. It was about jobs. The leaders of the group, according to reports in the *Sun,* included "a man known as Tony Green, a number of Negro organizations, and a large number of individual Negroes." Those who were there remember Lillie May Jackson, Thomas Hawkins, and Juanita Jackson, members of the NAACP, Baltimore Chapter, and of Bethel A.M.E. Church. The object of the demonstration was to let Baltimore know that, though the customers of the establishments in those blocks were all black, their owners and employees were all white. The demonstrators argued that at least some of the jobs in those stores ought to go to African Americans. Their main weapon was the boycott, and among the main targets was the A&P food store at 1737 Pennsylvania Avenue, at the corner of Laurens Street, then one of the Avenue's largest employers.

The timing of the protest, according to some observers, could not have been worse. The country, and Maryland, were bleeding from the wounds of racial conflict; the times were charged with threat and uncertainty. The famous case involving nine black youths in Scottsboro, Alabama, had been decided two years earlier. Eight of them, arrested for the alleged rape of two white girls (who were the sole witnesses; one of the girls later changed her mind), received the death penalty; the ninth, nine years old, was sentenced

to life imprisonment. In October 1933, George Armwood, an African American, was arrested in Somerset County on the Eastern Shore after an alleged attack on an eighty-two-year-old white woman. On Wednesday night, October 18, an enraged mob broke into the jail, dragged Armwood from his cell, bound him, and hanged and burned him. Pieces of the rope were distributed as souvenirs. The lynching was widely, vigorously, and loudly condemned. When troops of the Maryland National Guard's Fifth Regiment went to Salisbury to arrest six lynching suspects, they met "a barrage of bottles, bricks, stones, and streams of water." The atmosphere on both shores was tense and threatening.

Nonetheless, on that Saturday morning in December dozens of Baltimore's black residents gathered on Pennsylvania Avenue, some carrying signs, and launched their protest for jobs. There was no violence, nor were there arrests. William H. Murphy was a boy of sixteen at the time, but he remembered the protest and explained why there were no arrests. "This was 1933, remember? Different times. Those blacks protesting were sternly instructed—no violence. That was because it was known quite well in the black community that if there were violence, the perpetrators would get their brains bashed in by the police."

The protests went on sporadically. The merchants refused to give in, although business was reported to be off by as much as 60 percent. Eventually the merchants went to court, seeking a cease-and-desist order that they hoped would bring the boycott to an end.

The matter came before Judge Albert S. J. Owens, who first issued a temporary injunction to restrain the pickets and then granted an injunction declaring the picketing unlawful: its object "was to coerce the storekeepers by causing them business losses, that this effect could only be caused by the violation of the legal rights of the plaintiffs and of the public law as well, in that the assemblage of the defendants' marchers and their friends unlawfully and willfully hindered and obstructed the free passage of persons along the street and was a constant menace to the public peace, and tended any time to create a riot."

The judge declared that the defendants were "colored persons of the highest type, educated, respectable and religious," adding that it was "inconceivable that they could have been misled into believing their actions were justified."

The *Afro-American* newspaper profiled the picketers. It reported that the youngest girl on the picket line was Ruth Bailey, a thirteen-year-old Douglass High School student; the oldest woman was Mrs. Annie Jordon,

fifty, a grandmother—"She is thought to have spent the most time on the picket line."

The protest that began on Pennsylvania Avenue in 1933 formally ended in the spring of 1934, when the A&P began to hire blacks (the first was Thomas Hawkins) and stores began to post signs on their windows: "This store is OK," "We employ colored," "This store is open to you," and, finally, "You are welcome."

5 | Eating Out

■ HEAVY ON THE GERMAN SIDE BUT FAMOUS FOR BEING FAMOUS Marconi's, Haussner's, Miller Brothers, the Chesapeake—each of these restaurants in small-town Baltimore got to be famous for fine food. But Schellhase's became famous for being famous.

Schellhase's opened in 1924 at 302 West Franklin Street (then in the heart of the theater district) and in 1935 moved to 412 North Howard Street, where the restaurant found its niche. Schellhase's special character and color made it a favorite of so many for so long. H. L. Mencken's Saturday Night Club met there, and perhaps Mencken's influence helped bring in those many others from the worlds of art, music, literature, the theater, and journalism who gathered at Schellhase's for long lunches and even longer dinners. And on all the walls at Schellhase's hung very wisely selected pictures, hundreds of them, of these same celebrities.

Shellhase's new menu tilted toward the Central European, offering the standard knockwurst and German potato salad. As for the decor, that didn't appear to have much going for it. Patrons who recalled it said the place always seemed dark. It was paneled with dark woods and heavily draped in dark curtains. "Schellhase's has a certain gloom about it," a restaurant critic wrote of her experience there. Eventually the owners remodeled it, only to do it all over in what another critic described as "Plastic Modern."

But no matter—the glamorous clientele kept coming. Henry Fonda and Margaret Sullavan were married in Baltimore and held their reception at Schellhase's. Alfred Lunt and Lynn Fontanne dined there every night of their performance of *The Taming of the Shrew,* joining other stars who happened to be in town performing at other theaters.

Restaurants, lunchrooms etc. - Baltimore - Schell

Schellhase's Restaurant

MD. V.F.
ENOCH PRATT
FREE LIBRARY

OUR DRAUGHT BEERS ARE PRE-COOLED

DO NOT CIRCULATE

CARTE DU JOUR

November 17, 1938

Cherry Stone or Little Neck Clams..30 Cocktail..35
Tom's Cove Oysters on Half Shell....35 Cocktail..40
Crab Flake or Shrimp Cocktail..45 Lobster Cocktail..95 Fruit Cocktail..25

*Fried Oysters..55 Oyster Stew..50 Panned Oysters..65 Oysters au Gratin..65
Broiled Oysters on Toast..65 Oyster Shell Roast, Bacon..75
Maryland Ham and Oysters..70 Smithfield Ham and Oysters..90
*Imperial Crab..75 *Deviled Crab..55 *Crab Cakes..65 Crab Flake Saute..75
Crab Flake Charlotte..85 Crab Flake Creole..65 *Mackerel, Broiled..75
*Fried Filets of Sole, *Shrimps or *Scallops, Tartare Sauce..75
*Rockfish, Broiled..75 *Trout, Fried..65 *Bluefish, Broiled..75
*Fried Smelts, Tartare Sauce..65 *Norfolk Spots, Saute..65
Dishes with * include Potato Salad and Cole Slaw

Prime Rib Roast of Beef, Vegetable and Potatoes......................75
Calf's Liver Saute, Onions or Bacon and Potatoes......................75
Spanish or Crab Flake Omelette, Mashed Potatoes......................55
Spare Ribs, Sauer Kraut and Mashed Potatoes......................55
Frankfurters or Knackwurst (Import Style) Sauerkraut and Mashed Potatoes..55
Braised Sweetbreads, Mushroom Sauce, Peas and Potatoes............70
Chicken Liver Omelette, Mashed Potatoes......................75
Filet Mignon, Mushroom Sauce, Peas and Potatoes75
Broiled Pork Tenderloin, Fried Sweet Potatoes and Peas......................75
Creamed Chicken on Toast, Peas and Mashed Potatoes................ 65
Hungarian Goulash, Spaghetti and Potatoes......................50
Broiled Lamb Chops on Toast, Peas and Potatoes85
Pig's Knuckle, Sauerkraut and Mashed Potatoes......................60
Sour Beef, Apple Sauce, Potato Pancakes or Dumplings..............75
Hamburger Roast, Creole Sauce, Mashed Potatoes and Peas......................50
Pork Chops Breaded, Potatoes and Peas......................65
Salisbury Steak, Mushroom Sauce, Peas and Potatoes65
Veal Cutlet Breaded, Spaghetti and Potatoes......................65
Roast Fresh Ham, Sauerkraut and Potatoes......................60

Cold Steamed Lobster, Mayonnaise..1.10 Broiled Lobster, Drawn Butter..1.10
Sea Food Platter Consisting of Half Lobster, Crab Cake, Shrimps,
Scallops, Filets of Sole, Potato Salad or French Fried Potatoes....$1.10

Imported Westphalia Rollschinken (Raw), Asparagus Tips......................85
Pig's Knuckle in Gelee, Potato Salad......................60
Pickled Lamb's Tongues, Potato Salad and Cole Slaw......................55
Chicken Salad, Pineapple and Potato Salad......................60
Cold Smoked Beef Tongue or Sugar Cured Ham, Potato Salad and Slaw..........60
Crab Salad....75 Combination Salad....40 Egg Salad....40
Smithfield Ham, Potato Salad and Cole Slaw......................85
Assorted Cold Cuts, Potato Salad and Cole Slaw......................75
Marinirter or Bismarck Herring, Bread & Butter..25
Fresh Mushrooms on Toast..60 with Bacon......................75
Welsh Rarebit..50

Sliced Orange..15 Honeydew..15
Assorted Pies..15 Ice Cream..15 Pie a la Mode..25 Jell-O with Cream..15
Stewed Apricots..15 Apple Sauce..10 Fresh Apple..10 Grape Fruit..15
Coffee, Tea or Milk..10

Dishes checked (√) not served today

■ "CUT YOUR STEAK WITH A FORK, ELSE TEAR UP YOUR CHECK AND WALK OUT" Riding the B&O Railroad on its run from Chicago to Baltimore in the early hours of May 6, 1936, Sidney Friedman sat upright in his seat, sleeping fitfully. The car was almost empty because most of the passengers were asleep in their Pullman berths. Friedman couldn't afford a Pullman berth. He barely had enough money to travel coach.

He had made the trip to attend a trade show, where he hoped to get ideas that would help his family's fledgling business, the Chesapeake Restaurant. The eatery had grown out of his father's delicatessen and grocery at 1701 North Charles Street, just north of Pennsylvania Station. Friedman's sleep was made all the more uncomfortable because he was holding on his lap a crude and bulky "charcoal broiler." He'd bought it at the show for its highly touted ability to produce tender and delicious "charcoal-broiled" steaks. Most Baltimoreans had never heard of any such thing.

Within weeks of Friedman's return to Baltimore, the Chesapeake brazenly wrote ads declaring, "Cut your steak with a fork, else tear up your check and walk out." Word soon spread of a restaurateur so confident of his charcoal-broiled steaks that he promised his patrons they didn't have to pay if his claim did not hold up. "Our charcoal-broiled steaks were a first in Baltimore," Friedman's brother Phillip recalled, "and from there on out the Chesapeake grew to be one of the most popular of all Baltimore restaurants, taking its place with all time greats Miller Brothers and Haussner's."

The Chesapeake, with its dark wood paneling and deep, rich red banquettes, was the first restaurant, said the founding Friedman, to offer Baltimore the Caesar salad. "The first Caesar salad ever served in Baltimore was made and served by me—in the Chesapeake." The favorite appetizer was a kettle of steamed clams; the most oft-ordered entree was a sixteen-ounce steak. The most popular dessert by far was the restaurant's own coconut snowballs, Philip Friedman remembered from the 1940s. "How can I describe it? Two big scoops of vanilla ice cream drowned in a fudge sauce we made ourselves, and smothered with fresh—I mean *fresh*—coconut. The cost, $1.95!"

The restaurant was the popular gathering place for media types, sports celebrities, and corporate bigwigs. You were considered a VIP indeed if maître d' Isidor Friedman (Sid Friedman's nephew) recognized you and called you by your first name as he invited you inside the red velvet cordon to seat you. It was impossible to get a table Saturday night without a reservation well in advance—unless, that is, you knew Isidor.

Hot steamed crabs figure so large in the life of Baltimore that they serve as a symbol of the city. When outsiders think of Baltimore they think of crabs. But how did the association come about? There are many versions of the story. One of them takes us to remote Deal Island, down the Bay in Tangier Sound, at the Cedar Creek Crab Packing Co. There on a summer day in 1915, two men, one forty, the other seventeen, are standing in the crab-steaming shed and looking over a batch of freshly steamed crabs. The older man is Zack Windsor, a waterman in the business of catching and steaming hard crabs for "picking" (removing the meat so it can be canned and shipped up to Baltimore for wholesale grocery distribution); the younger is John Leonard, who works for one such distributor, U.S. Stewart.

Leonard has come down to meet with Windsor and look things over. The two agree that the catches are good ones; the "jimmy" crabs (the males) are running up to nine and ten inches across, claw tip to claw tip. Nothing so far suggests that Windsor and Leonard are about to make history, but they are. For reasons Leonard is never able to explain, he remarks to Windsor: "Eastern Shore watermen have been eating hot steamed crabs out of the shell since who knows when. Why wouldn't people up in Baltimore do the same? Let's ship some up there and see." Windsor is wary. Would Baltimoreans go to all that trouble, picking a crab apart with their fingers to get at so little meat? What about seasoning? And the crabs would have to be shipped cold—would cold steamed crabs be appealing? Windsor suggests to Leonard that he go back to Baltimore and talk the idea over with U.S. Stewart.

Leonard takes the boat home and several days later returns to Deal Island with good news: U.S. Stewart is interested. He persuades Windsor to pack barrels of steamed crabs and ship them, iced, so his distributor can promote retail sales in Baltimore. Windsor agrees and, after mixing a seasoning (Leonard recalled, "It was black pepper, salt, and 'something.'"), ships several barrels of steamed, iced crabs to Baltimore, marked for sale to A&P food markets.

The tradition-to-be almost dies, as results are disappointing. John discovers why: The ice that the crabs are packed in is washing off the seasoning, and they are arriving bland and wet. He devises a new system. Each crab is wrapped in parchment paper, which absorbs the water and keeps the crab dry. Again the crabs go to the A&P in Baltimore, where they sell for around a dollar a dozen. This time the idea catches on. Baltimoreans seem content, even anxious, to tear apart a crab and pick out every fleck of crab

FACING PAGE:
"'Old Crusty' Demonstrates His Nineteen-Inch Reach." In October 1936, the Baltimore American *found a story in "two of the biggest specimens" of crab "ever pulled from Chesapeake Bay." Caught at Kent Narrows early in the morning, that same day the two jimmies found their way to Frank Muller's restaurant in the 700 block of South Bond Street in Fells Point. Under a new state law that year, crab season ended on October 31, reopening the first of May.*

A Plea For Conservation

DR. REGINALD V. TRUITT, professor of zoology at the University of Maryland and director of the Chesapeake Marine Biological Laboratory at Solomons, Md., in addressing the Maryland Sportsmen's Luncheon Club, performed a simple act of justice to the Chesapeake crab by disproving the popular impression that the crab is a lazy traveler. BALTO. NEWS-POST

In exhibiting the preserved carcass of a tagged crab which had covered NINETY MILES IN THREE DAYS, including presumable stops to feed, he effectually discredited the crab's detractors.

But Dr. Truitt had a more important story to relate, which, if not entirely new, gained much impressiveness in the telling on this occasion.

The fact that the 900,000 acres of water and marsh area in Maryland which once furnished a livelihood to 70,000 persons now gives employment to only 40,000 is a matter which calls not only for serious consideration but for action as well.

Comparisons made by Dr. Truitt between the value of the harvests yielded by this aqueous area and those yielded by dry land gave force to his plea for adequate means for gathering facts upon which to base A SOUND CONSERVATION SYSTEM. MAR -5 1936

News. Post- Mar. 5, 1936

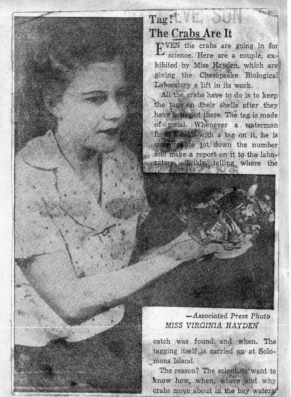

Tag! The Crabs Are It

EVEN the crabs are going in for science. Here are a couple, exhibited by Miss Hayden, which are giving the Chesapeake Biological Laboratory a lift in its work.

All the crabs have to do is to keep the tags on their shells after they have been put there. The tag is made of metal. Whenever a waterman finds a crab with a tag on it, he is supposed to jot down the number and make a report on it to the laboratory officials, telling where the

—*Associated Press Photo*
MISS VIRGINIA HAYDEN

catch was found and when. The tagging itself is carried on at Solomons Island.

The reason? The scientists want to know how, when, where and why crabs move about in the bay waters.

Eve. Sun. Dec. 24, 1936

Two Giant Crabs Taken From Bay

Each Measures 19 Inches From Tip to Tip

The crab season for Maryland doesn't end officially until next Saturday, but it finished yesterday for two of the biggest specimens ever pulled from Chesapeake waters.

Measuring nineteen inches from tip to tip of their extended claws, the two big crustaceans were taken early at Kent Narrows, off Kent Island, were on their way to Baltimore by mid-morning and by night were nicely steamed and waiting for some seafood connoisseur with a hearty appetite to come and get them.

ALMOST TWINS.

The two big crabs were almost twins in size, but Frank Muller, to whose restaurant, in the 700 block South Bond street, they were shipped, declared that one might have been an all-time record-breaker had he not suffered the loss of a claw, probably last summer. Mr. Muller pointed out that the new claw was only about half grown and that full growth would have given the crab a span of at least twenty-two inches.

SEASON ENDS.

The Kent Narrows, Mr. Muller said, is famous along the entire Atlantic Coast for the big crabs occasionally taken from its waters. Under the new Maryland law the taking of crabs will be prohibited from next Saturday night until May 1.

"OLD CRUSTY" DEMONSTRATES HIS NINETEEN-INCH REACH
With the crab season due to end in one more week this big fellow had the misfortune to be caught off Kent Island yesterday.

Balto. Amer. Oct. 25, 1936

meat. Along with grocery stores and amusement parks like Riverview and Carlin's, bars, too, begin selling steamed crabs.

It occurs to the distributors and the retailers that the crabs will be more appetizing if they can be steamed where they are sold and enjoyed on the spot. So Windsor begins shipping live crabs up to Baltimore, where it quickly becomes the custom to steam, season, and serve them hot, right on the premises, dumping them by the tray onto the tables of grateful diners. By the 1930s there are "crab-parks" like Bankert's and restaurants specializing in steamed crabs, such as Dowell's, Wilson's, Gordon's, Dubner's, Rossiter's.

The average size of the crabs appears, from accounts, to be holding at about nine to ten inches, claw tip to claw tip. But many are running larger, twelve and fourteen inches. On the early morning of March 4, 1936, two men out crabbing were stunned to discover that they had caught two monster crabs, each measuring nineteen inches. According to a report of the catch, which made the newspapers, "The crabs were on their way to Baltimore by midmorning and by night were nicely steamed and waiting for some seafood connoisseur with a hearty appetite to come and get 'em." The report noted that the two big crabs "were almost twins in size, but Frank Muller, to whose restaurant in the 700 block of South Bond Street they were shipped, declared that one might have been an all-time record-breaker, had

it not suffered the loss of a claw, probably last summer. Mr. Muller pointed out that the new claw was only about half grown and that full growth would have given the crab a span of at least 22 inches."

Many years after the beginning of Baltimore's steamed crab business, a reporter, looking to authenticate the story, asked Leonard if he himself ate steamed crabs. "Nope," he said. "Too messy."

■ NOT THE BEST CHINESE RESTAURANT IN TOWN,

BUT EASILY THE MOST POPULAR Baltimore's most popular Chinese restaurant, the New China Inn in Charles Village, was best known by the name of its owner, as "Jimmy Wu's." Critics disagreed about Wu's cooking. "It might not be the best Chinese restaurant among the many in Baltimore," a *Sun* food critic wrote, "but it's the most popular." Gourmet Gideon Stieff, author of "The Damask Cloth" column in the Roland Park-Guilford-Homeland magazine, *Gardens, Houses and People,* gently dissented. "I have dined in the best Chinese restaurants in San Francisco's and New York's Chinatowns, and I have not eaten better Chinese food than Jimmy serves."

James Fong Wu came to Baltimore from Canton in 1920 as a boy of four. He struggled in immigrant poverty, but a teacher in the eighth grade at P.S. 1 (on Fayette and Greene Streets) took a liking to him and persuaded him to enroll at City College, where he could pursue the humanities. Though he was not a native English-speaker, he did amazingly well in the heady academic atmosphere of City, excelling academically and serving as editor of the yearbook. But when he graduated in 1933, in the depths of the Depression, there were no jobs—certainly not for Chinese immigrants.

Young Wu finally was hired as a waiter in a Chinese restaurant in Baltimore's Chinatown, near Park and Mulberry. In 1941 he became a partner in the New China Inn, a small restaurant at 406 Park Avenue. Five years later, after the war, he moved it to 2430 North Charles Street.

In no time, Wu's tiny establishment expanded into row houses on either side, creating a rabbit's warren of rooms at various levels (the "Confucius Room," the "Ming Room," etc.). Wu stayed at 2430 North Charles Street for thirty-six years, all the while providing much of the energy, marketing, and advertising talent that would help the popularity of Chinese food in Baltimore soar and the number of restaurants serving it become larger than a four-column Chinese menu.

Wu's cuisine was Cantonese, though he was businessman enough to have an American menu, too. When the Szechuan style of Chinese cooking became popular, Wu resisted it. He quoted a Chinese saying: "Live in Soo-

chow, where they have the most beautiful women, but dine in Canton, where they have the best food."

If you believe fortune cookies, here's one for you: According to an older Jimmy Wu's memory, in 1941 the young Jimmy Wu was dining alone in his tiny restaurant, well after midnight; all the diners had left. Wu finished his meal and wearily opened his fortune cookie. It read: "You will have a long and successful life in Baltimore in the Chinese restaurant business. And you will be thought of fondly for it."

6 | ALL THAT JAZZ

■ PRODIGY OUT OF WEST BALTIMORE On the night of Thursday, December 12, 1935, there was, as on most nights in Baltimore, a lot going on. Over in Highlandtown, the merchants opened their Christmas shopping season with an official lighting of their community Christmas tree (City Council President George Selmayer did the honors). At Carlin's Park in northwest Baltimore, the Orioles ice hockey team was losing 4 to 2 to the New York Rovers in the Eastern Ice Hockey League; on North Avenue, crowds were making their way into the Parkway to see *Mutiny on the Bounty* (in its fourth week). At the Lyric on Mt. Royal Avenue, concert pianist Sergei Rachmaninoff was in concert; before the evening was over he would provide renditions of Bach's "Toccata and Fugue in d Minor," Brahm's "Ballade," and a Beethoven sonata. Over at Douglass High School at Calhoun and Baker Streets, hundreds crowded into the auditorium to celebrate the eleventh anniversary of the Baltimore Urban League.

In the school's auditorium, speaker after speaker addressed the theme of the evening, "What the Urban League Means to Me." Mayor Howard W. Jackson, Governor Harry W. Nice, and Judge Joseph Ulman, president of the Urban League, all spoke. The keynote address was given by First Lady Eleanor Roosevelt.

At some point early in the two-and-a-half-hour evening, the City Colored Chorus rendered stirring versions of "Deep River" and Wagner's "Hail Bright Abode." Then, following a modest introduction, an eleven-year-old black pianist, Ellis Lane Larkins, took the stage. Young Larkins, who had made his debut a year earlier in 1934 with the City Colored Orchestra, played the "Waltz in E-Major" by Miszkowski.

By the time Ellis Lane Larkins was in his teens, he was already being referred to as a musical genius. Although in those days the Peabody Con-

servatory would not enroll blacks, he managed to attend anyway. He showed such promise that, after graduating from Douglass in 1942, he accepted a scholarship to Juilliard in New York. He left Baltimore and, with a few exceptions (like the 1962 Delta Sigma Theta Sorority reunion), did not come back for forty years.

In New York he focused his career entirely on jazz and established himself as one of the foremost jazz pianists of his time. With a style that *The New Yorker* called "diaphanous, elusive, with a feather touch," he made his New York (and world) debut at the age of nineteen at Cafe Society Uptown, in a trio led by famed guitarist Billy Moore. For the next ten years he led his own trio, playing to rave reviews at the Blue Angel and the Village Vanguard. In the 1950s he recorded for Decca Records, the foremost label in the New York jazz scene.

Eventually he played Carnegie Hall with Leonard Bernstein and Ella Fitzgerald and was featured in jazz festivals all over the world. Working from the Carnegie Tavern, Larkins established a career that set him alongside the world's jazz greats—Billie Holiday, Coleman Hawkins, Sarah Vaughn, Mildred Bailey, Eartha Kitt, Maxine Sullivan.

Back to that evening in 1935 at Douglass High and young Ellis Lane Larkins's performance: There is no official record of the audience's response to his playing of "Waltz In E-Major," but it must have been stunning. No sooner had he finished—the applause was still ringing—than Mrs. Roosevelt stepped to the stage front. She requested that young Mr. Larkins be brought stage front, too, so that she might compliment him. He shyly presented himself, and that night the First Lady of the United States shook the hand of this gifted young black musician, who had grown up on the streets of West Baltimore.

It is something of a coincidence that Sergei Rachmaninoff played the piano across town at the Lyric Theater that same night. In his review of the Rachmaninoff concert the following morning, *Sun* critic Donald Kirkley wrote, "Last night Rachmaninoff was not at his best." Kirkley should have heard Larkins—who was.

■ THE GREATEST JAZZ DRUMMER OF ALL TIME

> A-tisket, A-tasket, a green and yellow basket.
> I took a basket to my Mommie and on the way I dropped it.

It was a likely day for a funeral, June 20, 1939, with overcast skies further darkening the mood of the mourners gathered by the thousands in front of a tiny row house at 1313 Ashland Avenue in East Baltimore. They

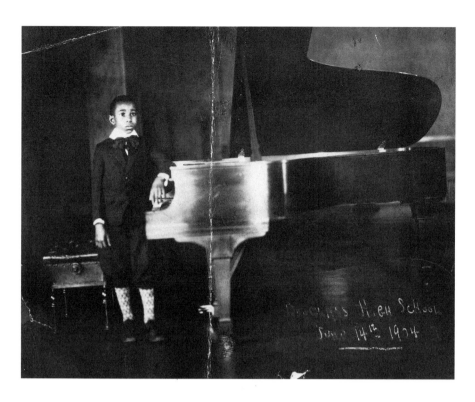

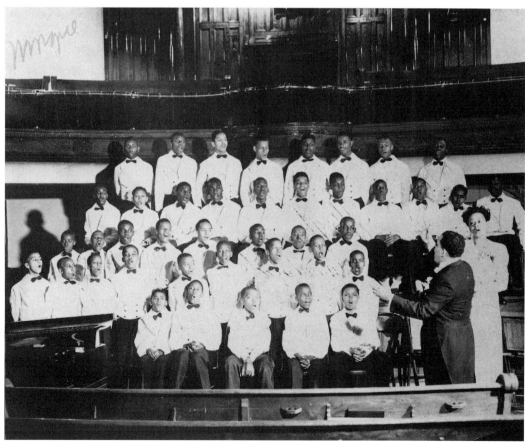

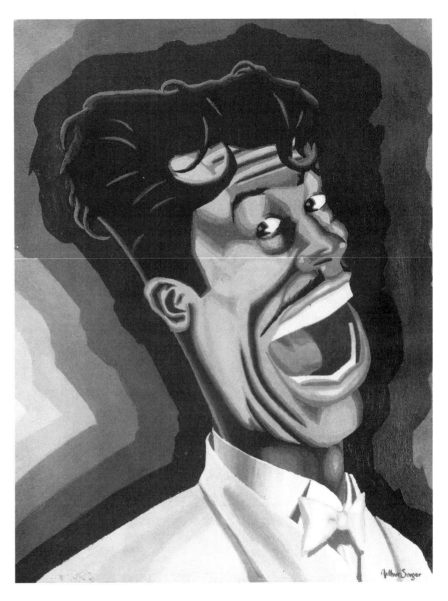

*The trademark Cab Calloway stage
presence is caricatured here for a
promotional piece from the spring
of 1936. Many years later, when the
former Baltimorean starred in a
highly acclaimed Broadway pro-
duction of George Gershwin's folk
opera,* Porgy and Bess, *a news re-
lease explained that Calloway's
longtime fame "has depended on the
driving frenzy of his jazz band con-
ducting and a rapidfire-wail singing
style."*

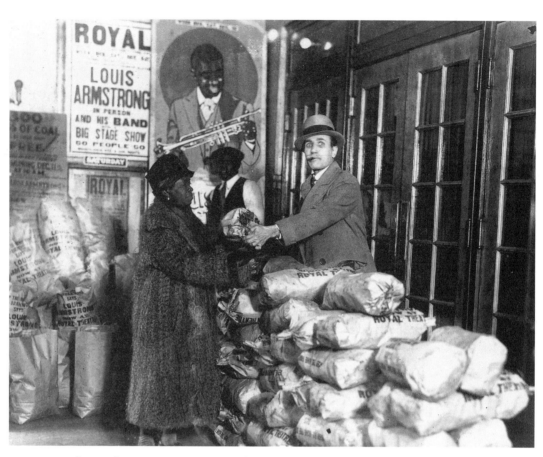

At one point during the Depression, a city charity used the lobby of the Royal Theater to distribute relief. Here, what seem to be potatoes in sacks marked "Royal Theater" go to feed the needy—as Louis Armstrong looks down approvingly. Courtesy of the Maryland Historical Society.

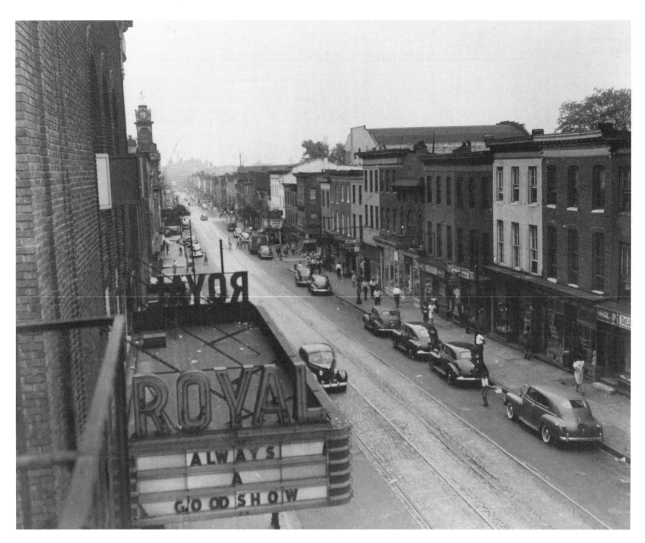

Pennsylvania Avenue on a quiet day after what likely had been an exciting night before, around 1945. Standing on a balcony next door to the famous Royal Theater, the photographer captured management's promise: "Always a Good Show." Courtesy of the Afro-American *Archives.*

had come to say goodbye, with unhidden tears, to Chick Webb, by consensus of his peers the greatest jazz drummer the world had ever known.

William Henry "Chick" Webb, a barely four-foot-tall, crippled African American, grew up selling newspapers on the streets of Baltimore. To while away the time, he played at being a jazz drummer, practicing on the bottoms of overturned garbage cans. At sixteen he ran away to New York to try his luck. It proved good; at seventeen he was leading his own band, and by the time he was eighteen he was known as the "King of the Drums." In 1937, in the "Battle of the Bands" (Benny Goodman versus Chick Webb, in Harlem's famous Savoy Ballroom) no less a drummer than Goodman's famous Gene Krupa could only say, "He just cut me to ribbons."

The casket was taken to the Waters African Methodist Episcopal Church on Aisquith Street near Jefferson Street, where an unbroken line of rich and poor, famous and infamous, young and old, black and white filed past the coffin to pay their last respects. In the line were jazz luminaries Duke Ellington, Cab Calloway, Gene Krupa, Fletcher Henderson, and Jimmy Lunceford. The service took more than two hours; as part of it, Ella Fitzgerald tearfully sang "A-tisket, A-tasket," as she had never sung it before.

> She was truckin' on down the avenue.
> Without a single thing to do.
> She went peck, peck, peckin' all around.
> When she saw it on the ground.

Estimates of the funeral crowds vary from fifteen thousand to twenty-five thousand. Mourners jammed the streets from curb to curb, milling about outside 1313 Ashland Avenue and trying to squeeze into the church. After the service the funeral procession moved on to Arbutus Memorial Park on Sulphur Spring Road, where Webb was laid to rest. It was raining by the time the last shovel of dirt was spread over the coffin and the last mourner departed.

> Was it red? No! No! No! No!
> Was it blue? No! No! No! No!
> Was it green? No! No! No!
> Just a little yellow basket.

Ella Fitzgerald had written the words and music to "A-tisket, A-tasket" (based on the old nursery rhyme) in 1937, and she'd sang it often with Chick Webb's band as a bit of innocent nonsense. But it turned out to be the funeral dirge for the little drummer who had gone all the way from the back

alleys of East Baltimore to world fame, then came home to die and be buried among his own.

By late afternoon of June 29, 1939, all who had come to Webb's funeral had gone their separate ways, leaving the house at 1313 Ashland Avenue, the Waters Church, and the Arbutus Memorial Park, like the drums of Chick Webb, silent.

■ "HI DEE HI DEE HI DEE HO" ALL THE WAY TO THE TOP
One night in 1930, after the last show at the Crazy Cat Club at Forty-eighth Street and Broadway in New York, where Cab Calloway was performing, the headwaiter came up to Calloway and said, "Cab, some guys downstairs want to see you." Calloway explained that it was late and he was really too busy to see them, which sent the headwaiter into a panic: "You had better see them," he said, and turned and rushed from the room. The gentlemen "asking to see" Calloway were from the mob, and in their own gentle way they told Cab that Duke Ellington, then playing at the Cotton Club, had to leave the club to do a movie. The syndicate had decided that from then on out Calloway's band was to play the Cotton Club regularly. That incident began the long association in which, as the history of American jazz makes clear, Calloway made the Cotton Club and the Cotton Club made Calloway.

A lot had to happen to Cab Calloway before he got to the Cotton Club and enjoyed the fame and fortune that followed, and much of it happened in Baltimore. Cabell "Cab" Calloway was born in Rochester, New York, in 1907, and moved to Baltimore as a boy of eleven to live with his grandmother at 1017 Druid Hill Avenue. "I have a lot of bad memories of those days," Cab recalled in his 1976 autobiography, *Of Minnie the Moocher and Me.* "As a boy I went wild in that town. I sold papers on the numbers five and thirty-three streetcars all the way to Pimlico, which is when and where I fell in love with horse racing. During the day I hooked school and hustled in the streets."

He loved music and found he had a good singing voice. "One night in the mid-1920s," he said, "I was hanging around with my gang at Druid Hill and North Avenues and this guy comes running up and asks, 'Any you guys play drums? I got a gig tonight and need a drummer bad!' I said, 'Yeah. I'm a drummer, I'll do it.' Next thing you know I was playing drums in a joint out on Washington Boulevard. And I had never played drums before in my life!"

Calloway waited tables at the Southern and the Belvedere Hotels and hung around the Pimlico Racetrack, all the while playing nights on the Baltimore nightclub circuit. "I remember we played a lot at the Arabian Tent Club on North Howard Street near Monument Street." Throughout his ca-

reer, in Chicago and New York, Calloway stayed connected to Baltimore. However mixed his memories of the town, he talked about home and came back often. He remembered Baltimore as a center for jazz and recalled playing impromptu sessions with Chick Webb, Eubie Blake, Ulysses Chambers, and Harold Steptoe. He remembered his high school years as a star basketball player at Douglass High and the glory days of the Regent and Royal Theaters on Pennsylvania Avenue.

Calloway told the *Sun* that he first introduced the world to his now classic version of "Minnie the Moocher" in 1930 at the Cotton Club. And in the lore of jazz, there is this other Calloway story (apocryphal, perhaps): One night, while Calloway was belting out a song on a nationally broadcast radio show, his mind went blank—he forgot the lyrics, totally. Desperate, he started singing nonsense syllables, inventing a style scholars later dubbed "scat." To help cover his problem that night, he even got his band involved in background vocals, coaxing them to answer ad-lib lyrics that he sang and shouted out as "HiDeeHiDeeHiDeeHo." And so, one historic night in Harlem, Cab Calloway, the story holds, made scat and "HiDeeHiDee-HiDeeHo" a part of American musical history.

7 | DAYS OF DELIGHT, NIGHTS OF MAGIC

■ THE CIRCUS COMES TO TOWN Crowds are jammed along the curb five and six deep. Children sit on fathers' shoulders, balloon vendors are doing a brisk trade, and the warm May air is electric with anticipation. Suddenly, cheering! People have heard, from up the way, the reedy wheezing of the steam calliope. It is the circus come to town, and this is the annual parade that moves the troupe from railroad yards to circus grounds at different sites in Baltimore, over the years.

Behind the calliope come the heavy, gilt-trimmed wagons, with trapeze artists riding high atop them. Next, the cages with lions and tigers, sullen and snarling. Then camels and elephants and prancing horses and, at the end, clowns cavorting—the last link in a long chain of uninterrupted free entertainment.

Before 1900, the circus paraded from the Pennsylvania Railroad Yards on East Monument Street to North and Greenmount Avenues. Later the parade moved through the city, from the East Monument Street yards to, among other sites, North and Gay Streets, Bentalou Street above Edmondson Avenue, and Belvedere and Park Heights Avenues. Sometimes the pa-

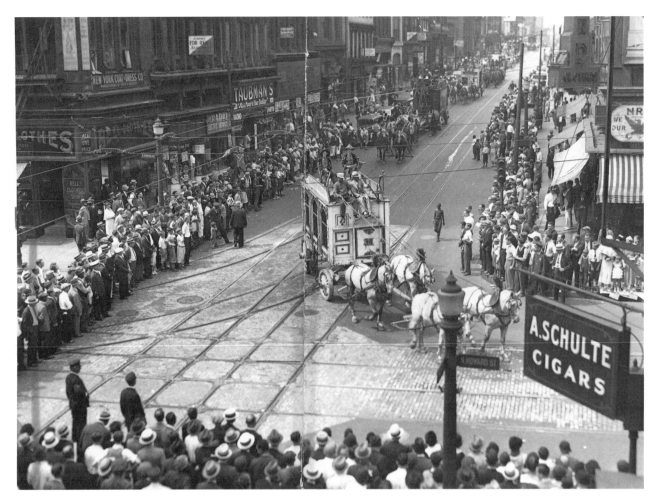

The circus parade turns north from West Baltimore onto Howard Street in mid-September of 1934. Not just children but grownups, too, stand on the curbs, transfixed by the spectacle.

rade passed through downtown; eyewitnesses recall its passing by the Emerson Hotel at Baltimore and Calvert Streets.

The parade was only the beginning. Youngsters by the thousands would follow it on to the circus grounds, melting into that scene of canvas, steel poles, ropes, pulleys, and working elephants. There they would watch the big tent itself rise, mushroomlike, out of the dust and chaos. By the time a kid was at long last seated in the stands to cheer a performance, he already had developed a kinship with it. The miles of parade-chasing, the pungent animal smells, the voices of the roustabouts as they banged tent-spikes into the ground—all of it became part of the memory of the circus parade passing through Baltimore.

■ THE ASCENDENCY OF RIVERS CHAMBERS Beginning in the 1930s and for a long time afterward, the Rivers Chambers orchestra was far

Circus-goers buy balloons from a friendly vendor.

and away the most popular band playing Baltimore's proms, parties, and receptions, from dances in the high school gym to the grand white-linen-and-crystal, sweet-sixteen formals in suburban country clubs. Party planners would first "clear the date with Mr. Chambers," then build their party around that night.

Rivers Chambers started out as a black kid from a poor family, born on Etting Street in West Baltimore. In the late 1920s and early 1930s he played in the pit band at the old Royal Theater on Pennsylvania Avenue. In those days a musician had to have, as he put it, "more courage than good sense" to eke a living out of the business.

In 1937, Chambers found himself playing with sidekicks Buster Brown and Leroy "Tee" Coggins at the Wilkins Tavern on Harford Road. "What happened," Brown recalled, "is that somebody out there that night in the crowd called out, 'Play "Cut Down the Old Pine Tree!"'" We knew that tune as a country-western, about a lover mourning for his dead sweetheart. The words were, 'Build a coffin of pine,' and 'She's not alone in her grave because my heart will always be there with her.'

"We were in no mood to sing about coffins and graves, that night or any night, that's not what we did. So when I started to sing, I just ad-libbed 'cottage of pine' for 'coffin of pine,' and for a refrain that sounded like, 'Oh, see her grave,' I substituted 'Oh, cut it down.'

"Well, the minute we started singing 'Oh, cut it down,' for some reason everybody started singing and clapping and joining in:

> Oh, cut it down, Oh cut it down,
> Yes, they cut down the old pine tree,
> To build a cottage so fine,
> For that sweetheart of mine,
> Yes they cut down the old pine tree.

"That song," said Brown, "carried us for the evening." The "new arrangement" became a signature number, raising the local visibility of the Rivers Chambers orchestra and giving a generation that had grown up in Baltimore a chorus to forever remember their high school proms, parties, and romances by.

■ SATURDAY NIGHTS Throughout the 1930s and 1940s Baltimore had huge dance ballrooms, where crowds from all over town would gather to listen and dance to the music of a big band. Forest Gardens, the outdoor dance pavilion at Carlin's Park, enjoyed great popularity in the 1930s. The

huge open-air ballroom featured local bands like Mike Green, the Townsmen, or Billie Isaacs. At Danceland, Carlin's indoor dance ballroom, Jimmy Lunceford, Gene Krupa, and Tommy Dorsey played swing music for girls wearing bobby socks and guys wearing "zoot-suit" pants that ballooned at the knee and tapered sharply at the cuff. Several places got to be known collectively as "the Roofs"—Keith's Roof, the rooftop of Keith's Theater at Lexington and Liberty Streets; the Roof Garden over the Stanley Theater at Howard and Centre Streets; and the Spanish Villa, high atop the Southern Hotel at Light and Redwood Streets. The Alcazar, at Cathedral and Madison Streets—a spacious and beautiful ballroom for big bands, big sounds, big crowds—boasted a mirrored ball that sent diamonds of light coruscating all over the dance floor, ceiling, and walls. It was especially popular for New Year's Eve, when couples could dance to Eddie Dowling, Lou Ginsberg, or Bob Iula. Under the glitter of more famous chandeliers, the Charles Room of the Belvedere Hotel offered dancing to the sophisticated music of Don Bestor. The Summit was a converted big barn of a house way, way out Pimlico Road. Dancing went on inside and out on the wide porches, with a full view of the summer night's star-studded sky. The great New Orleans dance-band leader and recording artist Louie Prima played there often.

The Dixie Ballroom at Gwynn Oak amusement park may have been the only Baltimore dance ballroom with a posted dress code: "No gentlemen admitted without a coat and tie." The dances were broadcast nationally every night to a dance band–crazy America, as were dances at the Glen Island Casino, the Savoy Ballroom, and the Hotel Pennsylvania ("Pennsylvania six-five-oh-oh-oh!" as a popular song of the era spelled it out). Brent Gunts, a dean of Baltimore broadcasting for fifty years, did the announcing. "We presented Hudson DeLange," he said, "Glenn Miller, Artie Shaw—the biggest."

■ SUNDAY AFTERNOONS Early photographs show the lake near the zoo in Druid Hill Park neatly edged by a stone wall and, between the lake and the road, an iron fence. In many of these images, the lake is dotted with rowboats. The men are seated in the bow, supposedly rowing though their oars seem at rest; the women sit in the stern primly, some holding parasols. The men are wearing coats, ties, and straw boaters; the women are wearing full skirts. These scenes of the old Druid Hill Park boat lake make for an impressionistic painting. All the elements in the composition are vaguely imprecise and suspended. Time is standing still. "In winter," said Bob Aro, a longtime Park Service veteran, "we hosed down the ice so that

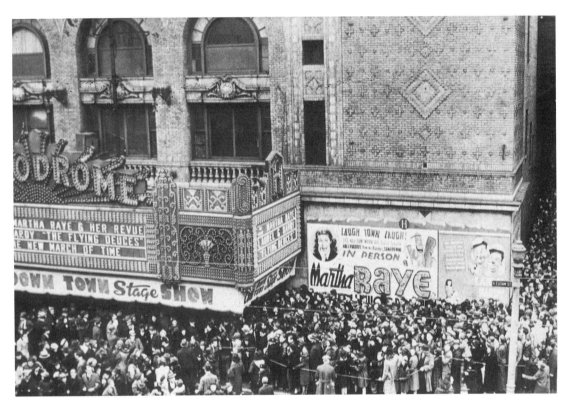

In 1939 crowds thronged in front of the Hippodrome Theater, which at the time was featuring Martha Raye and her revue as well as the Laurel and Hardy film The Flying Deuces.

Right: *Margaret Sullavan and Henry Fonda, who often played in Baltimore, were married in Baltimore and often dined at Schellhase's on Howard Street. In 1932, the couple worked together at the Maryland Theater, playing husband and wife in the play* Mary Rose.

Below: *What to do? Check the entertainment page from the evening paper in the 1940s.*

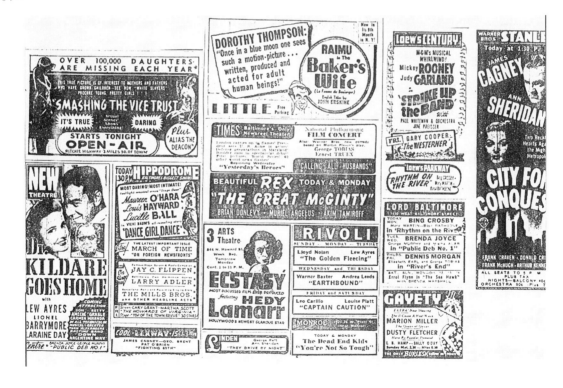

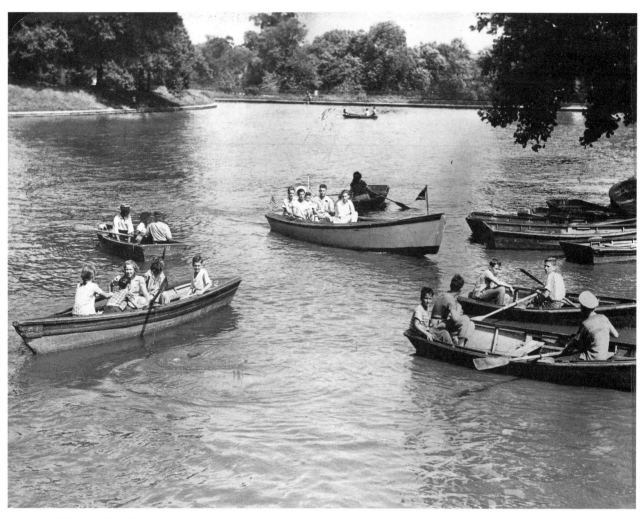

Boaters glide over the lake at Druid
Hill Park, in the summer of 1942.
"All but the oarsmen cooled off,"
the paper said.

On the morning of November 20, 1938, Les Sponsler, a well-known fight promoter, swung a pick into the frosted ground on a North Monroe Street lot just south of Alexander Brown's Mondawmin estate, launching construction of the Coliseum. Sponsler predicted that it would bring Baltimore "boxing, wrestling, basketball, tennis, and musical events all under one roof." As the marquee demonstrates, it did, for a time.

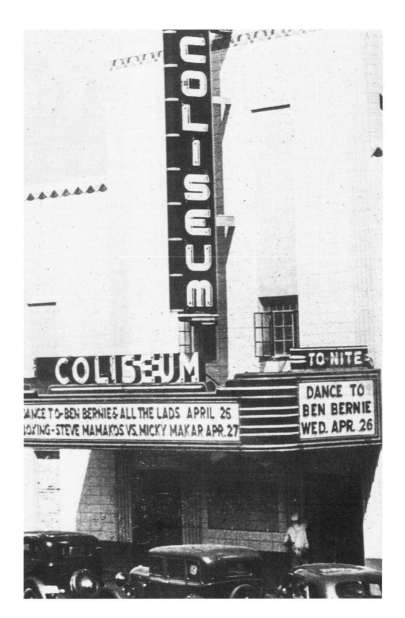

it would freeze evenly for skaters. At night you saw the fires they'd built on the island to warm up and to roast marshmallows. Some nights you could hear singing."

◼ SINGING ALONG UNDER THE STARS It is a hot and languid summer evening in the late 1930s on the grassy acreage sloping down from the Mansion House to the boat lake in Druid Hill Park. These years of Depression and war in Europe are not the best of times, but you would never know it from the mood of the three thousand or so people lounging about on chairs and lying on blankets, dreamily listening to this concert in the park. The band is playing "In the Good Old Summertime," and Ken Clark is leading the audience in a sing-a-long. The singing is warm, cheerful, wistful: "Strolling with the one you love, with your baby mine . . ."

The daylight starts to fade and the stars come out, diamonds in black velvet, making the night sky overhead wondrous to behold. The light on the bandstand flickers on now, the sing-a-long comes to an end. Clark announces to the crowd that "there are six children up here who have lost their parents." In moments, after some confusion, the strays are claimed. Now Constance Heyja, a mezzo-soprano, sings an aria from *Carmen*. It is well received, the applause is generous; then the stage is once again Clark's, and he presents two more lost children. A freshening breeze, gaining strength as the heat of the day loses its grip to the night, stirs the leaves in the ancient trees and brings them alive into whisperings. The band music continues, this time punctuated weirdly and at odd places by the off-key trumpeting of Mary Ann, the elephant, from her cage at the nearby zoo. Clark announces another sing-a-long, and the crowd goes at it:

> We were sailing along, on Moonlight Bay,
> You could hear the voices calling,
> They seemed to say,
> You have stolen my heart . . .

By now, though, the end had come: first, of the song; then, of the evening; then, like a film winding down, of the era.

◼ A WHOLE NEW LISTENING FORMAT On the afternoon of March 1, 1941, Howard Street (between Lexington and Saratoga) looked like a parade crowd had gathered at the curb, children holding balloons and gripping confetti, adults with pennants at the ready. Down the street came the drum and bugle corps, led by strutting drum majorettes. High overhead, strung curb-to-curb, huge banners proclaimed the reason for the fes-

tivities: "Welcome to Baltimore, Radio Station WITH!" Up at the Maryland Theater on Franklin Street, the biggest stars of New York's Tin Pan Alley were on stage, in town to help mark the historic occasion. The legion of celebrities was led by no less than Irving Caesar and Johnny Green.

WITH burst onto the Baltimore radio scene as the brainchild of Tom Tinsley. In its early years the station was responsible for a string of firsts in Baltimore radio. It introduced new ideas in programming and featured personalities who would make the station a peculiarly Baltimore institution. In early 1941 the CBS Network had WCAO as its Baltimore affiliate; Mutual had WCBM; the NBC Red Network had WFBR; and the Blue Network had WBAL. All of them aired mostly network serials (in the afternoon, *Jack Armstrong;* in the evening, *Myrt and Marge*). WITH came on with no network affiliation; it was the first independent station in Baltimore, so it did what none of the other stations dared do: not only did it play records all day long, but it also aired a newscast every hour on the hour, twenty-four hours a day (two firsts). "All of the other radio stations in town," recalled Robert "Jake" Embry, station manager of WITH, "thought we'd die with that format." The WITH format soon led to further experiments and eventually evolved into the previously unheard-of news, weather, sports, and music format.

8 | SMALL-TOWN SPORTS

■ "STILL FIGHTING, ARE THEY?" At about 10:30 on the night of December 3, 1933, dozens of city policemen, night sticks in hand, charged up the long row of steps leading to the entrance of John J. Carlin's "Iceland," in Carlin's Park, the home rink of the Baltimore Orioles ice hockey team. Rushing inside, they found their work cut out for them. A full-scale riot was in progress: fists flew between players and players, fans and players, fans and fans. It was an hour before police could get the combatants separated, the teams downstairs into their locker rooms, and the fans dispersed.

The Tri-State League game between the Orioles and the Atlantic City Seagulls had gone routinely for three tied periods, into overtime, when Smith of the Orioles and Foster of the Gulls started swinging at each other. And by the time the game finished (the Orioles won, 3 to 2), tempers on both sides had worn thin. Going down the steps to the locker rooms, Tupling, an Atlantic City guard, pushed Reilly of the Orioles, or so Reilly said.

That brought in Braconnier of the Orioles, who took a punch at Tupling, which in turn brought in both teams, then coaches, then fans—everybody, more or less.

Still, by 11:30 the fans had dispersed, the Seagulls were on their bus to Atlantic City, the Orioles had gone home, and one more Carlin's ice hockey game was on the record. Years later Herb Keough, a wing on that Oriole team, reminisced. "We were little guys; I was five feet, four inches, I weighed a hundred and thirty-five pounds. Good thing we never had to play big guys. We'd be killed."

In addition to the park, Carlin owned the Baltimore ice hockey team until 1940, when he sold it to local sportsmen. Early in World War II, the Orioles became the Coast Guard Cutters, and shortly afterwards the league shut down for the duration. "I caught a few Baltimore hockey games after I'd retired," Keough said. "Still fighting, are they? Things haven't changed much."

■ THE KID FROM PIMLICO VERSUS THE PRIDE

OF LITTLE ITALY In the 1930s and into the 1940s, many Baltimoreans chose to spend evenings watching "the fights" at, among other places, Carlin's Park, the Coliseum, and the 104th Medical Regiment Armory. That whole era of professional boxing in Baltimore was captured in black and white pictures on the walls down at Joe Poodle's Pool Hall and Boxing Museum on South Milton Avenue. There they are, fighters standing midring in their boxer shorts, arms extended, fists clenched in the classic pugilist position: Bucky Taylor, Jack Portney, Joe Finazzo, Vince Dundee, Kid Cocoa, Harry Jeffra, Lou Transparenti, Clarence "Red" Burman.

It's Friday night, February 16, 1934. Fight Night at the 104th Medical Regiment Armory at Fayette and Paca, next to the Biltmore Hotel: The main event on the card matches a couple of heavyweights, George Culotta and Lou Raymond, but that's not the match this partisan crowd has come to see. They're here to cheer for their own neighborhoods and the featherweights who represent them: the "Kid from Pimlico," Harry Jeffra, and the "Pride of Little Italy," Pete Galiano.

"Pete had his whole gang there," Jeffra recalled. "I had mine. We were both undefeated and we were out to kill each other." Tension had been building in the neighborhoods for weeks. The two even staged a fight the day before the event on the street in front of the *Sun* building at Charles and Baltimore Streets. "We were locked up," Galiano recalled, "and paid the fine. But it made the papers and built up the fight." The six-rounder was

close all the way. Jeffra recalled that "late in the fourth round my left jab started working. I knew Pete was hurting."

"No way," Galiano said. "I outpunched him from the opening bell."

But when the sixth round ended referee Charlie Baum shouted over the din, "The winner from Pimmm-lee-co—Harry Jeffra!" "The Pimlico fans went wild," Jeffra said.

Galiano remembered it differently: "My guys from Little Italy booed. They thought I beat him. Nobody really won that fight."

Galiano went on to box until 1944, taking on four world champions, including Henry Armstrong. Jeffra lasted a few years longer, along the way capturing two world championships. For the rest of their lives Jeffra was known as the "Kid from Pimlico" and Galiano as the "Pride of Little Italy."

On the night of March 2, 1937, Portney versus Cocoa is the Main Event, but the big show comes later. After twelve tedious rounds the Portney-Cocoa bout is scored more or less even. In the middle of the twelfth, Portney takes a bad cut over his left eye and referee Charley Short orders the match stopped. Cocoa is handed the decision and the five thousand fans who make up the crowd that night are vaguely disappointed. The next fight is between Angelo Meola and Kid Lloyd, and starting from the opening bell the fight is "torrid," as *Sun* sports writer Jesse Linthicum wrote. Lloyd is no sooner out of his corner when, in seconds, Meola decks him with an overhead right. Lloyd takes a count of five and then is up scrapping, then down goes Meola. The fighters exchange knockdowns that round and into the second, when Meola finally knocks Lloyd unconscious.

Amateur wrestling was a popular draw in Baltimore, December 1934. Harold Bloom of the Jewish Educational Alliance here bridges out of a double-bar scissors as applied by Charles Haley, who represented a German athletic club, the Germania Turnverein, during a match in the 145-pound class at the Alliance gym. "Bloom ultimately won over Haley," the paper reported, "but only after the latter had extended his opponent to the limit." The Germania boys won the meet overall, 19 to 11.

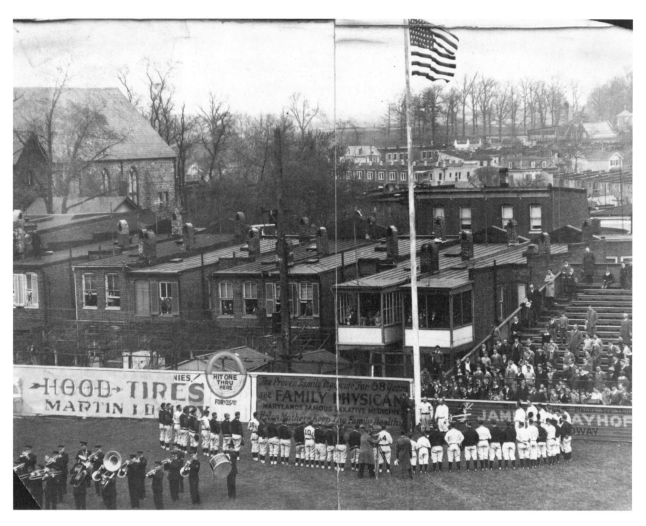

Crowds and players gather for Opening Day at Oriole Park, Twenty-ninth Street and Greenmount Avenue, in 1930. Hood Tires offered players a $25 prize if they hit a home run through the top half of a painted tire. Next to the flag a sign on the outfield fence touted a product named "The Family Physican [sic], Maryland's Famous Laxative Medicine," which claimed to help mothers "keep the family healthy."

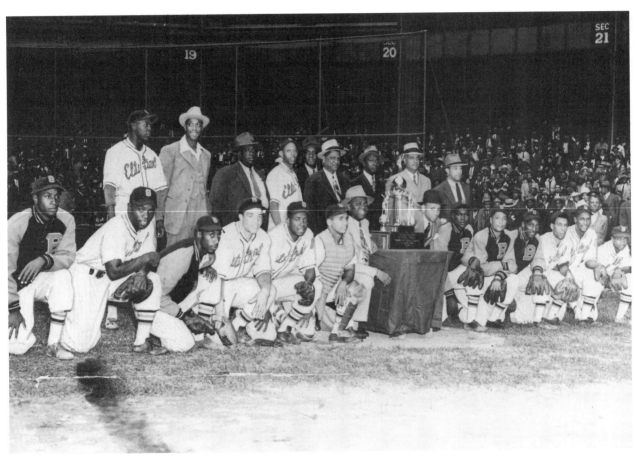

The 1937 Baltimore Elite Giants, champions of the Negro National League, pose for photographers after the presentation of the Jacob Ruppert Trophy. The Elite Giants went on that day to defeat the Pittsburgh Homestead Grays, 2 to 0. The manager, Felton Snow, is visible standing directly behind the trophy, to the left of team owner and league president Tom Wilson. Left of Snow stands the Elites' secretary, Vernon Green and, left of him, James Semler, owner of the Black Yankees. Courtesy of the Afro-American Archives.

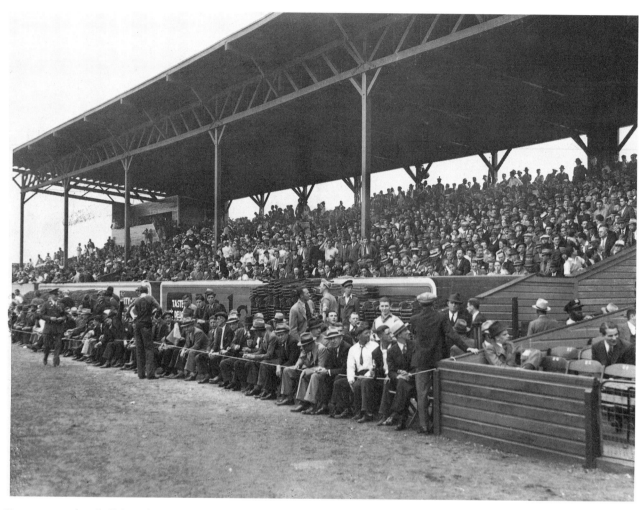

"Some 11,000 baseball fans crowded their way into Oriole Park to watch the Baltimore Birds battle the Rochester Red Wings to open the International League baseball season," the paper reported in the spring of 1938. "So dense was the crowd that seats were placed on the edge of the field and the spectators 'roped in' for the afternoon." Most of the spectators (not a woman to be found among them) wore jackets, ties, and hats. The game got under way after a colorful parade and the usual Opening Day ceremonies, featuring remarks from state and city officials.

A few years later, sitting in Joe Poodle's Pool Hall and Boxing Museum, Angelo Meola talked about that fight as if it had happened yesterday. He sounded as if all of the fighters pictured on the walls were all alive and well and would walk into the pool hall to join the conversation, contributing their own memories. As a matter of fact, some of the ex-pugilists did, including Buddy Ey, the official historian among ex-fighters. They could go on forever, apparently, exchanging reminiscences about those smoky nights, when "the fights" in Baltimore were big business and big news and Angelo Meola—like Baltimore itself—was young enough to think that the fight era would never end. For Meola and the old pugilists who gathered at Joe Poodle's to stare at the pictures on the wall and call back yesterday, it never did.

■ "MORE HONEST THAN FISHING" Wrestling in those days had a stranglehold on Baltimore; there was no escape. Every day the sports pages were full of stories of the big matches from Carlin's, the Coliseum on Monroe Street, and the 104th Medical Regiment Armory, trumpeting the deeds of such grunt-and-groan stalwarts as Strangler Lewis, Stanislav Zbyszko, Gus Sonnenberg, Rudy Dusek, Dr. Sarpoulis, and Rajah Raboid.

The match of all matches, born out of box-office hype, was held on the night of November 20, 1934, at Carlin's Park, between Jimmy (fans called him "Jeemy") Londos and Dick Shikat. Promoter Ed Contos had been ballyhooing the match-up for two years, and by 7:00 P.M. on fight night there was not an empty seat in the house (not even with four thousand extra folding chairs). Guests included many of Baltimore's socially prominent citizens, among them Judge O'Dunne and Governor Ritchie, at ringside seats. Londos was the favorite; he had beaten everybody in the business, including Shikat two years earlier. After the preliminaries, referee Ted Tonneman announced the main event and then reminded the audience that "should neither rival boast a fall by the 11:30 P.M. curfew, the match will automatically end in a draw."

With that, the protagonists went after each other with everything they had—hammerlocks, toe-holds, headlocks, airplane spins. After exactly one hour, fifteen minutes, and thirty seconds Tonneman stepped into the middle of the ring and announced the end of the match—in a draw! A lady in the front row shouted out, among the deafening boos, "You dirty (so-and-so)!" and a neighbor living in the Carlin's area later reported she heard those boos two blocks away.

Professional wrestling in 1930s Baltimore came down to a test of will between Stanley Scherr, then chairman of the Maryland State Athletic Commission (charged with overseeing professional athletics in the state)

and fight promoter Ed Contos. Their verbal matches brought color to the Baltimore wrestling scene, providing a kind of side plot for fans of wrestling to follow. Scherr suspected (meaning he knew) that the grunting and groaning was faked and the decisions fixed. But Contos (of course) maintained that his wrestlers and referees entered the fray "in innocence, anxious only to do credit to the honorable sport." The newspapers gave lots of attention to the "sport," and there was much talk around town about cleaning up the business.

Not surprisingly, nothing changed. On a later night, the Coliseum was once again filled to capacity, as a howling, hissing, booing crowd lusted for blood. The object of their scorn was the wrestler coming down the aisle to the music of "Pomp and Circumstance." He had flowing gold hair, done in ringlets, and wore a gold robe with a white silk lining, embroidered with glistening sequins. A "slave girl" circled about him with an atomizer, spraying for bugs. The wrestler acknowledged the attention by removing hairpins and tossing them to the audience. This was "Gorgeous George," the Coliseum's most controversial (and maybe its most honestly phony) wrestler; his opponent that night was an underdog the sportswriters had called "a poor but honest boy in a shabby robe." His name was "Wild Red" Berry.

Moments after referee Harry Smyke introduced the protagonists, "Wild Red" began pulling at George's locks. The fight became a swirl of sweating bodies in all of the legitimate holds known to wrestling—and many that weren't. All the while, George's slave girl was moving about outside the ropes, perfuming her master.

The referee, trying to keep order, found himself on the floor, his own life threatened. Then the slave girl stepped into the ring and began to spray all three of them. By some mystical signal, "Pomp and Circumstance" started up. And then, based on absolutely nothing, the referee declared "Wild Red" Berry the winner, and Gorgeous George strutted about in disbelief. Some in the crowd booed, some cheered. Nobody knew quite who won, or why.

Just another night of wrestling in Baltimore? Yes, but Scherr had seen it all and he'd had enough of Contos's brand of wrestling. "Hereafter," he wrote in a heated report to the athletic commission, "wrestling should not be called a sport. It should be called an exhibition. I was watching a match only recently. I saw blood. I sent in a doctor to check on it. He came back and said it was only that red antiseptic medicine, Mercurochrome."

Contos demurred. "Wrestling in Baltimore," he said, "is more honest than fishing."

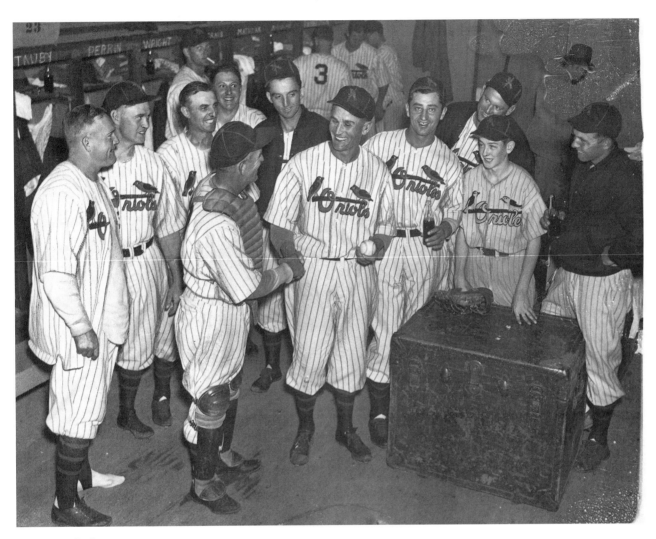

*In the Oriole dressing room on open-
ing day in 1938, player-manager
Bucky Crouse congratulates the win-
ning pitcher, Harry Matuzak, on his
six-hit victory.*

■ ORIOLE PARK: COMFORTABLE SEATS, AMPLE

STANDING ROOM Old Oriole Park at Twenty-ninth Street and Greenmount Avenue seated about twelve thousand and had room for two thousand standees. It had one covered deck that spanned the distance between first base and third base. Simple, backless bleacher seats took up a small area way out in right field. In the fading evening hours of July 3, 1944, only about six thousand fans saw the International League Orioles blow the game against Syracuse in the tenth inning, allowing seven runs to drop behind, 11 to 4. With hope that springs eternal, they watched the Orioles come up in the bottom of the tenth, only to see Howie Moss strike out and Bob Latshaw and Ab Tiedeman fly out. Melancholy in defeat, the crowd filed out of the park (many to board the streetcars for home), not knowing that within hours there would be a lot more for Baltimore baseball fans to mourn.

At about 4:40 the following morning, July 4, a monstrous fire broke out in Oriole Park, destroying it. The fire burned so quickly and savagely that six alarms were blaring within fifteen minutes, bringing to the scene not only all those fire engines but also Mayor Theodore R. McKeldin, who (according to eyewitness accounts) was busy handing out autographed pictures of himself.

Tommy Thomas, the Orioles manager, announced that the season would resume at Baltimore's Municipal Stadium on Thirty-third Street, but not until the team could find new equipment—everything had been lost in the fire. The team canceled the sellout game scheduled for July 4. Fans and players alike were dismayed at the news, save one—Oriole second baseman Blas Monaco. "I remember that early morning following the loss to Syracuse and getting the news of the fire," he recalled. "I was sound asleep and the phone rang at four in the morning. It was Herb Armstrong, our general manager. He said, 'I have bad news for you, Blas, Oriole Park is burning down. I don't know when or if we'll play again. It's terrible.' 'No,' I said, 'it's great. I'm having a lousy year!'"

■ LISTENING TO THE INTERNATIONAL LEAGUE ORIOLES In the 1930s, WCBM broadcast the old minor-league Orioles, sponsored by Wheaties. Lee Davis, who did the play-by-play, brought an infectious enthusiasm to his broadcasts, including the away games, when he wasn't even there to see the action he was describing! He'd sit in Baltimore's WCBM studio watching code come in on the teletype from, say, a game in Newark: "2cf" meant "double, center field." That was all Davis needed; he'd go wild at the microphone, imagining an entire colorful scene from the bits of code.

Line drives were always "screeching," fielders' catches were "diving," runners were always "sliding in safely just in the nick of time—oh, was that close!"

Eventually joining WITH to do play-by-play for the International League Orioles, Bill Dyer had a trick that would become part of the legend of the town. Broadcasting away games remained a matter of reading the teletype as word of what was happening in some faraway ballpark came clicking in. With tape in hand, Dyer would embellish the story, describing the action as if he were actually a witness to it. When the Orioles needed a hit, Dyer would say, "Well, folks, time for me to walk around my little red chair." This ceremony, he insisted, would bring the team good luck. Some said that Dyer had the tape indicating the hit in his hand well before he offered to walk around the chair. Others were believers.

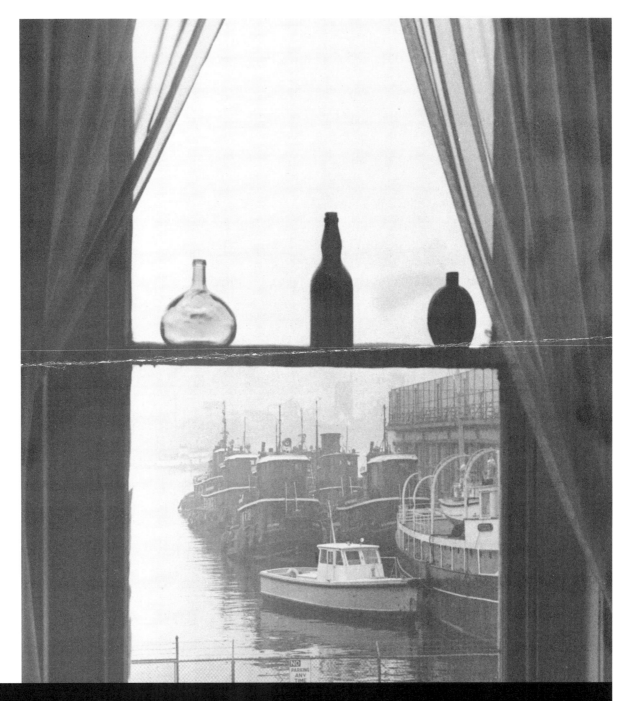

Part II SOUVENIRS

9 | Getting Away

■ ALL THAT'S LEFT IS THE SILVER SERVICE In the fall of 1930, during the early days of the Great Depression, the Baltimore Mail Steamship Line announced it would launch luxury passenger steamship service from Baltimore to Le Havre, France, and Bremen, Germany. Given the tenor of the times and the small-town culture of 1930s Baltimore, that was big news.

The enterprise began at 6:00 P.M. on July 2, 1931, on Pier 11 in Canton. A German band played ("lustily," recalled Frank Roberts, president of the Association of Commerce) while several hundred people cheered. Mayor Howard W. Jackson presented the steamship's captain with a silver service: tray, hot water urn, coffeepot, teapot, cream pitcher, and sugar bowl. Later that evening, the *City of Baltimore* backed into the river and turned down toward the Bay, beginning the first direct Baltimore-to-Europe steamship passenger service since before World War I. A crossing took eighteen days, a round-trip cost $180.

Samuel S. Strouse, an executive with the May Oil Burner Company, was aboard for that maiden voyage. "Once we got under way," he recalled, "there was a house party atmosphere. Everybody—there were only eighty of us—knew everybody else. All at once, there were dances, parties, and get-togethers in the bar, a magic word in those days of Prohibition. All the way down the Bay we were saluted by fireboats, which sent huge geysers of water into the air. On the second night out there was a very festive Fourth of July party. It was a costume ball, with ladies draping themselves in American and Maryland flags. Guests gathered for conversation and card playing

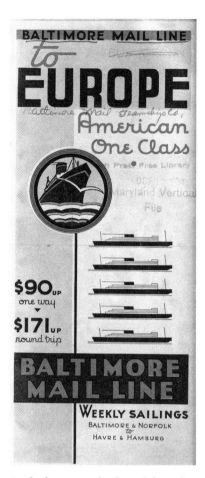

In the late 1930s leaflets of the Baltimore Mail Steamship Line invited passengers to travel to Le Havre and Hamburg for as little as $90 one way or $171 round-trip. Courtesy of the Maryland Room, Enoch Pratt Free Library.

in the lounges. We sang around a grand piano and strolled the decks under a star-studded sky."

Cruise memoirs suggest that dining was the high point of every day and evening. Small wonder: The dining "saloon," according to the line's literature, was "light and airy, featuring snowy linen, gleaming glass and silverware, deft unhurried service." And as for the food itself, on the menu for breakfast were such delicacies as poached salt cod with egg sauce and lamb kidney on toast; for lunch, Welsh rarebit and liver sausage; and for dinner, poached striped bass a la Creole, Maryland fried chicken, baked Virginia ham. "And always after dessert and coffee," Strouse said, "we were invited to the buffet to enjoy a second cup of coffee or tea. We helped ourselves from the ship's beautiful silver service. I remember that the pieces had dolphin handles, sea-dragon spouts, and gulls and sea shells all around, and all in gleaming heavy silver. The city's seal and flag and the line's house flag graced each piece. The serving set was the always a topic of conversation and admiration among us."

There were five ships in the fleet—*City of Baltimore, City of Hamburg, City of Havre, City of Norfolk,* and *City of Newport News.* All of the staterooms were amidships, outboard, and on upper decks. Each stateroom boasted colorful wall hangings, built-in wardrobes, dressing tables, and lamps. Most of them had private baths.

After 1941 the *City of Baltimore* became the U.S.S. *Heywood,* seeing service as an armed assault transport at Guadacanal, Tulagi, and the Marianas. She came through unscathed and was awarded a Unit Citation. Of the *City of Baltimore*'s glory days as a cruise ship, one relic remains, salvaged as a last souvenir of the long-ago time—the silver service presented to her captain that first day in Canton. It rests comfortably at the Maryland Historical Society.

■ ROUND-TRIP TO BOSTON ABOARD THE S.S. *DORCHESTER*
You dined (having been summoned by the mess boy's bugle) on Maryland crab, in a bright, spacious room with high, wide windows, in an atmosphere of unhurried ambiance. Waiters hovered about; the orchestra played "Ramona." After dessert and coffee and brandy, you adjourned to the smoking room, some of the guests drifting to the music room, on the next deck below, others to the library—richly paneled in cherry and black walnut. For all of the amenities and trappings of luxury, you could be forgiven for thinking you were in some grand hotel of turn-of-the-century splendor. But you are in fact aboard the S.S. *Dorchester* bound for Boston, one of as many as fifteen destinations offered by the Merchants and Miners cruise line oper-

ating out of Baltimore's inner harbor. It's Tuesday, June 15, 1937, at about 10:30 in the evening. Five hours ago you were on the promenade deck, waving goodbye as the *Dorchester* slipped out of her berth at Pier 3, on Pratt and Gay Streets.

On the morning of the fourth day, after a quick stop in New York City, you are in Boston, staying at the Copley Plaza. The fifth day you cruise through the Cape Cod Canal, and by the morning of the eighth day you are home, again tied up at Pier 3, having breakfast (you have gotten to like the sound of the mess boy's bugle!) while your luggage is being carried onto Pratt Street. Other Merchants and Miners cruises out of Baltimore ran to Savannah and Jacksonville to the south and Philadelphia, Boston, and Providence to the north.

People who took those cruises remembered them fondly. In a letter, one recalled that the captain offered passengers "grass sod in a box to stand on" as a cure for seasickness. Another told the *Sun,* "After the first big dinner on sailing day, no one was seasick any more." Thinking back to those famous meals aboard the Merchants and Miners, someone else agreed, "The chefs on the Merchants and Miners cruise ships must have been very special people, indeed!"

The S.S. *Dorchester* became part of Baltimore legend in World War II, when she was sunk off the coast of Greenland. As she was going down, four chaplains—two Protestant, one Catholic, one Jewish—gave up their life jackets to sailors who did not have any. The chaplains went down with the ship.

■ DELUXE SERVICE, ALMOST TO NEW YORK The most famous train ever to travel between Washington and New York began service on June 21, 1935. On that day, Mary McIntyre, daughter of President Franklin D. Roosevelt's secretary, with an escort of fifty lady employees of the B&O serving as her "court of honor," participated in the christening of the Royal Blue Line at Union Station in Washington. Miss McIntyre broke across the front of the locomotive a bottle containing water from all seven rivers the B&O crossed on its path from Washington to New York. Someone released a thousand homing pigeons from the various cities along the route. The B&O Women's Music Club sang railroad songs.

The B&O train to New York did not actually go into New York; it took passengers to Jersey City, where they'd get off the train and board one of five buses, each headed for any one of as many as fourteen stops in New York City and in Brooklyn. "A highlight of the trip," one rider, George Nixon, remembered, "was that bus ride, right onto a ferry that took you

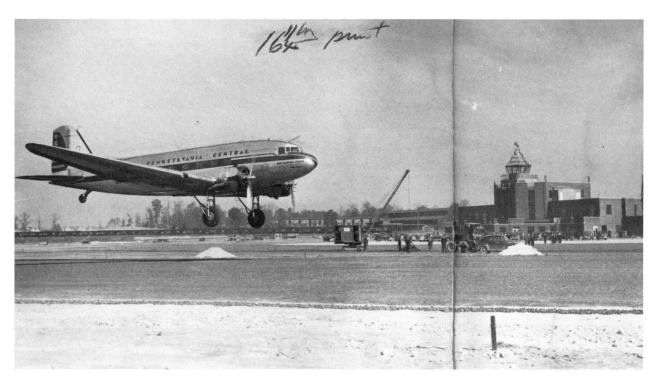

After the opening of Baltimore Municipal Airport in mid-November 1941, air travelers could fly on DC 3s of Pennsylvania Central Airlines —"Serving the Capitals of Industry" and connecting Baltimore to Washington, Norfolk, Harrisburg, Pittsburgh, Akron, Detroit, Chicago, and even such distant places as Buffalo and Traverse City on upper Lake Michigan—or on Pan American's famous flying boats to Europe—"48 hour service, via Bermuda and the Caribbean."

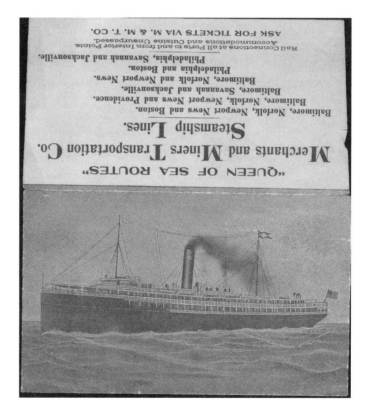

The Merchants and Miners Transportation Company advertises its steamship cruises on a folded calling card. Courtesy of the Maryland Room, Enoch Pratt Free Library.

Ogden Nash's family load up for one of their many trips (left). A portrait of Mrs. Nash and daughters Linelle and Isabel (below) appeared as the first in a series in the News-Post in April 1941, part of a piece on "Maryland mothers and children." Mrs. Nash, her author husband, and their daughters were "so constantly on the move between Maryland and California, with occasional side trips to New York, where Mr. Nash's family live, or to the Eastern Shore, where her parents, Mr. and Mrs. William W. Leonard, now spend so much time," the paper declared, "that it is hard to know where to find them at any given time. But they are planning to be in Baltimore during most of the spring."

The wry poet Ogden Nash, though born a New Yorker and enjoying national renown during the 1930s and beyond, long identified himself with Baltimore—and for good reason. In 1931, while living and working in New York, he met and married Baltimorean Frances Rider Leonard. Three years later the couple moved to Baltimore, taking up residence in Guilford. Nash became one of America's most popular writers of droll verse, unlikely rhymes, and memorable aphorisms like "Candy is dandy, but liquor is quicker." One critic noted Nash's attention to the "eccentricities of domestic life as they affected an apparently gentle and somewhat bemused man." His poems appeared regularly in newspapers and magazines, including the New Yorker, and in more than twenty books, including You Can't Get There From Here and I'm A Stranger Here Myself.

across the Hudson River. You'd leave the bus and go to the front of the ferry and there you'd see it coming into sharper view as the ferry moved along—the towers of Manhattan! Rising right out of the Hudson! Magnificent!"

Among the souvenirs Nixon kept stored in the attic of his mind was an afternoon ride on the Royal Blue one April. "What a ride!" Nixon rhapsodized. "You'd board a beautiful, absolutely spotless coach and get settled, then head for the diner. The Royal Blue dining car was fitted out in charming art deco. The maître d' would seat you at a table covered with a thick, snowy-white tablecloth, set with heavy silver, beautiful blue and white china. And what food! For breakfast, bacon and eggs and biscuits and steaming hot coffee. For dinner, steak and gourmet fish dishes. The service was flawless!"

The Royal Blue was known for its amenities, among them the Buffet Lounge, with tables and a buffet at one end and large, comfortable easy chairs, settees, card tables, and writing desks at the other. "The Club Lounge," literature read, "has the charm of a living room. The dining car offers table service for thirty two, the observation-parlor car the informal charm of a club—overstuffed sofas and movable chairs, carpeted floors, table and floor lamps, a clublike atmosphere, and wider windows that allow a more enchanting view of the scenery."

The Royal Blue to New York claimed to be luxurious, but it never claimed to be fast: Passengers would leave Mt. Royal at 4:58 P.M., arrive in Jersey City at 8:14, and step out in New York City (Forty-second Street) at 8:45. Baltimore to New York in three hours and forty-seven minutes.

■ BC&A: TO OCEAN CITY, BY FERRY AND TRAIN,
IN ONLY SEVEN HOURS With the completion of the Chesapeake Bay Bridge, the trip from Baltimore City to Ocean City eventually dropped to about three hours by car, less if you pressed it. But in the 1920s and 1930s, getting to the Eastern Shore was surely more interesting and memorable, even if the trip might take as long as seven hours. What hours they were: a mix of the rich scenery and the civilized camaraderie of fellow travelers. More than a trip, it was romance and adventure.

You started out on the Love Point ferry out of Pier 8, Light Street, steaming either to Love Point, on the northern tip of Kent Island, or to Claiborne, south and east of Kent Island. Though they were all called "Smokey Joe," there were actually at least three Love Point ferries—the *Philadelphia,* the *New Brunswick,* and the *Pittsburgh.* The Schunick family operated the cafeteria concessions on the ferries. Mr. Schunick recalled the trip in winter: "Those ferries would cut through ice fifteen to thirty inches deep.

The Lord Baltimore, a shiny new lightweight steam locomotive and a signature of the B&O's refurbished Royal Blue Line, passes through Mt. Royal Station and takes on passengers in June 1935. For about half a century—thanks to deals with the Reading, Jersey Central, and other lines—the B&O cobbled together tracks and challenged its main rival for access to New York City, the Pennsylvania Railroad. Hit hard by the Depression, the B&O was further pressed as the Pennsylvania began converting to electricity, supposedly faster and much cleaner than steam, on its New York–Washington route. The B&O answered by dressing up its steam service and gambling that many riders would find the B&O tradition for elegance and service more appealing than speed alone. Posters and brochures celebrated the good food, comforts, and Maryland ambiance of the old Royal Blue.

Nothing, however, changed the fact that the B&O train to New York did not actually go into New York—it went to Jersey City. Connecting bus routes included stops at the major hotels on their way to the B&O "station" at Pershing Square, right across the street from Grand Central Terminal at Forty-second and Park Avenue (one Liberty Street bus crossed the Manhattan Bridge to Brooklyn and the St. George Hotel). The B&O boasted that the Royal Blue train from Washington to Pershing Square crossed five states in five hours.

The spacious and elegant interior
of Mount Royal Station was well
known in the 1930s.

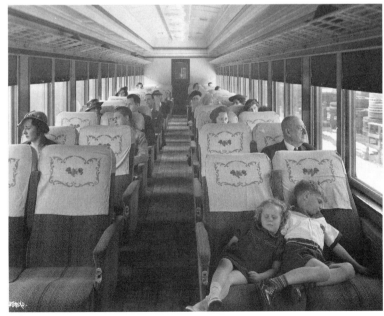

The Royal Blue departs, heading
into one of several tunnels that
lead north and then east through
Charles Village and on to Jersey
City. Observation-car amenities
included a bar, easy chairs, settees,
and tables for playing cards. Com-
fort was the hallmark of travel on
the Royal Blue.

In winter some trips took as long as ten hours. We sold a lot of food on *those* trips."

Robert Wilson, chief engineer of the *Pittsburgh,* remembered the trip in summer: "Families would have picnics and crab feasts out in the sunshine of the open decks. The two-hour-and-twenty-minute trip went quickly. Before you knew it you were at Love Point." There, you connected with the Ocean City Flyer of the Baltimore, Chesapeake, and Atlantic Railroad (BC&A), which took you to the Ocean City train station and your hotel. With smoke-belching steam locomotives pulling open-windowed cars— passengers seeking relief from the stifling heat had no choice but to keep the windows open—the BC&A line earned its affectionate nickname of "Bugs, Cinders, and Ashes," or, a variant, "Black Cinders and Ashes."

In any event, the Flyer didn't exactly fly. It meandered through lush Eastern Shore farmlands, making the trip to Ocean City in roughly five hours. A 1908 map published in a Wicomico County newspaper shows stops in a slew of villages—McDaniel, Harper, Riverside, Royal Oak, Kirkham, Bloomfield, Turner, Bethlehem, Preston, Ellwood, Rhodesdale, Barren Creek, Parsonsburg, Pittsville, New Hope, Whaleyville, and St. Martin's. Small wonder the trip from Love Point to Ocean City took so long. Millard C. Fairbank, who lived in St. Michaels, recalled that the high point of a Sunday afternoon in his youth was the train's ninety-second stop in town. "A crowd assembled at the station every Sunday evening, just to watch the Flyer go through."

The era of the Black Cinders and Ashes journey to Ocean City stopped in the early 1930s. "The refrigerated trucking industry was partly to blame," wrote Kenneth Patrick Folks, a longtime patron of the line. "They could haul fruits and vegetables faster than the train could. But a couple of wrecks figured in the demise, too. There was one at Dover Bridge and another at Gravely's Branch." If that wasn't enough, a massive storm in August of 1933 damaged much of the roadbed. The BC&A came to an end, though the ferry system continued for another generation.

■ SAD NEWS FROM BROWN'S GROVE Shortly after the midnight hour of July 5, 1938, fire broke out in the roller coaster of Brown's Grove, an amusement park and bathing beach on Rock Creek, south of Baltimore and slightly west of Fort Smallwood. The blaze, reported as "spectacular," was raging out of control by the time the Riviera Beach Fire Department answered. A second alarm brought the Orchard Beach Fire Department, but it was too late. Only a pile of smoldering rubble remained of the roller

coaster, merry-go-round, refreshment stands, midway, picnic groves, and bathhouse of Brown's Grove.

News of the fire created little stir in Baltimore's white neighborhoods, but in the black community there was much sadness and reminiscing. Brown's Grove was the first, last, and only seaside "excursion" resort of the times open to African Americans. There were other local beaches that catered exclusively to blacks—Sparrows Beach, Twin Pines, Carr's Beach, and Highland Beach, among them—but none offered steamboat excursions. Brown's Grove advertised itself as "the only Steamer and Resort Owned and Operated by Colored People in America."

Chuck Richards, one of the first black talents to be seen on all-white Baltimore television, recalled the era. "We boarded the excursion boat *Starlight* at the foot of Broadway every Sunday morning and took a lovely forty-five minute ride over to Rock Creek and to Brown's Grove. We spent the day picnicking, taking the rides in the amusement park, swimming, and boating. Later in the evening as dusk came on, we took the excursion boat back, often under the moon. There was a ballroom aboard, and dancing, and always a good band."

Brown's Grove and the excursion boats (including the *Avalon* and the *Newhill*) were owned by Captain George Brown, who had arrived in Baltimore in 1893 as a poor unemployed black man with, he would say, "just enough baggage to fill a cigar box." Half a century afterward he had become the first black member of Maryland's Masters Mates and Pilots' Association and a prosperous and prominent businessman. Brown died in 1935, three years before fire destroyed his beach and amusement park and sent his excursion boats to the scrap pile.

10 | Getting Around

■ "DISCONTINUE THE LOCUST POINT FERRY?
NEVER HAPPEN!" At precisely 5:00 P.M. on New Year's Eve, 1938, Captain Leon Joyss was standing at the rail of the harbor ferry *Howard Jackson*, then tied up at the foot of Broadway. He barked a command at the seamen to let go of the lines, beginning a historic journey—a four- or five-minute voyage across the inner harbor to Haubert Street in Locust Point. This was the last time the famous Locust Point Ferry, which had been providing service across the harbor since 1813, would make the run. The captain, who had gotten the final word only the day before, remained

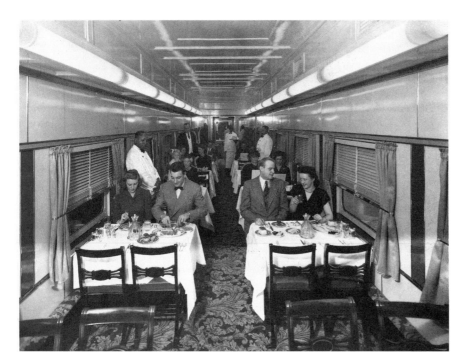

Dining on the Royal Blue offered service comparable to that of the finest restaurants. Food was prepared to each diner's taste. "How would you like your eggs?" waiters asked; "Do you prefer your steak rare, medium, or well done?"

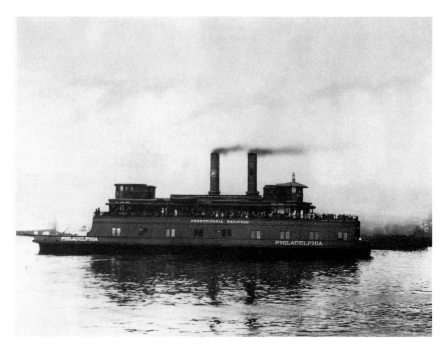

Three times a day, the Love Point ferries left Pier 8 on Light Street for the trip to the Eastern Shore. Here the Philadelphia is pictured with a full load and plenty of smoke. Courtesy of the Maryland Historical Society.

skeptical. "Discontinue the Locust Point Ferry?" he snapped. "I'll believe that when I see her tied up. Never happen."

The old captain had reason to be doubtful. The ferry had been in service for more than a hundred years and seemed to have become of enormous value to the community. In the early '30s, between one hundred and four hundred people a day made the crossing, avoiding the long trip and heavy traffic on the land route via Pratt and Light Streets, down through Key Highway and Fort Avenue around the harbor. Polish parents in Locust Point may have raised the loudest objections to the announcement of the ferry's demise; they had relied on it to carry their children to the Polish schools in East Baltimore.

Nevertheless, the ferry was indeed doomed. Doubts and protests aside, it was costing the city $25,000 a year. Officials supplied various reasons for the ferry's demise—improved streetcar service, better roads, the automobile as a way of life. In the end Mayor Howard W. Jackson figured $25,000 was too high a bill for taxpayers to continue footing.

A few minutes past five, the *Howard Jackson* nosed her way into the Haubert Street dock, and Captain Joyss shouted orders to his mates to secure the lines. He did take time out to say this last piece about the whole affair: "It wasn't any of those things killed this ferry. It was *the cost of the ride.* Right now it's three cents for children, seven cents for adults, twenty-two cents for a car. That's just too much money to charge anybody to go to Locust Point."

■ "PEEP-PEEP! PEEP-PEEP!"—FOR FIFTY-FIVE

MINUTES AND THIRTY STOPS For many years, the Baltimore & Annapolis train was the favored way for Baltimore's senators and delegates to get from the city to the State House in Annapolis. Though considered by some to be jerkwater and rickety, it nonetheless offered its passengers the pleasure of one another's company and the special luxury of watching the world go by through the window of a train. Depending on the year, it left one of two Baltimore stations (Howard and Lombard Streets and Camden Station) every half-hour, and on some runs made as many as thirty stops. Stations were only a minute or two apart.

For example, though it varied with the year, if you left Baltimore on the 8:05 in the morning, you'd be in Westport at 8:17, English Consul at 8:18, and then

8:20	Rosemont
8:21	Baltimore Highlands
8:22	Pumphrey

8:24	North Linthicum
8:26	Linthicum
8:28	Shipley

and so on for fifty-five minutes into Annapolis. (The 8:05 A.M. got to Glen Burnie at 8:35 A.M.)

As the train approached and left each station, it would give out a couple of tiny "peep-peeps." Because of the frequency of the stops and starts, passengers would hear the peep-peeping nonstop all the way to Annapolis. It was actually the conductor's signal to the engineer—three peeps to stop at the next station, two to start up again. And, at every station, passengers would witness the human drama of greeting and goodbye so very special to rail travel, and to life in a smaller town.

The loveliest part of that ride was the trip across the wooden Severn River Bridge, particularly in spring and fall. The colorful foliage was reflected in the water as the train made its way through the sylvan Brigadoon, then out of it, and then into the city of Annapolis. Last stop: Bladen Street Station.

■ "FARES IN THE BOX, PLEASE!" Double-decker buses were once a recognizable part of Baltimore's public transportation system, running on a regularly scheduled route and making nine round trips a day up and down Charles Street from Redwood Street as far north as Thirty-ninth Street. The double-decker buses seated thirty on the first deck and thirty-five on the upper, and they carried full loads most of the time. Although the last such buses in use had a roof over the upper deck, the most memorable ones were those of the early 1930s, which were uncovered. Riders sat up on the top deck in the open air as the bus moved along Charles Street near the Hopkins campus, and the bus passed so closely under low-hanging trees that youngsters would often reach up and grab a handful of leaves.

The Charles Street double-decker was the bus of choice, most every day, of the formidable patriot Mrs. Reuben Ross Holloway. "She always sat directly behind me," Ed Willis, once a driver of a double-decker, recalled, "and kept me posted on what she was up to." F. Scott Fitzgerald was also a frequent passenger and was supposedly inspired by the bus ride to write his classic *Afternoon of an Author.*

■ DOWN GUILFORD AVENUE, BY ELEVATED TRAIN The Guilford Avenue "El" ran on an overhead trestle, a cross-girder affair for streetcars only. It rose at Guilford Avenue and Chase Street and landed in the area of Guilford Avenue and Saratoga Street, near the door of the popular and historic restaurant, Welch's Black Bottle. Built in 1893, the trestle

carried passengers on the No. 8 line between City Hall and Roland Park. "The cars came crashing up and down the steel superstructure above Guilford Avenue one right after another," wrote an observer describing its first day in operation, "from early morning to late at night." There were stops along the elevated way, including those at Madison Street, Monument Street, and Centre Street, which passengers got to by means of a steep, steel staircase.

Newton Brown was a motorman on the No. 8 streetcar and recalled making the elevated run of eight blocks, almost four thousand feet, in good order. "It was a three-minute trip," he recalled, "but we used the run to make up time. We made the entire trip in less than a minute when we wanted to. We really sailed along."

Jim O'Reilly, another motorman, knew well the risks of handling the "El" in Baltimore on Halloween night. As he drove his streetcar north along Guilford Avenue, past Baltimore Street, past Fayette Street, past Lexington Street, and toward the Saratoga Street approach to the "El," he had to worry about the twenty-degree incline that took his car up to the trestle. On more Halloween nights than O'Reilly cared to remember, kids would grease the incline. As his experience told him, when his car hit the grease, it was all over. All he could do at that point was call for Big Bill (the transit company's towing truck) and get towed to safe ground. Seated in the driver's seat on those nights, O'Reilly approached the incline stiffened with anticipation and gave the car an extra shot of power—hoping that if the pranksters had put down the grease, he might shoot over it. That wishful thought dissolved in his mind as he felt the car losing momentum, spinning its wheels, and coming to a dead stop. Time to call for Big Bill.

■ RIDING THE NO. 13 In the 1930s and for some years later, the best way to see the sights along North Avenue, the popular five-mile stretch that split the city between north and south, was to take a trip on the No. 13 streetcar. Imagine yourself starting at Walbrook Junction, at the extreme west end of North Avenue, where you look out on lovely, tree-lined streets and red-brick row houses with scrubbed white steps. The streetcar rattles along, and things begin to get more urban as the car approaches North and Pennsylvania Avenues. Veteran riders remember the conductor's barking out of the names of stops in a peculiarly Baltimore sing-song.

"PENN-sylvania Avenue, Pennsylvania!" There, on the left, stands the Metropolitan Theater. "The Met" opened in 1922; in 1928 it had an exclusive engagement of America's first talkie, *The Jazz Singer*, with Al Jolson. Along with the Senator, it was among the few outlying theaters that carried

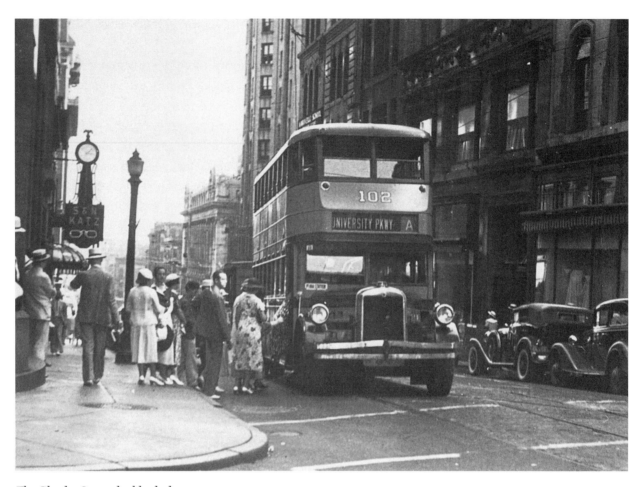

The Charles Street double-decker
bus takes on fares at Lexington
Street in the 1930s. S & N Katz,
jewelers and optometrists, stands
just down the east side of the block.

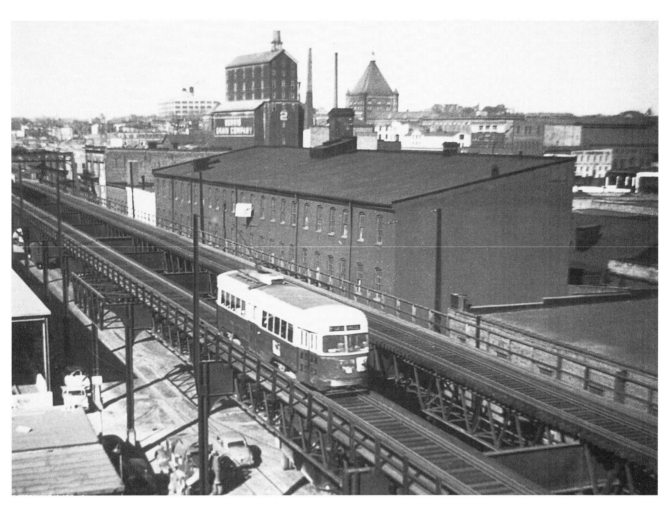

*High above Guilford Avenue, Balti-
more's version of the "Elevated
train" glides along, the steeple of
the Maryland Penitentiary visible
to the northeast.*

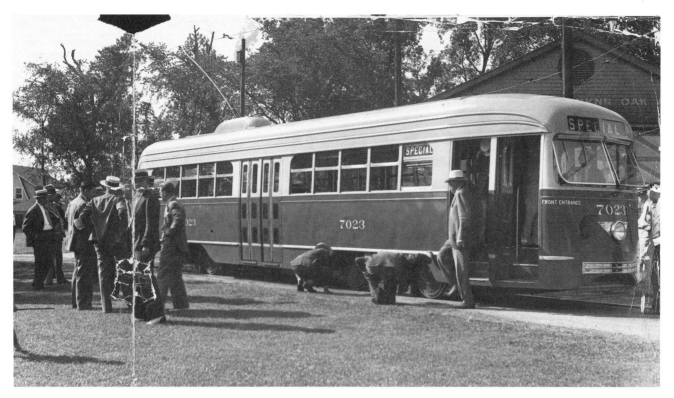

In the fall of 1936, Baltimore Transit installed padded rubber wheels on at least some of its streetcars, aiming to cut down on street noise as well as wear and tear on riders' seats. This early example, a special, drops off passengers at Gwynn Oak Park.

Bus driver Harry Smith pauses to check on some official details.

first-run movies. The movie house across the street, fronting Pennsylvania Avenue, is the Schanze.

Next, *"LINden Avenue, Linden!"* and Baltimore's most popular all-night delicatessen and restaurant, Nates and Leon's, famous for corned beef sandwiches, cheesecake, and characters who seem to be right out of *Guys and Dolls* and never go home.

Farther east and across the bridge, *"MARYLIN Avenue, Maryland!"* and, on your left, between Charles Street and Maryland Avenue, the North Avenue Market. "What makes the market different," Pete Kelly of Corcoran's Meats says, "is the telephone shopping service. Customers call in their orders to the market shopper and one of several nice ladies actually go down on the market floor and shop for them, item for item. The orders are gathered and put on delivery trucks. We keep four trucks going, to Homeland, Green Spring Valley, Ruxton, Roland Park, and Gibson Island." On your right, you see the old Parkway Theater, which opened in 1915.

Just across *"CHARLES Street, Charles!"* you pass the Aurora Theater. Next door to that is an Oriole Cafeteria and, almost directly across the street, the Sports Center, a highly popular ice rink used by high school hockey teams.

Heading east, now passing *"GREENmount Avenue, Greenmount!"* you see, on the right, Green Mount Cemetery, one the most famous resting places in Baltimore—and in America. Enoch Pratt is buried there. So are William and Henry Walters, Johns Hopkins, poet Sidney Lanier, *Sun* founder A. S. Abell, and Maryland governor and presidential aspirant, Albert C. Ritchie.

Just a little farther along, No. 13 approaches *"HARford Road, Harford!"* where, on the northeast corner, Sears & Roebuck's mighty retail emporium dominates. The store features the largest plate-glass window in the world, a tourist attraction by itself—forty feet high and forty feet wide. Beyond lies Belair Road and, for this trip, the end of the line.

■ OUT TO BAY SHORE AND BACK Perhaps the most legendary streetcar ride of them all was the No. 26 to Bay Shore Park. On humid summer Sundays, Baltimoreans, like lemmings flocking to the sea, would hop onto any streetcar that would get them to Fayette and Pearl Streets, where they boarded the No. 26 to Bay Shore. The route took passengers through East Baltimore to Eastern Avenue, to Dundalk through Turner's Station, then across the Bear Creek Bridge to Ninth and D Streets at Sparrows Point. Ray Wheatley worked as a motorman on that run. "We'd seat fifty-five people and stand a hundred in the aisles. The trip took an hour, and

there were so many people aboard and we were moving so fast that it was hard to bring the car to a stop. When there was something in the way we just hit it." The No. 26 met another streetcar that traveled back and forth from Ninth and D Streets to Bay Shore itself, a ten-minute run.

Streetcars started out for Bay Shore as early as 5:30 A.M., and picnickers would spend all day in the amusement park and picnic grounds. As darkness came on they would begin to board the cars and head back to the city. By midnight they were still boarding, though in dwindling numbers. "The last car out," Wheatley said, "was at one in the morning, and we tried to be certain we didn't leave some people out there. But we were never sure." After 1947 he didn't have to worry; Bay Shore Park had closed.

11 | Overnight Stays

■ THE GRAND DAMES Small-town Baltimore boasted more than half a dozen major downtown hotels, each of which developed a personality over the years that made it different, in mood and function, from the others. For formal atmosphere and elegance, Baltimoreans steered out-of-towners toward the Beaux-Arts Belvedere on the corner of Charles and Chase. Farther downtown, the Congress, on Franklin Street between Howard and Eutaw Streets, became a favorite of theatrical guests; Ford's, the Hippodrome, and the Auditorium were all nearby. The Southern Hotel may have been best known for standing on the site of the historic Fountain Inn, a favorite home away from home for George Washington and the Marquis de Lafayette. The New Howard Hotel, on Howard Street between Baltimore and Fayette Streets, became home to the many merchants visiting Baltimore's vast wholesale and manufacturing district. The Biltmore, on Paca Street between Baltimore and Fayette Streets, had a popular Turkish bath. The Stafford and the Park Plaza probably staged more high school proms and fraternity and sorority dances than all the other hotels combined.

In its glory days, the Emerson, at Calvert and Baltimore Streets, played host to celebrities and statesmen alike, including Charles Lindbergh, Jimmy Durante, and Herbert Hoover. Diners took seats in the Maryland Room; drinks were served in "the Enchanting Hawaiian Room"; and the Chesapeake Lounge was a popular, dimly lit rendezvous site. After the onset of Prohibition, however, the Emerson became notorious as the favorite watering hole of the b'hoys, those Baltimore Democrats who met regularly to watch election returns and count their winnings and losses. It was said that every election eve, politicians would rent a suite in the Emerson

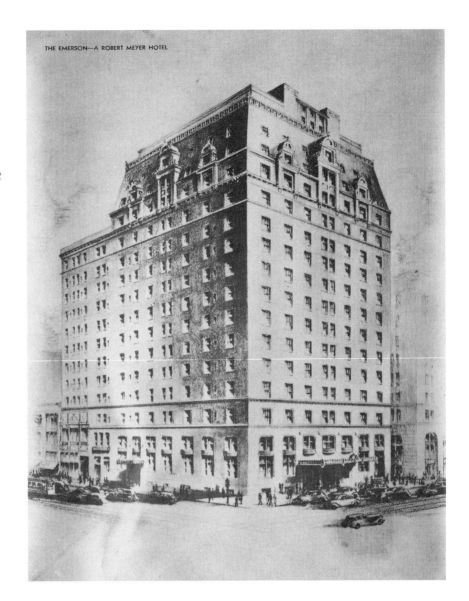

The Emerson Hotel, from a promotional piece put out about 1940. Baltimore lore holds that, on an exceptionally hot day around the turn of the century, the Bromo-Seltzer magnate Captain Isaac E. Emerson was dining in the prestigious Belvedere Hotel. He took off his coat and carefully put it on the back of his chair, whereupon the maître d' rushed over and commanded Captain Emerson to please put his coat back on. According to the story, likely embellished, Emerson then bellowed, "I'll build my own hotel and wear what I please." Whatever the case, the Emerson Hotel provided nineteen floors of anecdotes. Courtesy of the Maryland Room, Enoch Pratt Free Library.

and, as the evening wore on, withdraw, room by room, until the top bosses were all alone in the bathroom. There, according to ancient rules of the political game, they allegedly used their privacy to divide the cash "contributions" that had been gathered in the bathtub.

Then there was the Lord Baltimore, at Baltimore and Hanover Streets. Downstairs, its barber shop, patronized by the rich and famous, seated a dozen men at one time. Barbers slowly trimmed each patron's hair with a comb and scissors and then laid a hot towel over his face, leaving him to relax under it for a few precious moments. For some reason, state Republicans preferred the Lord Baltimore for their election-eve fetes. Usually fairly quiet on those occasions, the Lord Baltimore's ornate lobby, the

Delicious selections are touted on the "Carte du Jour" from the famous Hotel Rennert, whose kitchen specialized, to the delight of patrons such as H. L. Mencken, in "Sea Food Direct from the Chesapeake." Courtesy of the Maryland Room, Enoch Pratt Free Library.

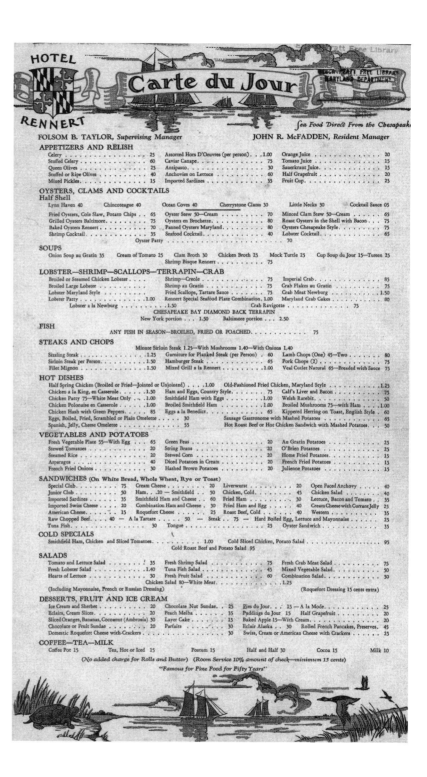

Sportsmen's Lounge, and the Florentine Room hosted the successes of only Theodore Roosevelt McKeldin.

The Rennert, at Cathedral and Saratoga Streets, dated from 1885. In the years before the Eighteenth Amendment it accumulated even more politicians than did the Emerson—the Rennert's lobby, bar, and dining room served as stand-ins for both City Hall and the State House and as a congressional lounge away from Washington. Presidents Woodrow Wilson and Benjamin Harrison paid their political respects to the Maryland establishment here. Baltimore City boss John J. ("Sonny") Mahon more or less ran things from a chair in the rear of the lobby. Senator Isidor Raynor lived at the Rennert, as did boss Arthur P. Gorman. The hotel was known worldwide for its food, and it became famous for charming the newspaperman and critic-at-large H. L. Mencken. "I ate lunch there every day from 1906 through 1915," Mencken wrote. "The place used to be a political headquarters, but all of that ended with Prohibition. The Rennert made much of its reputation with its excellent food. It specialized in Maryland cooking: Maryland oysters, terrapin, wild duck. They pursued the old custom of serving seven oysters to half a dozen and thirteen to a dozen. When the game laws stopped the hotel from serving wild duck, that was a hard blow."

At about 8:00 in the morning of December 14, 1939, in a story sad to relate, the phone rang in Mencken's house, waking him, to his momentary annoyance, and a reporter broke the news to him that the Sage's favorite hotel, the famed Rennert, was closing. It had survived the ban on alcoholic drinks and the worst of the Depression, but by 1939 the establishment had fallen too far in the red. A few hours later, Folsom Taylor, the hotel manager, called Mencken and invited him to attend the last meal that same evening. He said, "A small group of Rennert habitués are going to sing Auld Lang Syne and close the place down in style. Come join us." "I'll be there," Mencken said; he took along his music and his brother, Gus. The kitchen had not been restocked in days, but at 6:30 the staff did its best, and as midnight approached the mourners formed a chorus around the piano. WBAL radio was there to broadcast a special fifteen-minute segment. Mayor Jackson ordered coffee. His waiter brought him tea, explaining, "It's all we have left, sir." The old Rennert had run out of coffee and out of time.

■ INSIDE THE COLOR LINE In the anecdotal literature of the civil rights movement, there is an oft-told story involving Louis "Satchmo" Armstrong. One night long before the 1960s, the jazz great tried to check into one of the best hotels in Boston—he was scheduled to play in its nightclub the next evening. The hotel clerk told Armstrong that it admitted

Pennsylvania Avenue, not far from the Penn Hotel, temporary home to many entertainers who played the Regent and the Royal. From the 1930s through the 1960s, the 1400 block through the 1600 block of Pennsylvania Avenue was the heartbeat of black community life. Sidewalks overflowed as young and old patronized the theaters (the Regent at 1619, the Royal at 1332, the New Albert at 1230); the night clubs (Club Casino at 1515, the Comedy at 1414); the Tommy Tucker "5 and 10" at 1707; the PennDol Pharmacy at 1200. But the highpoint of life on the Avenue was probably the annual Easter parade, an event that was, according to Jeanette Leath, black Baltimore's most popular and longest-running fashion show. By 1:30 P.M. on Easter Sunday, the Avenue's sidewalks and streets were crowded with strollers. Whole families were out, taking in the sunshine and the holiday mood.

Leath ought to know; she was a saleswoman and buyer in the black community's most popular and prestigious women's fashion store, the Charm Center, 1811 Pennsylvania Avenue. "Most of the best-dressed women in those parades," Leath remembered, "wore outfits, from head to toe, that they chose at the Charm Center. In those days, you could not separate the Easter parade from the Charm Center."

The Charm Center grew out of the frustration felt by Baltimore's fashion-minded black women. Ac-

cording to Leath, the only white-operated stores that would sell to black women in those days were Schleisner's, Gaxton's, and a few in Philadelphia. Those stores simply did not provide the fashion that Baltimore's black women wanted, particularly at Easter. So Victorine Adams—who later served in the City Council and organized the Fuel Fund—opened the Charm Center, and it was an instant success. "The Easter parades on Pennsylvania Avenue in those days were in large part a fashion show for the Charm Center," Leath believed.

She recalled that most of the women in those parades wore suits in either pink, yellow, or powder blue and patent leather shoes. And, always, elbow-length white gloves and a wide-brimmed straw hat with a colorful streamer flowing from it.

The parade of strollers moved by the reviewing stand, which was located on the sidewalk at Pennsylvania Avenue and Laurens Street. The panel of judges was made up of local black radio personalities and VIPs; Leath recalled Furman Templeton, then director of the Urban League, as one. The panel would choose the "Best Dressed Woman" and present her with the grand prize—a gift certificate good for purchase at, not surprisingly, the Charm Center.

The Pennsylvania Avenue Easter parade was a two-day affair. On the Monday afternoon after Easter there would be a matinee dance at the Strand Ballroom, on the Avenue near the Royal Theater. "I can remember dancing to the big band music of Buddy Johnson," Leath said. "It was big band music, plenty of swing, and plenty of blues."

whites only. Armstrong, the story goes, showed no emotion. He simply turned away slowly, announcing in that famous gravelly voice: "I don't play where I can't stay." The matter was quickly settled and a comfortable room was found for Armstrong.

In that era, black entertainers visiting Baltimore faced the same problem. The most prominent of them, including Ella Fitzgerald, Nat King Cole, and Sarah Vaughan, to say nothing of black academicians, athletes, and politicians, were not accepted in the downtown hotels, which had a whites-only policy. They had to stay in one of three hotels that accommodated African Americans, all near North and Pennsylvania Avenues.

On the northwest corner of Dolphin Street and Madison Avenue, not far from the Royal Theater on Pennsylvania Avenue, the four-story, twenty-room York Hotel became the place of choice for most black performers. Whether playing at the Royal or an all-white establishment like the Hippodrome, such celebrities as Dinah Washington, Count Basie, and Billie Holliday stayed at the York. Outside, the hotel resembled a typical Baltimore townhouse; inside, it was decorated with Italianate finery. Its lounge, the York Bar and Grille, featured elegant blue mirrors. As a meeting place, the hotel also figured prominently in Baltimore's black political history. In the old days, remembered William Adams, a prominent black businessman and civic leader, it was "the finest hotel for blacks in Baltimore."

But the York had rivals. The Penn Hotel, a modest, two-story inn at 1631 Pennsylvania Avenue, had a reputation for being small, exclusive, and expensive. It stood a few doors away from the Regent Theater, so it, too, catered to African American entertainers. It was the favorite of comedian Red Foxx. Baltimore's oldest and largest black hotel, Smith's, stood at Druid Hill Avenue and Paca Street. Black political boss Tom Smith built it in 1912, using lots of marble, mahogany, and red carpeting. It attracted high-rollers, particularly gamblers from New York and Chicago. "Tom Smith served the finest bourbon whiskey in all of Baltimore, of any establishment, black or white," recalled William H. Murphy. "John Barrymore was a regular at the bar, whenever he came to town. I saw Governor Ritchie come in there often."

12 | THE HOME FRONT

■ CLOSING "THE NEW AQUARIUM" In June 1938, the administration of Mayor Howard W. Jackson completed conversion of the pumping station at the Druid Hill Park Zoo's Reptile House into an aquarium, greatly

pleasing Fred Saffron, a longtime aquarium enthusiast and among the founders of the aquarium movement. "It all started out in 1913," he recalled. "I was a Boy Scout in Troop 178 in southwest Baltimore, and I got interested in natural history." That interest led him and fellow scouts to work toward bringing Baltimore a first-class aquarium. They managed to put together a coalition of the Park Board, the Maryland Conservation Society, the Natural History Society, and the Fish Culturalists of Maryland. With funds authorized by President Franklin D. Roosevelt, the activist group made it happen. Maryland Congressman Ambrose Kennedy made the announcement.

"The aquarium," Saffron reminisced, "was beautiful inside, all pink and blue. We had more than one hundred and fifty varieties of fish." In one week in 1939 the little aquarium in Druid Hill Park had thirty-three thousand visitors. After December 1941, it became a casualty. "Our biologist had to go into war work, and the park laborers took over. Within a month, the alligators and the terrapin were all that were living." Baltimore's first aquarium closed in 1943.

■ AIR-RAID SPOTTERS Sixty minutes of every hour, twenty-four hours a day, starting in late December of 1941 and continuing for the duration of the war, a group of volunteers—mostly men above and below the draft age, as well as many women—kept a lonely and constant vigil waiting to call out two words, *Baltimore Red,* the signal that enemy aircraft were about to attack Baltimore. Despite all their straining through binoculars into the dark and sometimes moonlit sky, those words were never spoken; no enemy aircraft was ever spotted approaching Baltimore. "But out there spotting, you felt you were really into the war," recalled Jim Gentry, who was one of the air-raid volunteers early in World War II. "I remember on cold Saturday mornings when I had that 4:00 A.M. to 7:00 A.M. watch, my dad and I would head up to the American Legion Post Tower on the Mt. Pleasant Golf Course. My mom had us well bundled up and well supplied with thermos jugs of hot chocolate. Some of the thermos jugs of the spotters we relieved from the midnight to 4:00 A.M. shift didn't exactly have hot chocolate in them."

There were spotting towers and warning and filter centers all over the area. "They do not offer the glamour or excitement of a firing line," read a recruitment pamphlet in December 1941, "but the conscientious fulfillment of their responsibilities is essential until the war with the Axis powers is ended." Gentry went on to serve in the army and fought at Bastogne during the Battle of the Bulge. Yet memories of looking for enemy planes that

Returning for homecoming games, Morgan College (after 1939 Morgan State) alums took rooms at "colored" hotels like the York, Penn, and Smith's. This group—from left, Thelma March, Audrey Smith, Vashti Murphy, and Alease Thompson—rooted for the Bears at a game in late November 1940. Courtesy of the Afro-American Archives.

Catching the eye with an angry Uncle Sam wielding a baseball bat, WITH invited Orioles fans to listen in every game night. Courtesy of the Maryland Room, Enoch Pratt Free Library.

Listen Every Game Night at 9:05

W·I·T·H

1230 ON YOUR DIAL

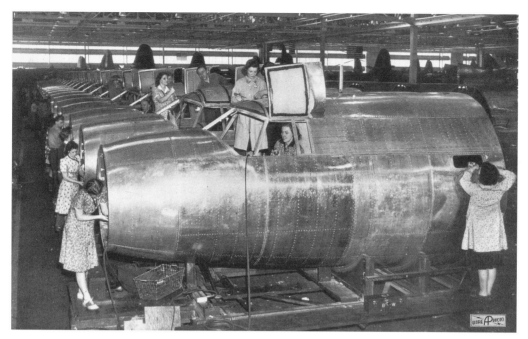

*"Doing a Man's Job." Women, most
of them with electrical training,
work at the Glenn L. Martin air-
craft plant in Middle River in Janu-
ary 1942. "These girls," said the
news release, "busy on production
of B-26 medium bombers, perform
tasks normally reserved to men."
Another such photo description
during the war noted that, in work-
ing on airplanes, training as a beau-
tician "comes in handy."*

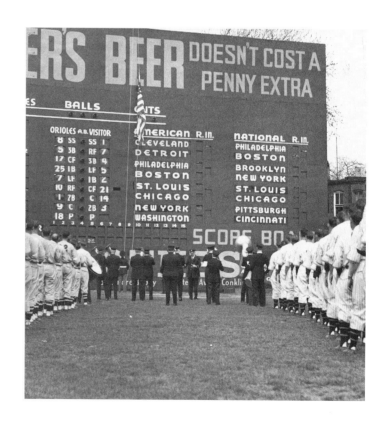

*The flag is raised in Oriole Park
on opening day, April 1942, in front
of an improved scoreboard. In the
big leagues (besides New York),
Boston, Philadelphia, Chicago, and
St. Louis all hosted teams in both
circuits.*

might be headed toward Baltimore never left him. "Even now," he said in 1946, "when I walk down Charles Street, I see a plane flying overhead, I find myself saying something like this to myself: 'Single flight, two engines, northwest to southeast, at two miles, three thousand feet.'"

■ BALTIMORE NIGHT CLUBBERS:

A REPORT FROM THE FIELD

In 1948, a *Sun* writer watched small-town Baltimore edge ever so warily into nightclub life. "Baltimore is no longer afraid of the dark. It goes out at night now," he wrote, "and sometimes stays until morning. Night clubbing in Baltimore has become big business. . . . The city's most popular night club [the Club Charles, 1300 North Charles Street] seating 450 persons raises its minimum and still has to close its doors at show time several times a week."

On the other side of the ledger, Baltimoreans, by the same writer's account, had peculiar entertainment-spending habits, few of them producing black ink. "Your Baltimore night clubber doesn't tip well by metropolitan standards, and he doesn't run up large checks. And more often than not he arrives in time for the floor show and, whether it's a $100 or $1,000 production, he leaves promptly after it's over. And he carries away with him whatever souvenirs he can get his hands on. The average Baltimore night club devotee," the streetwise sociologist explained further, "whether he frequents the honkytonk cellars of East Baltimore Street or the big new clubs on Charles Street, is apt to be closer in age to 35 than to 25. He drinks highballs rather than cocktails, and requests popular sentimental songs rather than congas and tangos. When he tries dancing to a Latin dance he really does the fox trot."

■ "SHIPYARD HILLBILLIES"

Lay that pistol down, babe, lay that pistol down.
Pistol packing mamma, lay that pistol down.

It is January 6, 1944, in the Bethlehem Fairfield shipyards. No less a celebrity than Mary Pickford herself (America's sweetheart of the silent movies) is about to crack a bottle of champagne across the bow of the Liberty ship S.S. *Samnid*. Standing behind her, to add a note of festivity to the launchings, is a musical foursome called the O'Dell Brothers. Dressed in tattered, torn, red-wool plaid shirts, they have mastered the "pure country" look. "But we're just hill-billies, that's what we are, hill-billies," Orville, who plays guitar, tells an observer at the scene. "Yeah, we're from the hills," adds brother George, who plays the fiddle. "Yep," chimes in brother Stanley, who

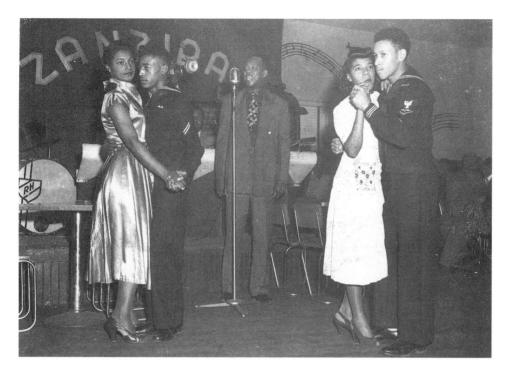

Sailors on leave enjoy a dance at the Club Zanzibar, on Pennsylvania Avenue, during World War II. Courtesy of the I. Henry Phillips Collection.

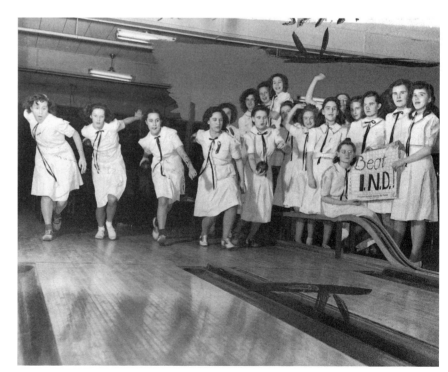

War or no war, Seton High girls practice for the upcoming Catholic junior- and senior-high bowling tournament, where they fully expect to prevail over their principal rival, the Institute of Notre Dame. About to bowl, from the left, are Agnes Klasmeier, Mary Albers, Patsy La Shine, Kitt Hogan, and Jean Hotem. Fittingly, the championship honored Florence Nightingale.

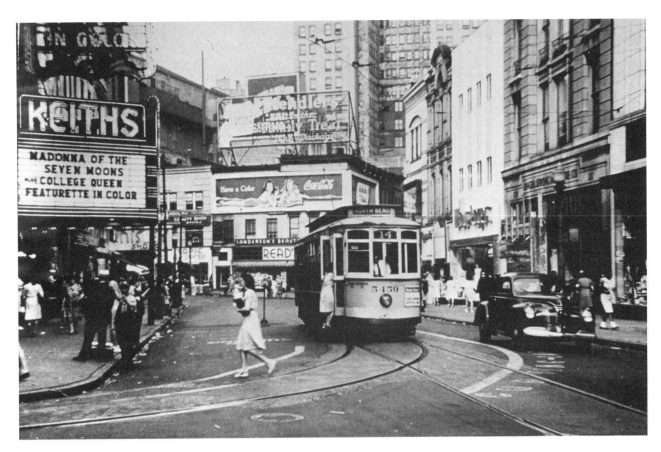

The No. 14 streetcar stops for a passenger on West Lexington Street between Liberty Street and Park Avenue on a cloudy day in 1944. This district had two prominent theaters, the New at 210 (not shown) and Keith's, which had been at 114 West Lexington since 1915 and through the years became a favorite among downtown moviegoers. Above Read's Drug Store, a billboard advertises Baltimore's own Hendler's Ice Cream.

plays mandolin, "way back in them hills. All right, boys," he shouts, "let her rip."

> Drinkin' beer in a cabaret and was I havin' fun
> Till one night she caught me right and now I'm on the run

In the frantic early wartime days in Baltimore, Bethlehem Fairfield was hiring thousands of workers a week to build Liberty ships. Where many of them came from was obvious from the graffiti scrawled on the tool sheds: "Summerfield, W.Va.," "Galax, Virginia," "Ashland, Kentucky," "Sharps-burg, North Carolina." And if you missed the graffiti, all you had to do was listen to the music, blasting out of the yard's loudspeakers. "All day, all night," said Michael Andrews, a supervisor at the yard, "the music we play over the loudspeaker system is hill-billy. More than seventy percent of the workers want to hear hill-billy."

> I'll see you every night, babe, I'll woo you every day
> I'll be your reg-lar daddy, but put that gun away.

During World War II, hundreds of thousands came down from the hills of Appalachia to work in Baltimore's weaponry factories, and when the war was over, many stayed, further enriching the ethnic diversity of Baltimore and forever changing the human landscape of the city.

■ STAYING IN TOUCH Decades ago, to phone someone in Baltimore you picked up the receiver and heard a pleasant voice on the other end of the line asking, in a tone as if she were your own mother coaxing you to drink your milk and eat your cookies, "Number, pul-eeeez?" That voice belonged to any of the manual operators, of whom Mary Hart was one. She worked in the Madison exchange beginning in 1941. "Callers gave us the exchange they wanted and four numbers," she recalled. "They'd say, 'Mulberry 2947' or 'Liberty 5190.'"

The exchange names did more than merely relate to the geography of the city. Over time they came to be code words, synonymous for status—or lack of it—in Baltimore City. "University" or "Tuxedo," for example, indicated Guilford and the area surrounding the Homewood campus of Johns Hopkins University; "Vernon" encompassed the grand and stately homes around Mount Vernon Place; "Madison" and "Lafayette" stood for the in-town aristocracy of Bolton Hill. There was "Liberty" for the northwest, taking in the neighborhoods out Park Heights and Liberty Heights Avenues, and "Forest" for Forest Park. If you heard "Saratoga" or "Mulberry" or "Lexington," you knew the call was going downtown. "South" was a dead giveaway for South Baltimore, and "Pennsylvania" served the area around

The famed 29th Division returns to New York and American soil, January 5, 1946, aboard the transport Lejeune. Left to right (top) are Baltimoreans Corporal Curt A. Jerschke of Worthington Road, Private First Class Wilbert J. Hinkelman of Bond Street, and Tech Sergeant Henry Calvert Jr. of Bentalou Street.

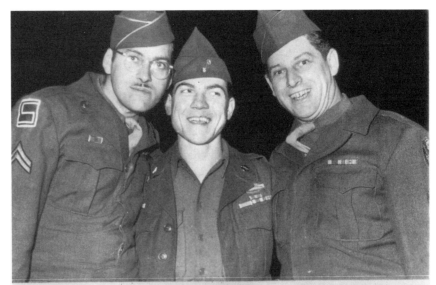

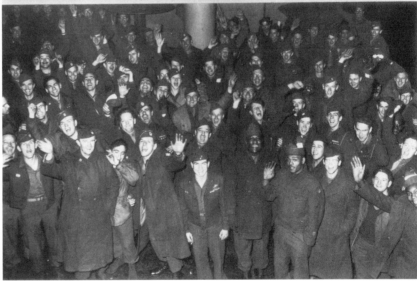

Pennsylvania Avenue. "Idlewood" meant York Road; West Baltimore had its "Edmondson," "Wilkins," and "Longwood" exchanges. "Orleans" and "Eastern" signaled Broadway and East Baltimore. Hamilton naturally answered to "Hamilton"; Clifton Park had "Clifton."

"When somebody gave you the exchange and the number," Mrs. Hart recalled, "you somehow felt as if you were helping them personally. I remember a lady who would call me every morning. She said, 'I live alone. And I just want to make sure you are there in case I need you.' Once a woman called and said, hurriedly, 'Better get me to a hospital; I'm in hard labor!' I got her to a hospital! Whenever there was bad news, I could tell it the moment I walked into the exchange. The board would be all lit up. The day Roosevelt died, for example. When people were calling one another you knew there was news going around, family to family, neighbor to neighbor. We lived in a small town."

■ REAR-GUARD ACTION During the WWII years in Baltimore, if you were young enough, old enough, healthy enough, and had no deferment, you were in the armed services. But if you failed to fit into one of these classifications, you were fighting a rear-guard war of your own.

You jostled with crowds at the Bethlehem Shipyards where workers built Liberty ships or at Glenn L. Martin, where they built Mars Flying Boats. You stood in long lines for butter, sugar, film, cigarettes. So precious were so many items that whenever people saw a line forming anywhere, they would get into it and buy whatever was being sold at the front. You scavenged for ration stamps (there was a flourishing black market for shoes, gasoline, hosiery, meat—a pound of hamburger required seven points. A 1944 newspaper picture shows a long line at Lexington and Liberty Streets, as customers queued up for nylon stockings.

You may have worked at an aircraft filter station, plotting aircraft movements, or at a Red Cross, serving coffee and doughnuts to soldiers and sailors between trains at Camden Station or Penn Station. Or you were an air-raid warden, with white helmet and armband, going house to house checking to see that the blinds were drawn tightly. If you owned a small boat you were likely in the Coast Guard auxiliary, on the prowl for Japanese submarines in Back River.

You grew a Victory garden.

On Tuesday night, August 14, 1945, you may have been one of those who swarmed into Sun Square at Baltimore and Charles Streets to celebrate. It was night of wild delirium, with singing and dancing in the streets—the likes of which has not been seen since.

13 | That's Entertainment

■ "THEY'RE GOING TO BUNDLE FOR TWO HOURS.

DO THEY CARE WHETHER THERE'S A MOON?" People at
Pier 8 on Light Street this warm July night in 1946 crowd onto the gang-
plank and board the steamer *Bay Belle* for the nightly moonlight cruise
down the river. No moon shines upon them. "It doesn't matter there's no
moon," Captain J. H. Lyons reassures a concerned observer. "Look at these
people, they're going to bundle for two hours. Do they care whether there's
a moon?" The captain appears to be right; passengers rush up to the top
deck, grabbing chairs and settling in for the two-hour cruise through the
warm night and the dark water to dreamland.

In minutes the *Bay Belle* is downstream, and on middeck the orches-
tra of Bob Craig (or Eddie Dowling or Rudy Killian) is playing the "One
O'Clock Jump." Some young couples come down from the top deck long
enough to dip and shag and drop and twirl, in what can loosely be called jit-
terbugging. But most of the other couples never leave the top deck; they sit
close, out in the open, gazing at the moon that isn't there.

By 10:00 P.M. the *Bay Belle* reaches Seven Foot Knoll, where it churns
itself around and heads back. The sights of Baltimore harbor come back into
view—the flames of Bethlehem's furnaces dancing on the water, the lights
of the shipyards playing on the sides of the brooding tankers. Now nearly all
the couples are on the top deck saying goodnight to each other in the way
that couples do as a moonlight excursion comes to an end, and the orches-
tra plays "Good Night, Sweetheart." The *Bay Belle* slips into her berth and
the passengers file out, moving noticeably slower than they did when they
came aboard earlier in the evening. On the gangplank as guests are leaving,
a reporter observes this scene: A lady pushes determinably through the
crowd, finds the man she is looking for, and is heard to ask,

"Say, are you the guy who kissed me?"

"Me? Gosh, no! I've got a wife aboard this boat."

"So what? I've got a husband aboard this boat, and he wasn't the guy
who kissed me!"

■ THE CHANTICLEER

DEAN: That your case of Arrow beer?
JERRY: Yup.
DEAN: Where are you going with it?
JERRY: I'm taking my case to court.

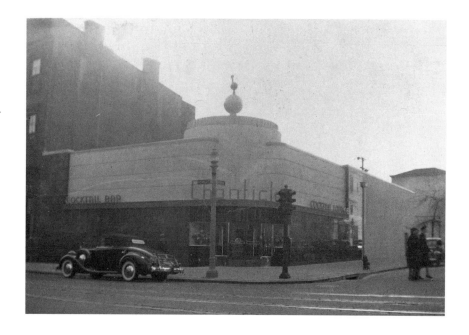

The streamlined Chanticleer Cocktail Bar and Restaurant, on the southwest corner of Charles and Eager Streets, sports a natty roadster parked outside—as if a paid advertisement. Courtesy of the Maryland Historical Society.

Dean was Dean Martin and Jerry was Jerry Lewis, together as part of the floor show of the Chanticleer night club at Charles and Eager Streets in 1946, and that is the way the act is recalled by some of the people who used to work there in those days, including emcees Bernie Lit, Mike Golden, and Lenny Hobbs. This was just after World War II, when the Chanticleer, which seated about three hundred people, was, along with the Club Charles, the biggest game in town.

"Dean Martin came to work a few years earlier," Golden said. "He was just a 'production singer,' he wasn't good enough to sing on stage so he sang offstage, accompanying the acts when they needed vocals." A few years later Jerry Lewis teamed up with him. Martin was the straight man; Lewis was the cutup and acted very "burlesque": to start their routine Lewis would go over to the door of the ladies room, bang on it, and holler, "Come on out, ladies, the show is starting!"

The biggest names in show business played the Chanticleer: Sophie Tucker was a regular, as were Zero Mostel and Henny Youngman. Victor Borge opened the club in 1941; he played the opening performance and then quit. He said he couldn't do his act over the noise of the ventilator. But from there on out there were two shows nightly, 10:30 P.M. and 12:45 A.M.

DEAN: You've got that same case of beer and now you've got a ladder, where are you going now?
JERRY: I'm taking my case to a higher court.

You had to have been there—the Chanticleer, Baltimore, 1946.

■ TERROR IN THE BOOKIE JOINTS "Police arrest 26 as illegal lottery operation is raided," read the headline in the *Sun*. "The raids were at 16 locations. Seized were $17,700 in cash, illegal lottery slips, ledgers, answering machines, calculators, tape recorders and cassettes." Michael Bass, police spokesman, remarked, "The operation is a rather large one, but we're not so naive to believe it's the only one."

Judge Joe Sherbow enjoyed such news like medium-rare beef. Through the 1940s and into the 1950s, Sherbow, with the help of an improbable captain of the vice squad, Alexander Emerson, struck terror in the heart of every bookmaker in town. They faced steep odds. So widespread was the business that certain radio stations made daily announcements of the winning numbers. The judge aimed to expunge the bookmaker from the streets of Baltimore; he lived to see the day when the criminal element considered bookmaking dangerous work.

Sherbow relied heavily on Captain Emerson, an indefatigable, totally committed, and, so the bookmakers thought, crazy native of Nebraska. He would begin a raid by knocking at the door with a giant maul. Ordinarily the mauls used to break through doors in those raids weighed ten pounds. But Emerson's favorite was an all-steel eighteen pounder. "There weren't many people could use a maul as well as I could," he modestly admitted. "I mauled rails when I was a boy, cow-punching in Nebraska, and I knew how to hit. Generally I gave one lick and the door came open. When I hit a second time the whole door frame would come crashing down." Once inside the suspected gambler's lair, Emerson would rush to the kitchen or the bathroom. There, he would thrust his hand into either the stove or the toilet to extract the torn number slips hastily thrown in by surprised suspects.

Emerson suffered for his zeal, losing several of his teeth after being struck by a woman with a crutch. He had his coat shredded by a slashing razor; he was choked with his own necktie and stabbed with a pair of scissors. He said he had been bitten, thrown down stairs, hit with a chair and with a pool cue, attacked by dogs, and had doors slammed on his fingers. He had a halting way of speaking that occasioned mimicking imitations: "There was a bookmaker uh up there on Lexington street uh near the market and uh he had a filthy place on the second floor uh I thought he was a clergyman uh when I first met him until he opened his mouth. He had a uh filthy uh mouth."

The acme of Emerson's break-ins took place in 1947 at a house on West Lexington Street. Four wooden doors and nine iron doors fell before the captain's fury on that day. It took two and a half hours to get to the fourth floor, he recalled. "The door frames themselves were eight-by-eights, and

Captain Alexander Emerson of the Baltimore City Police emerges from an alleged numbers parlor, presumably masked against the dust he and his vice squad continually raised in the late 1940s and early 1950s. He likely did not intend the scarf as a disguise; earlier in his career the News-Post had run a photograph that clearly pictured him as he admired a pile of silver and crystal, "part of the three patrol wagon loads of loot" taken from a house on East Preston Street. The police had acquired the goods following the arrest and questioning of one John Kelly, who admitted to fifteen burglaries in Baltimore and more elsewhere.

A nocturnal view at North Charles and Lanvale Streets captures signs advertising two of Baltimore's favorite beverages—Mount Vernon Straight Rye Whiskey and Arrow Beer. Before Prohibition, Maryland rye enjoyed proverbial status, the gentleman's drink of choice; in the 1940s, when the Hughes Studio took this picture, sales were strong but Baltimore distillers far fewer than earlier. By the 1940s, surviving Baltimore beer labels, in addition to Arrow, included Free State, Gunther, American, Weissner's, and National. Local beer gardens—Muth's, Riverview, Carlin's Park, Seeger's, Beck's, Prospect Park—helped to move the barrels through the system. Courtesy of the Maryland Historical Society.

Art imitating life: Here popular Sun cartoonist Richard Q. "Moco" Yardley tells the story in words and pictures of "Comings and Goings in Our Big City." While Judge Sherbow and Captain Emerson direct bookmakers toward "the Big House," a prisoner makes his escape. On the night of July 8, 1949, then serving his eighth year of a twenty-year sentence for burglary, Joseph "Tunnel Joe" Holmes began scratching away at the concrete floor of his cell with a piece of metal. Holmes seemed to have thought of everything. He acquired tools and lamps and disposed of dirt down the commode without detection, and he concealed the noise by digging only when the prison radio played. He even accumulated money and clothes for use after his escape. He dug vertically down to a depth of twenty-six feet, at which point he made a ninety-degree turn and began tunneling horizontally under the jail itself and beyond the wall. Completing this engineering feat, he surfaced into the cold night air on February 15, 1951, pushing up through the narrow strip of grass between the penitentiary wall and Eager Street.

Yet, for all his preparation, Holmes had not reformed. In early March 1951, police arrested him after a hold-up near the Washington Monument, and in minutes he was back in his cell. "I went to Philadelphia to get a job," Joe said, "but I found that no one would hire me. So I came back to Baltimore to get a ship out. If I had gotten a job I never would have come back and gotten caught." And why couldn't he get a job in Philadelphia? "I forgot to get a Social Security card," he said. Once Tunnel Joe Holmes was safely back in prison, Yardley gave his cartoon to Judge Sherbow. Courtesy of Joseph Sherbow.

when I hit 'em I jarred half of Lexington Street." After having crashed through thirteen barricades, Emerson and his squad broke in on eighteen men sitting around a table covered with playing cards. "If you'd rapped," one of them said—looking up indifferently and signaling the group's lack of concern for the noise, Emerson's mission, and Emerson himself—"we'd have opened the door." Emerson smiled. "You know," he said, "there ain't any card game that eighteen men can play."

Appearances before Sherbow's bench carried additional misery for Baltimore's bookmakers. The judge adopted a no-exceptions policy of sending all bookmakers, regardless of station, to jail. "The stiff penalty policy," according to a newspaper account, "soon had its effect. Jailed bet collectors, not used to prison life, soon began to expose their defaulting backers to the state's attorney or the grand jury. Higher-ups in the racket were indicted and several of them were convicted of gambling and conspiracy charges."

Much to the relief of Baltimore's bookmaking fraternity, Sherbow resigned from the bench in 1952, citing low pay.

■ "STEP RIGHT IN, FOLKS!" The storied stretch of Baltimore Street cabarets, burlesque houses, theatrical hotels, pawn shops, flop houses, and peep shows between Guilford Avenue and the Fallsway has long been known in the city, around the country, and around the world as "the Block."

The roll-call of spots must begin with the Gayety. The Gayety put Baltimore on the map as a burlesque capital, and the man who put the Gayety, which opened in 1906, on the map of Baltimore was John "Hon" Nickel. Nickel took over the Gayety in 1926, after a colorful career as a fight promoter. Over the next ten years he brought in the most popular burlesque comedians on the American burlesque circuit—Phil Silvers, Eddie Cantor, Jackie Gleason—as well as such stars from the exotic dancing world as Ann Corio, Margie Hart, and Georgia Southern.

It took a thousand people to fill the Gayety's orchestra seats, balcony, boxes, and standing room area, but under Nickel's management the place sold out "quite often," as he later said. "When stripper Ann Corio came to town we turned away customers. A show ran about two and a half hours. There was a star stripper, a number-two strip act, and often a number-three stripper. And three minor 'take-it-off' performers. There would be a big-name comedy team, and possibly one or two other comics working alone. There was a house singer who did two numbers each show, usually as accompaniment for a costume number staged by the traveling chorus of twelve showgirls. Every rainy day the theater would be packed with cus-

tomers whose work was hampered by bad weather, mostly salesmen. There was continuous entertainment from noon to 5:00 P.M. and 8:30 to 11:00 and the place was open seven days a week. We closed only during the hot spell from late May to early September. No air conditioning." Crazy, corny, and side-splitting described Gayety burlesque—baggy-pants comedians doing their skits on stage while vendors hawked boxes of Crackerjacks in the aisles ("Big surprise inside each box, folks!").

The day "Hon" Nickel died in 1951, the show at the Gayety (with Winnie Garret as the featured dancer) went on as usual. Hon would have liked that.

During the golden age of Baltimore's night clubs, every club seemed to have its own style. The Club Charles and Chanticleer featured Broadway shows, the Pan American had its Latin bands. Beginning in 1948, six nights a week from 1:00 A.M. to 4:00 A.M., the Copa Club on the 100 block of West

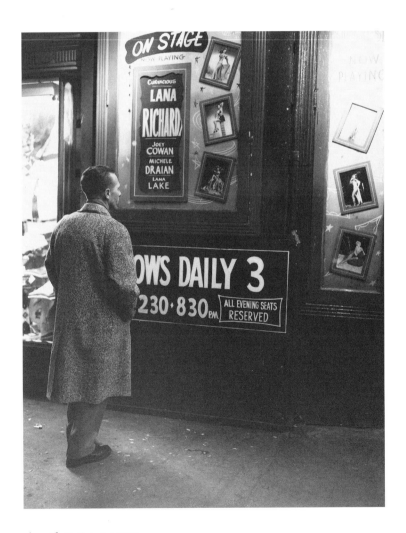

A patron eyes posters at the Gayety, around 1950. Courtesy of Tom Scilipoti.

The Gayety, shown here in about 1950, was Baltimore's legendary burlesque house. For more than fifty years the brightest stars in American burlesque entertainment performed on its stage. Comedians included Eddie Cantor, Phil Silvers, Abbot and Costello, and Jackie Gleason. At one time or another the Gayety featured strippers Margie Hart, Georgia Southern, Hinda Wassau, Paddy Waggin, and Ann Corio. Plus there were skits. One of them, simply called "The Hospital," went something like this: Over a patient's bed hangs a large sign reading "Quiet." But visitors are shouting at one another. A "doctor" in baggy pants (a part often played by the famed Joe "Cheese and Crackers" Hagen) rushes in, brandishes a pistol, and fires it with a loud bang. "When I say 'quiet!' I mean QUIET!" There were two and sometimes three shows a day.

Proud of what it was and never claiming to be more, the Gayety fascinated the folk who dressed up in tuxedos and sequined gowns. What could be more fun than slumming at such a place on New Year's Eve? Courtesy of the family of John "Hon" Nickel.

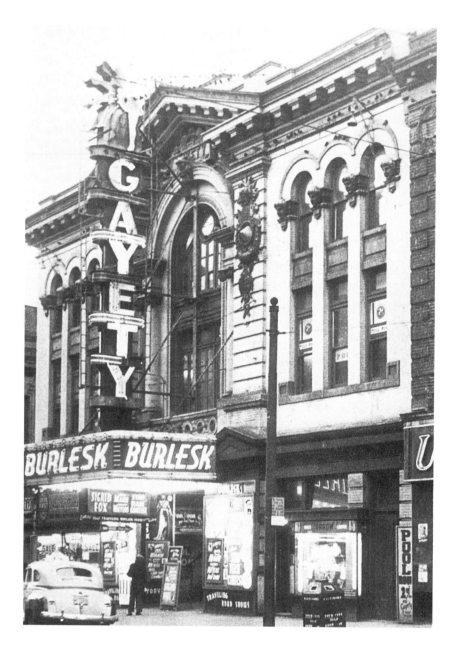

Baltimore Street (not, strictly speaking, on the Block but a few blocks west) featured a personality named Jack Wells hosting the first radio call-in show in Baltimore, and maybe only the second in America. The show went out over WITH and lasted for about five years.

Wells recalled the show with wonderment. "I'd sit at a table near the dance floor with a microphone on my right and a telephone on my left. I'd broadcast, 'I'm at the Copa, where are you? Call me.'" And call him they did, by the dozens each night, with call backed up against call. The technology was primitive. "When callers talked to me on the phone," Wells explained, "the call was just between the two of us, the radio audience could hear me over the air, but not the caller. I had to answer the caller, and talk over the air at the same time, in such a way that the audience would get the gist of what the caller was saying, and the drift of the whole conversation. But so often I got calls from nuts out there, guys who were going to blow up the world, quacks with cure-alls, people whose conversation was at a taste level I couldn't possibly let out over the air. So I'd answer in some innocuous way, like, 'That's fine. I'm glad your aunt is getting better.'" Years after the Copa closed, when Wells was living in California in the 1970s, he remained on his guard. "Whenever the phone rings in my home, I am still afraid it's some guy calling to tell me the world is going to end in fifteen minutes." The Copa and its call-in show were both modeled after the famous Copa in New York. The club offered a musical bar, seating for three hundred, and dancing to local bands.

The Oasis Cabaret, a basement night club at the southwest corner of Baltimore and Frederick Streets, billed itself as home to the "World's Worst Show," which was not all you saw once you stepped down into it and your eyes adjusted to the lack of light. Oasis floor shows were a laugh from start to finish, bawdy and outrageous. They featured sixteen girls who could neither dance nor sing, and who were, most of them, overweight. The club's master of ceremonies for twenty-five years, T. Willie Gray, would introduce them with aplomb. "Let's hear it for these *lovely, lovely* ladies." After each act Gray warned the audience, "Don't go way folks, the next act is going to be worse." In case anyone honestly believed that the Oasis show *was* the world's worst show and said so out loud, there were two husky bruisers, "Machine Gun" Butch Gardina and "Little Jack" (six feet four inches) Horner waiting to escort them unceremoniously up the stairs and out onto Baltimore Street.

The Oasis found itself the subject of constant vice-squad surveillance—a role that carried with it much favorable publicity for a strip-joint owner. On the evening of June 18, 1954, police made one of their periodic

The menu for the Oasis Cabaret boasts, "If your drink is not listed, name it and we will make it." Courtesy of the Maryland Room, Enoch Pratt Free Library.

If Your Drink Is Not Listed, Name It and We Will Make It

COCKTAILS

Manhattan	$.35
Martini	.35
Old Fashioned	.40
Clover Club	.40
Pink Lady	.35
Bronx	.35
Alexander	.40
Side Car	.40
Stinger	.40
Coffee	.50
Bacardi	.50
Jack Rose	.40
Orange Blossom	.35

IMPORTED CORDIALS

Apry Liqueur	.50
Creme De Cocoa	.50
Creme De Menthe	.50
Anisette	.50
Kummel	.50
Blackberry Brandy	.50
Benedictine	.50
Curacao	.50

IMPORTED LIQUORS WINES - GINS

Martell Brandy	$.50
Hennessy Brandy XXX	.50
Courvoisier Brandy	.50

IMPORTED SCOTCH

Old Angus	$.50
Martin's V-V-O	.50
Haig & Haig XXXXX	.50
Teachers	.50
White Horse	.50
Black & White	.50
Johnny Walker	.50
Cutty Sark	.50
Ballentine's	.50
Walker Black Label	.60
Haig & Haig Pinch	.60
Vat 69	.50
De War White Label	.50

IMPORTED RUM

Carioca	$.50
Bacardi	.50
Ron-Rico	.50
Myers Jamaica Rum	.50

ROMA WINES

Sherry	$.25
Port	.25
Muscatel	.25
Claret	.25
Sauterne	.25
Sherry Flip	.35
Port Flip	.35
Sherry and Egg	.35
Sherry and Ice	.35

IMPORTED WINES

Imported Sherry	.35
Imported Port	.35
Imported Sauterne	.35

PUNCHES, ETC.

Milk Punch	$.50
Port Wine Punch	.50
Sherry Punch	.50
Pineapple Punch	.50
Orange Lemonade	.50
Claret Lemonade	.50
Coca Cola Punch	.50
Planters Punch	.50

● ● ●

OTHER BEVERAGES

Suburban Club Ginger Ale

Coca Cola	$.25
Ginger Ale	.50
White Rock	.50
Bowl Ice	.25
Order Lemons	.25
Grape Juice	.50
Tomato Juice Cocktail	.25
High Rock Ginger Ale	

Heidsieck Dry Monopole Champagne Sparkling Wines Served by the Bottle.

DRINKS DELUXE

Bonded Rye Whiskey	$.50
Carstairs Rye	.40
National's Eagle	.35
Old Grandad	.50
Schenley Rye Whiskey	.35
Seagram 5 Rye Whiskey	.35
Rye Highball	.35
Scotch Whiskey (imported)	.50
Scotch Highball (imported)	.50
Scotch and Soda (imported)	.50
Whiskey Sour	.35
Lord Calvert Rye	.50
Gin Rickey	.30
Sloe Gin Rickey	.35
Sloe Gin Fizz	.35
Gin Buck	.30
Gin Fizz	.30
Silver Fizz	.40
Golden Fizz	.40
Royal Fizz	.40
Jack Collins	.40
Tom Collins	.30
Bacardi Collins	.50
Ward Eight	.50
Brandy Fizz, imported	.50
Green Mint Fizz	.50
Benedictine and Brandy	.50
All Bonded Mixed Drinks	.50

BEERS

Bottle

National Premium Beer	.30
National Gold Seal	.25
National Bohemian	.25
Budweiser	.30
Ballentine Ale	.30
Pabst Blue Ribbon	.30
Schlitz	.30
Bruton Brewmaster	.25
Jolly Scot Ale	.25
American	.25
Free State	.25
Gunthers	.25
Arrow	.25

We will gladly mail one of our Menus or you can have this one.

OASIS CABARET
Baltimore & Frederick Streets
Baltimore, Md.

No. 11

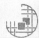

The Block, from its glory days up into the 1970s, was a glittering and exotic mix of burlesque offerings, including cabarets (the Oasis, the Miami, the 2 O'Clock Club, the Stork, the HiHo, the Pussy Cat, the Villa Nova), shooting galleries, all-night restaurants, theatrical hotels, photographic studios, barber schools, pawn shops, flop houses, and peep-show emporiums. Looking out from the northeast corner of Baltimore and Gay Streets in 1961, News-Post and American photographer William L. La Force Jr. captured the sign for the Hotel Edison with two of its letters burned out, leaving a provocative "HOT." This image may have stuck in someone's mind and led to the first script for the play Hot l Baltimore.

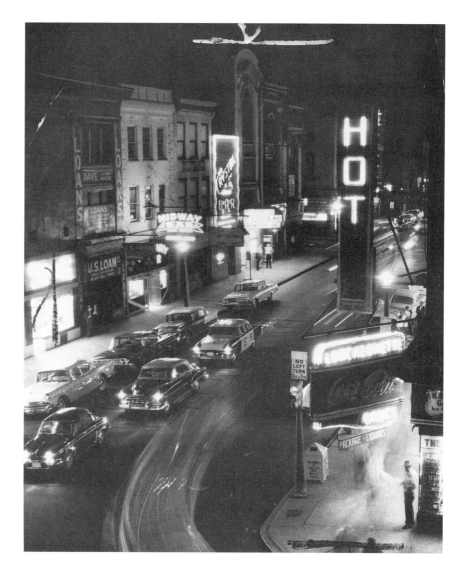

appearances and a crowd of spectators gathered on the corner. One by one, dancers, waiters, musicians, and patrons were herded into paddy wagons. As one of the suspects stepped into the street light, bystanders broke into cheers. The applause was to greet Willie the emcee, and it continued appreciatively until he had disappeared into one of the wagons. The next day the papers carried the names of all the Oasis personnel and patrons arrested in the raid. The list of notables included reporters and editors of the National Newspaper Editorial Association, in town for a convention.

Following another raid, Judge Samuel K. Dennis commented that, even assuming that none of the performers was actually naked, he still was "convinced that the performance was indecent." Five witnesses who had been at the performance (leading attorneys and business executives) loudly

protested to the judge that he was wrong. The attorney for Max Cohen, the proprietor of the Oasis, avowed that it "was one of the finest night clubs of its kind in the country."

■ THE HIPPODROME: BIG-NAME VAUDEVILLE IN BALTIMORE

I was wa-a-a-a-ltzing with my darlin'
to the Tenn-ah-se-e-e-ee waltz . . .

Cheers and applause poured from the audience at the Hippodrome Theater the night of Thursday, May 31, 1951. On stage Pee Wee King, accompanied by the Golden West Cowboys, twanged through the country western hit they had help make popular, "The Tennessee Waltz." This was vaudeville at the Hippodrome (on Eutaw Street between Fayette and Baltimore Streets) as Baltimoreans had known and loved it in the 1930s and 1940s, and the way things were going this evening you would think the Hippodrome vaudeville tradition would go on forever. King and the Cowboys segued into their finale, accompanied by bluegrass star Bill Monroe and his Grand Old Opry gang. They went deep into their country style; the beat was pronounced, the singing was wistful.

When an old frie-e-e-end I happened to see-e-e-e.
Innerduced him to my darlin'
And while they were dancin'
My friend stole my sweetheart from me-e-e-e.

Twenty years before, in May 1931, a thirty-year-old fellow from Philadelphia, Isadore Rappaport, walked aimlessly west on Lexington Street, having come to town to see about buying the New Theater, at 210 West Lexington Street and Park Avenue. By 3:00 he had looked at the place—and was not terribly excited by it. But his train back to Philadelphia did not leave for a few hours. Killing time, he'd wandered west on Lexington, crossing Howard, and then at Eutaw Street, for no special reason, he turned left and walked south. After crossing Fayette he spied, on the marquee of a theater on the west side of Eutaw, "HIPPODROME—for sale or rent. Maryland National Bank." Within a few weeks he had leased the theater, and thereafter the enterprise consumed every waking moment of his life.

Baltimoreans forever linked Rappaport to the glory days of the Hippodrome Theater. Tommy Dorsey and Glenn Miller, the Mills Brothers and the Andrews Sisters, Milton Berle—all played the "Hipp." In 1939 a Hollywood gossip columnist put together several lesser-known acts and went on

tour as "Stars in Review," a troupe that, quite naturally, appeared at the Hipp. One of those acts featured a couple who did light comedy and some singing—Jane Wyman and Ronald Reagan. Over the years Felice Iula, Phil Lambkin, and Joe Lombardi led the house orchestra. That night at the end of May 1951, John Urbanksi played trumpet for Lombardi.

In the 1930s, the Hippodrome, while not actually air-conditioned, had been "air-cooled," and people who patronized the old theater generally found it cool enough in hot weather. Helen Leonard Marshall, employed at the theater for forty-three years, remembered how the system worked. "It was a simple matter of blowing air across ice, and sending the chilled air into the auditorium," she recalled. "We had vents on the roof and chutes leading down from them into the theater. We'd drop huge chunks of ice into the vent and turn on the fans. The chilled air went down the chute and 'cooled' the theater." Marshall laughed, *Cooled?* Well, I wouldn't say it was exactly 'cool,' but it was comfortable enough. The bottom line, though, was that using only fans and the ice, business was just as good in the summer as it was in winter." Marshall said the Hippodrome received as much as one hundred tons of ice a day from Hoffberger Ice Company, which started deliveries every day at 10:00 A.M.

> Yes I lost my little darlin'
> the night they were playin'
> the bee-yoo-tee-ful
> Ten-ah-h-h-see waltz . . .

The curtain fell, the applause rose, and King and the Cowboys and the Opry gang came back for bow after bow. Then, as Urbanski remembered it, "We heard that the manager wanted to see us in the musician's room under the stage. When we got there he said, 'Fellows, it's all over. That's the last vaudeville show from the Hippodrome stage for a while.' We Hippodrome house musicians took a break we hadn't expected." The Hippodrome closed for repairs beginning June 1, 1951. Attempts to reopen with vaudeville acts proved erratic and unsuccessful—and remain largely undocumented.

14 | Scents and Sensibility

■ NOTHING IF NOT AROMATIC Baltimore's inner harbor—commercial, industrial, ungentrified—earned a reputation for its waterfront grit and the variety of its aromas. All were memorable, but for different reasons. Mencken, recalling the harbor smells he knew as a boy in Baltimore during

Smoke from various sources belches along Baltimore's waterfront in the 1940s

the 1880s and 1890s, compared the stench to that of New York's East River and pronounced that Baltimore's pungency was worse. "There was a difference," he wrote in *Happy Days* (1940). "The East River has swift tidal currents, whereas Baltimore's back basin has only the most lethargic. As a result, it began to acquire a powerful aroma every spring, and by August smelled like a billion polecats. The stench radiated all over downtown Baltimore." He went on to say that on Hollins Street, where he lived, the neighbors never detected that smell because "West Baltimore had a rival perfume of its own—the emanation from the Wilkins hair factory on Frederick Road. When a breeze from the southwest, bouncing its way over the Wilkins factory, reached Hollins Street, the effect was almost that of poison gas."

Through the 1940s, Baltimoreans aboard the excursion boats returning after a day down the Bay didn't need to see they were approaching the

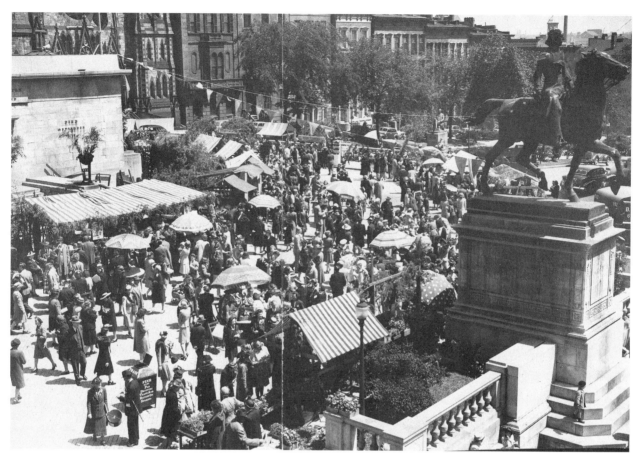

The Flower Mart, a twentieth-century spring tradition at Mount Vernon Place, is documented here in about 1945.

inner harbor, they could smell it. Much of what caught their noses emanated from Baltimore's giant fertilizer industry. Manufacturers whose plants were close to the harbor—Baugh, Miller, Dietrich, and Summers—regularly discharged the noxious odors of ground bone, manure, guano, and dried fish. Yet somewhere in there, delightful if one could catch it, were the heavenly aromas of cinnamon, sage, basil, ginger, marjoram, curry, rosemary—the heady and tantalizing spices wafting out of the windows of the McCormick building, which stood on Light Street near Conway in the harbor area.

For a time, at least, there also was the smoky scent of roasting chestnuts—"warm, roasted chestnuts may be obtained at most of the principal downtown street intersections," read a newspaper account in Mencken's day. "Some vendors sell several bushels each day." As late as December 1939, John Castina could be seen rolling his wagon (a child's coaster wagon) up to the busy southeast corner of Howard and Lexington Streets, in front of Read's Drug Store, and readying his wares for the day. In the wagon were a box of chestnuts and a crude, handmade brazier—actually, a tin pail with

glowing charcoal in it and a pan that fit more or less over the top. John would drop a handful of chestnuts onto the pan and in seconds they were roasting and popping, sending their aroma wafting into the chilled, snowy air. "Roast chestnuts, roast chestnuts," John called out, "ten cents! Get 'em while they're hot!" At the time, only three such stands still operated. Besides John's, there was one at Fayette Street and Park Avenue and another at St. Paul and Fayette Streets. The aroma of roasting chestnuts made for effective advertising, and John stayed busy most Saturday mornings. With each sale went a small guarantee. "Not a burned one in the bunch."

■ OVERHEARD IN THE CITY It's not just that Baltimore looked different before its gilded renaissance, it sounded different, too. There were distinct noises—voices and clangings and whistles and roars—associated with that long-ago commerce and industry. The streets were filled with the cries of newsboys—("*HeyGetchaSunNews!*")—and, within an hour of a major news event, shouts like "EXTRA! EXTRA! Louis KO's Schmeling in first round!" rang out. The air brakes of streetcars gave off a *whoosh-whoosh,* and the motorman's busy heel beat out the incessant ring-ring-ring of the bell. At Howard and Lexington Streets, vendors shouted "Shopping bag, three cents," and down the streets of row house neighborhoods the A-rabers called through cupped hands, *"Waldeemelonlopescaw"* (watermelons, cantaloupes, corn).

All day and night downtown, one heard the deep whistles of the ship traffic in the harbor below Pratt Street; the sonorous blasts of the banana boats of the great White Fleet; the *beep-beeps* of the excursion boats returning from beaches farther along the Bay. But the overpowering sound that truly evokes Baltimore's past is the *chuff chuffing* of the trains and the lonely wail of their whistles echoing up the Jones Falls Valley. On hot, still August nights, when sleep would not come, sitting on front porches or back steps in the small-town Baltimore of another time, one could always hear the railroads—the Pennsylvania, the B&O, the Northern Central, the WB&A, the Western Maryland. All were on the move constantly, and the sounds of their labor were never far from you.

■ DINING OUT ON THE HONOR SYSTEM There were no "restaurant critics" in the 1940s—that all-powerful breed came into being later. But if there had been, and one of them had chosen to critique the somewhat inelegant and nondescript food and shirt-sleeve ambiance of the popular Royal Quick Lunchroom in the Arcade (leading off Guilford Avenue, through the Hearst Tower Building, to Baltimore Street), here is how the review might have read:

The Rice's Bakery delivery truck, heaped with aromatic bread and rolls, cakes and pies, was a familiar sight in the neighborhoods of small-town Baltimore. The uniformed driver went door-to-door offering sinfully delicious baked goods, all moist and fresh. A typical order might include a loaf of Vienna bread, a dozen Parker House rolls, a cherry pie, and a Louisiana ring cake. Rice's Bakery opened in 1877, when Duane Rice bought a bakery on Gay Street. He did so well that he asked his brother, Lewis, to join him. Lewis had two sons, Duane and Emory Sr. "Before we had trucks," recalled Emory Rice Jr., who was in the bakery's management for many years, "we delivered door-to-door with horse and wagon! And it was a personal-service business. Each of our drivers would chat with each housewife customer. He'd tell her our specials, she'd tell him what, by way of bread and rolls and cakes and pies, she had in mind that day. The big favorite, year after year after year, was Rice's Louisiana ring cake."

The original recipe for Rice's Louisiana ring cake, so popular with Baltimoreans, is lost somewhere in the shifting, tangled stories that make up the history of Rice's Bakery. Although there were variations in toppings, all versions agree that it had a pound cake texture with an orange and almond flavor. Mr. Rice said, "However we made them, we sold a lot of them!"

"Funny thing about the Royal Quick lunchroom in the Tower Building arcade—there are no tables in the place. Not only are there no tables, there are no waitresses and nobody to write your check. Matter of fact there is no check. What there is, is a sea of chairs and a food-service counter along the side wall. The chairs are of oak and have one arm, which is slender at the back of the chair, spreading out towards the front to form a roomy resting place for the patron's lunch. All of which my companion and I knew beforehand, so we were not surprised to find ourselves at this particular noontime in 1949 as part of a line of men (there are no women in the place) ordering from the menu pasted on the wall above. When our turn came I ordered homemade vegetable soup (15 cents) and franks and beans (35 cents). The soup was hot and so thick it was almost a stew, and the franks were fat and spicy. My companion opted for the crab soup (20 cents) and the two hamburgers with mashed potatoes (40 cents). The soup had huge lumps of crabmeat, the hamburgers were large, medium to rare, and delicious. To complete our lunch, each of us took a homemade cruller (5 cents) and coffee (5 cents).

"Now about that check. When we finished our meal no waitress showed with a check and we were not handed a check on entering. The honor system prevails at the Royal Quick. When the customer gets to the register he tells the cashier what he had to eat, as best as he can remember it, and then pays—but only for the meal, there are no tips. All together, lunch for two, came to $1.30. But it was neither the food nor the prices that endeared us to the Royal Quick: It was the honor system. Nice to be trusted."

■ OUT GREENSPRING VALLEY ROAD FOR ICE CREAM For forty years it was a way of life: On hot August nights and fine Sunday afternoons in spring and fall, Baltimoreans drove out Greenspring Valley Road to Emerson's Farm to get some ice cream. Hundreds crowded into the tiny store by the silo and the pond to buy ice cream, buttermilk, chocolate milk, and cottage cheese. "We opened the store at nine in the morning and didn't close until eleven at night, seven days a week," recalled Lillian Jenney, who worked behind the counter in the early 1950s. "We had so many customers it took six and seven in help to wait on them all. We needed two men full-time just to park cars."

"Everything we made was sold right on the farm," said Linwood Tinsley, a herdsman on Emerson's Farm. "The flavor of our products was better because we didn't pasteurize. Nobody's ice cream and milk tasted nearly so good as ours did." Emerson's Farm closed in 1953, giving way for a time to

Emerson's Farm—at least part of the sprawling complex is pictured here—was considered a Shangri-la by ice-cream lovers for more than forty summers.

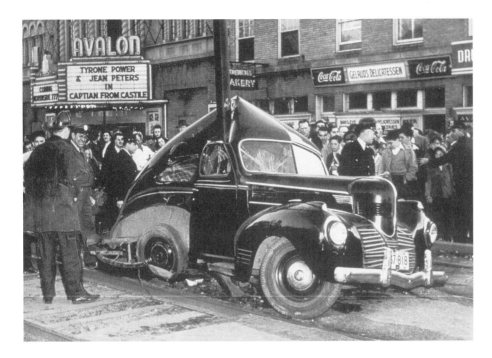

Oops. A Dodge coupe sits, wrapped around a light pole on Park Heights Avenue in 1947, the accident possibly the work of a streetcar. With the postwar increase in automobiles, people began to view streetcars as a nuisance to the free movement of autos. Meanwhile, at the Avalon, Tyrone Power and Jean Peters star in a story of Cortez's conquest of the Aztecs.

An umbrella-equipped "group of patient would-be riders" wait for a bus at Thirty-third Street and Harford Road in December 1952. The bus, the paper reported, was behind schedule "as usual." The story continued, "On snowy days and cold, windy days, the faltering transit service seems worse than on clear, warm days—or so say the riders. Scenes like the one above were duplicated all over the city."

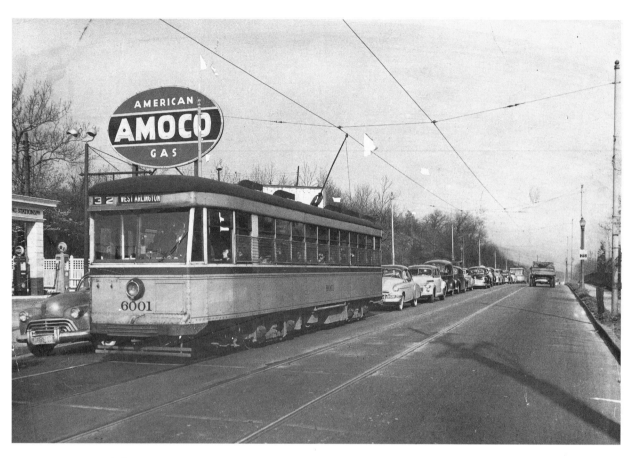

During evening rush hour, as cap-
tured for the newspaper, the prob-
lem is obviously the streetcar.

Don Swann's Hilltop Drive-In Theater. "After the farm closed," reported Mrs. James Fowke, who lived in the house that was once the calf nursery, "people were still driving out here, looking for Emerson's Farm, wanting to buy ice cream. They couldn't get over the idea that Emerson's Farm had closed."

■ SIEGFRIED WEISBERGER'S VERY OWN UNIVERSITY For more than half a century, at the Peabody Book Shop at 913 North Charles Street one could find a colorful mix of people who were comfortable in its contrived, campus-bistro ambiance. It was a dimly lighted, smoky place overflowing with dusty old books. Patrons sat by the downstairs fireplace on cold winter nights and talked, talked, talked. In their day, H. L. Mencken and Gerald Johnson were both seen imbibing there. Hopkins professors, students from Peabody and the Maryland Institute, reporters, and scruffy, would-be F. Scott Fitzgeralds all crowded in with the Valley set, in town to do some slumming and see life on the margins.

"Dantini the Magnificent" often entertained there. He was Vincent Cierkes in real life, a violinist and prestidigitator who performed in a tux and tennis shoes, making ladies' scarves disappear.

Siegfried Weisberger, a self-educated Austrian bibliophile, had opened the store in 1923. He had been a cook, salesman, butcher, clerk, and seaman, and along the way he got to love books. Legend holds that he had been rejected by the University of California and thus given up any academic hopes. So, with only six years of formal schooling, he set up his own university—the Peabody Book Shop and Beer Stube.

Students who *had* made it into universities flocked to Weisberger's university-in-the-cellar, compelled to explore the life of the mind—and the bar in the rear. What better place for serious discussions about the problems of the world than a small table (scarred with the carved initials of many previous philosophers) down in Weisberger's cellar, with one's hand around a glass of beer?

■ WHALE STEAK AND GREEN TURTLE SOUP For half a century, Miller Brothers Restaurant, on the south side of Fayette Street between Hanover and Liberty, was one of Baltimore's most enduring institutions, known the world over as "the Place to Eat." It opened in 1912, when John and Fred Miller took over the tiny Schemer's Restaurant and added to it, room by room, until it seated four hundred and fifty people, all on one floor. "I love to talk about the old place," said Elmer "Bud" Klunk, who was the maître d' from 1945 until the restaurant closed. "I can still see the streetcars rattling by outside on Fayette Street. And what a menu we had! We

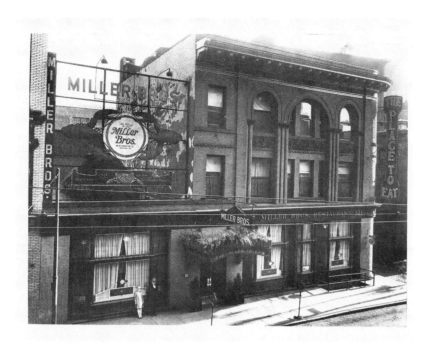

Miller Brothers Restaurant, 119 West Fayette Street, was demonstrably "The Place to Eat." The cover of its menu only hinted at the glories within.

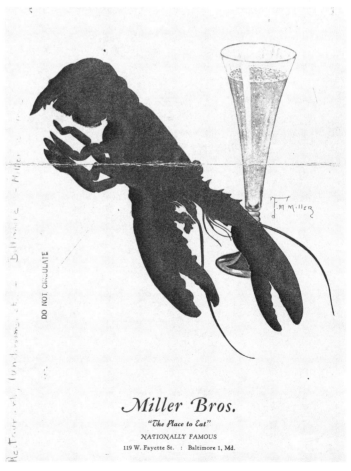

DO NOT CIRCULATE

Miller Bros.

"The Place to Eat"

NATIONALLY FAMOUS

119 W. Fayette St. : Baltimore 1, Md.

There were several political bosses *"and bosslets,"* according to reporter *Thomas O'Neill and* Sun *cartoonist Richard Yardley in March 1947. Yardley depicted the hall of a typical ward Democratic club—cheap suits, cigars, free-flowing beer, spittoons, a racing form, and dubious deals—and credited the party's leaders in the six council districts in the city with wielding bossy power: Gilbert A. Dailey, Ambrose J. Kennedy, James H. "Jack" Pollack, William "Willie" Curran, Patrick F. O'Malley, and Joseph M. Wyatt, each of them entitled to a derby and smoking cigar. Pollack had fought his way up from the streets of East Baltimore (literally, he was a boxer) and until the late 1940s was in supreme command of the fourth district, but he probably would not have been nearly so well known if Yardley had not consistently drawn him wearing a derby labeled "1/6 Boss." "Among the busiest people to be found at this time of year, when the calendar shows a primary election only three weeks away," began Thomas O'Neill, "are the members of that disparate crew who operate the city's political organizations. They puzzle and scheme, set up candidates and knock them down, promise and exact, all to the end that they may be in on the good things that flow from a measure of influence."*

Politics in midcentury Baltimore owed much to the example of the earlier Kelly-Mahon machine, which was fueled not so much by intimidation as by the milk of human kindness. Frank Kelly had turned the distribution of Christmas bas-

kets and scuttles of coal into big (and vote-getting) business. Ruling Baltimore from his modest home at 1101 West Saratoga Street, Kelly could neither read nor write. "But," he would say, "I know people who can." It was whispered that if there's a ton of coal in somebody's cellar tonight and a wreath on a coffin in somebody's parlor, Frank Kelly put it there. He shared his realm with John J. "Sonny" Mahon, a legendary Irish neighborhood tough kid who grew up throwing bricks at rival gangs in West Baltimore. "It seems to me," Mahon said in later years, "that I was always fighting." He was notorious for rounding up voters on election day, most of whom he had voting two and three times. In the hot months he ruled Baltimore from his "summer city hall," the front porch of his home at 7701 Seven Mile Lane; in winter, from his "Amen corner" in the lobby of the Rennert Hotel. "Politics in them days was rough," he would say, "and I was as rough as they made 'em."

Willie "Machiavelli" Curran waited in the wings and had inherited the machine in the 1930s. Curran was of a different breed. A lawyer and a schoolteacher, he wore pince-nez glasses and laced his speech with classical references. His shock troops (as he called those who helped scare up votes) exceeded four thousand of the faithful. Asked how big his organization really was, he responded with choirboy innocence: "I really wouldn't know." He could be the most gracious of men, but he played hard and always to win. Once he waited outside a meeting room for a caucus to end. A lieutenant finally emerged, according to the story, and reported, "We won." Unmoved, Curran asked, "What was the vote?" The answer came, "Seventy two to twelve." Curran's eyes narrowed behind his pince-nez glasses. "Get me the names of the twelve." When he died, in 1951, judges in the courthouses stopped all proceedings to pay tribute to him.

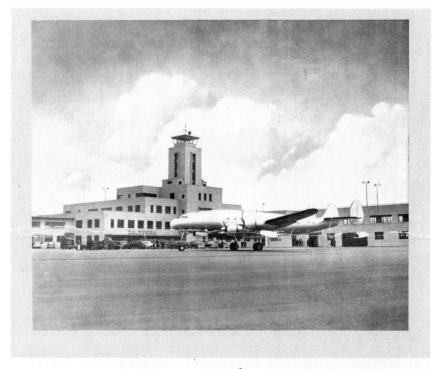

Friendship International Airport

served whale steak and green turtle soup. We'd bring in a two-hundred-and-fifty-pound turtle and butcher it right on the premises. We used to get an elk from Wisconsin and butcher it and display it outside on Fayette Street. It really stopped the crowds. Buffalo steak was another favorite. John Miller used to say, 'At Miller Brothers there are no frills, no music. The value is on the plate.' It sure was."

Peter Lorre, Basil Rathbone, Milton Berle—all the stars who used to perform on the Hippodrome stage around the corner—came into Miller Brothers when they were in town. During the racing season, FBI director J. Edgar Hoover was a regular.

Miller Brothers specialized in Thanksgiving dinners. While most Baltimoreans concentrated on the Toytown Parade and the City-Poly or Loyola–Calvert Hall football classics, for Klunk and others in Miller Brothers' employ, Thanksgiving meant the Miller Brothers turkey dinner lottery. "On the morning of every Thanksgiving day, the one hundred or so employees set up a lottery. A dollar got you into the action. You bet the number of turkey dinners the house would serve before the kitchen closed that day at 8:00 P.M." Every Thanksgiving morning Klunk put a dollar into the Miller Brothers lottery and, drawing on his experience, picked a number he

thought could win. "Through the years I played numbers close to 1,200. I played 1,197 and 1,240 and 1,219. But I never won. Never. I worked there twenty-one years and I never won!

"When the wrecking ball hit the place," Bud said sadly, "I felt as if I had lost a home and an old friend. Tearing down Miller Brothers was a bad mistake. It's one that many in Baltimore never got over."

■ "MR. FORTUNE" AND IAN ROSS McFARLANE By the 1940s, radio station WCBM had established a reputation for being different and always good for surprises. The origin of the station also was unusual. In 1924, a musician named Ed Anzmann was playing in a band called "Harry Dobe's Dominoes" at the Chateau Hotel on North Avenue and Charles Street. One day, according to radio archivist Tom O'Connor, Anzmann went to his boss and said he'd heard there was some secondhand radio transmitting equipment for sale in town. He thought it would be a good idea to buy the stuff and put the band on the air weekend nights (WCAO, WBAL, and WFBR were already broadcasting). Anzmann followed through, and his pet project became WCBM.

With its show-business roots, WCBM gloried in gags, characters, and promotions designed to "get 'em in the door." For a quarter hour, beginning at 9:45 A.M., the station broadcast *Dialing for Dollars*, with Homer Todd as the host, "Mr. Fortune" (later, Stu Kerr and Jack Wells took over), and jackpots building up to sums as fabulous as a hundred and fifty dollars. No housewife in her right mind left her radio for those fifteen minutes. *Dialing for Dollars* was probably the most popular radio show ever broadcast in Baltimore—so popular that it was syndicated in cities throughout America.

In these same years, the station did what was considered a strange thing (even for a station known for doing strange things)—it broadcast a "conversation" show on radio, a Baltimore first. The host was a former war correspondent who wore an eye-patch, Ian Ross McFarlane. Every night at 11:00 he and cohost Charley Roeder talked to each other and a guest. The show was called *Ian and I*.

Meanwhile, the morning drive, radio's most listened-to time slot, was owned by Lee Case of WCBM. Everybody in Baltimore, including morning radio men on rival stations, saluted him as "the Morning Mayor." And covering real politics, a young man named Eddie Fenton rose to the head of his class as one of the city's best-known and worst-feared radio news voices on WCBM. The formidable Fenton weighed two hundred and fifty pounds, had high blood pressure and phlebitis, wore a glass eye, drank hard, ate heavily, and never drove a car. Yet his signature statement, "For WCBM,

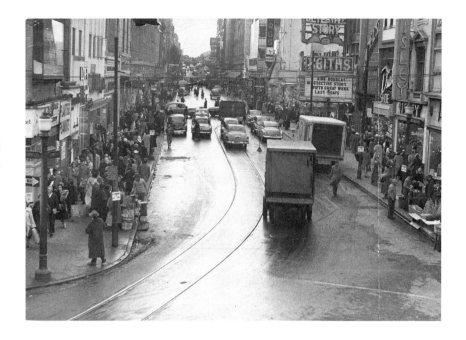

Looking west on Lexington Street from Liberty during the holiday rush in December 1951, one could see that Lexington between Howard and Liberty Streets was one of the busiest and gustiest thoroughfares in Baltimore. It was a street of small shops, the most memorable of which were the Planter's Peanut Store ("Mr. Peanut" himself handed out hot fresh samples to passersby), Ritz Camera, Maron's Candy, and Huyler's, a fountain shop very big with the Saturday-morning shoppers. The street seemed much too narrow to serve a modern city. Shoppers crowded its sidewalks and spilled out into the street, automobiles were bumper to bumper, and, as if forward motion wasn't difficult enough, the No. 4 and No. 14 streetcars bullied their way through, clanging all the way. To this mix, add street vendors who sold roasted chestnuts, newspapers, and shopping bags. One vendor of enduring charm, out of place in the rough-and-tumble, sold lavender.

this is Eddie Fenton, from the State House," made WCBM the station most listened to out of Annapolis during the General Assembly.

■ REFRIGERATED AT THE OLD LEXINGTON MARKET At about 4:30 in the morning of Friday, March 25, 1949, Naomi Mervis Egorin, whose family operated the Mary Mervis deli stall in the Lexington Market, was awakened by a phone call about her husband. "Naomi," her brother-in-law asked, "where's Ted?" "Gone to the market to open the stall, of course," Mrs. Egorin responded, "Why?" "Naomi," the caller said, "there is no market. It burned down this morning."

Indeed it had, in a spectacular six-alarm fire that called for twenty-four engines, two high-pressure units, a water tower, and 165 firefighters. The fire burned through the night and into the morning. After the flames had died down, the smoke had cleared, and the rubble had been swept away, that part of the market which had been in operation since 1803, between Eutaw and Paca Streets and along Lexington, lay a smoldering ruin. "We rushed over to the market," Mrs. Egorin said. "We found a complete disaster. The roof had caved in. But we found a vacant stall over on Greene Street, in that part of the market that had not burned down, and we were back in business over there. We were lucky." The rest of the Lexington Market was not, and it took almost a year and a half to build the new one.

"The old market," Mrs. Egorin, recalled, "was sprawled all over the place. There were stalls up and down Lexington Street, all the way west to the six hundred block. We worked weekdays in the stall from early in the

morning till early in the evening. On Saturday nights we stayed open to nine thirty to catch the crowds coming out of the Hippodrome. And it was *cold!* The 'walls' were only the wooden backs of the stalls themselves, and the entrances and exits were the spaces between the stalls. There were no doors. It was supposed to be an indoor market, it *was* under roof—but it was always so cold we felt we were *outdoors!* It was *so* cold we used to wear a sweater as pants. We'd put our legs through the sleeves, and pulled the rest of the sweater up around our stomachs. But it didn't help much. Even at home, when I thought about going to work at the market, my feet got cold."

■ THE RED BALL SPECIAL Horn and Horn was an improbable restaurant, conference center, and all-night hangout at 304 East Baltimore Street, and it was, as Times Square was to Old Broadway, the street's soul. Not only was Horn and Horn among the oldest restaurants in Baltimore (dating back to well before the turn of the century) and among the few restaurants to stay open all night long, but it was also the only restaurant where Baltimore's rich and poor, winners and losers, judges and pimps, merchant princes and number writers, fashion executives and exotic dancers, mayors and governors and city hall types alike all sat down next to one another comfortably, sharing time and space and conversation. The king of the place was an aged and dexterous counterman with lightning-fast hands and an astonishing memory, Kelly Raines, who never forgot your name and your face and the way you liked your eggs. It was this special mix of urban characters and urban ideas; of varied and sometimes outrageous dress and manners and conversation; of chicken biscuits and the famous Red Ball special (corned beef, cabbage, potato, coffee); of a long, complicated order given to a waitress who never wrote down a word but delivered it, in perfect order, to your table—it was all of this going on at the same time that made Horn and Horn an institution and, in turn, made downtown East Baltimore Street an institution as well.

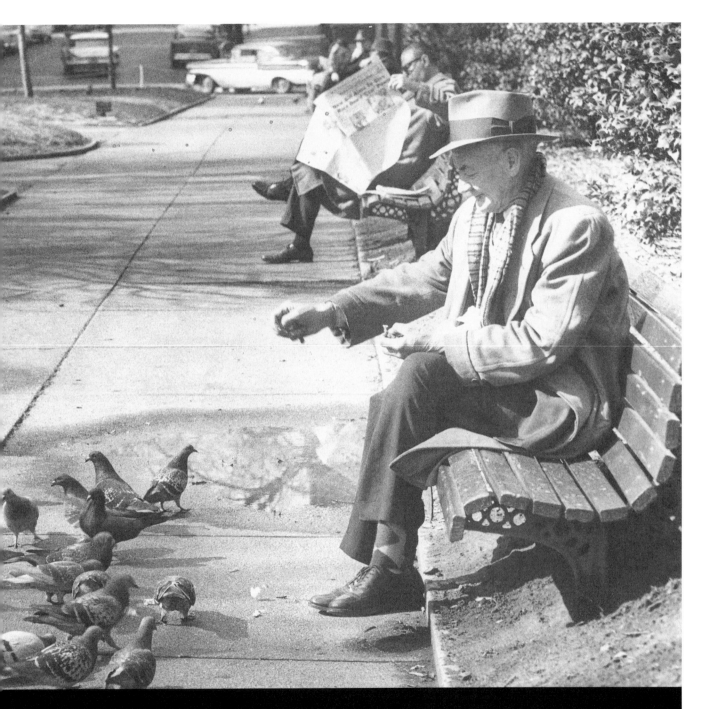

Part III MEMORIES

Malcolm's House and Garden Store,
524 North Charles Street, mailed
out this catalog in 1945.

VOL. IX-1945-1946

FOR INSTANCE

THE BOOK OF FASCINATING IDEAS

MALCOLM'S
HOUSE AND GARDEN STORE
524 N. CHARLES ST., BALTIMORE 1, MD.

15 | Simple pleasures

■ **THE STORES ON CHARLES STREET,**
THE LURES OF HOWARD STREET The Charles Street of small-town Baltimore seemed to be unchangeable. The stores lining the street were simply always there. Sylvia Wilner, at 311 North Charles, was one of the most prominent names in women's fashions, sharing an enviable reputation with Peck and Peck (at 337) and Maison Annette (at 343). More popularly priced women's fashion stores on Charles Street included Gaxton's (212), Lane Bryant (224), and furriers Auman and Werkmeister (301). Malcolm's House and Garden Shop at 524 carried anything one could want in the way of birdbaths and lawn furniture.

Hopper, McGaw, at 344, had been on Charles Street since 1880, supplying Baltimoreans with gourmet tastes for Bombay duck, Maryland rye, pheasant, goose, English jams, and canned rattlesnake. For many years in front of the door stood a wooden Indian. Clad in a green dress with a yellow medallion at her forehead and a hat of sweeping red feathers, she was supposed to be Pocahontas. When Hopper, McGaw went to auction in 1957, the new owner paid $430 for Pocahontas alone. As part of somebody's mischievous prank, she later made an appearance in 1959, at a dinner at the University Club, on Charles and Madison.

The Remington Book Store, across the street at 437, was a leading source of reading material.

Louis Mazor, at 345, stocked upscale furniture.

Lohmeyer, at 315 (it had merged with Payne and Merrill), sold gentlemen's clothes.

Fetting, at 314, was one of the better-known Baltimore jewelry stores.

The Metropolitan Savings Bank stood on the southwest corner at Saratoga.

Read's Drug Store was at Fayette and Charles.

O'Neill's Department Store, in several locations, wrapped around the southwest corner of Charles and Lexington Streets.

The Hub furniture store occupied the northeast corner of Baltimore and Charles.

In 1858, Moses Hutzler opened his little retail store on Howard Street and Clay. Over the next fifty years, other stores, both small and large, joined him, opening up and down Howard Street. The larger and most well-remembered Baltimore department stores included Stewart's, the May Company (later, Hecht-May), and Hochschild, Kohn. From the 1930s through the 1950s, Howard Street, from Centre to Baltimore Streets, provided the backdrop for Baltimore's busiest single retail area. Heading south at the 400 block, you see the Stanley Theater (later the Stanton) on your right—the once-famous red-velvet, gilt-and-rococo movie palace—and, in the same glance, the Mayfair Theater. On your left, to the east, you cruise by Grand Rapids Furniture and probably the most famous music store in Baltimore, Fred Walker's.

The street comes alive now as you move into the thickening traffic of the 300 block. On the right are Wyman Shoe and Hess Shoe, two fine old Baltimore names in shoe retailing, then another shop in the Oriole Cafeteria chain, and Schleisner's, one of the street's and the era's most prestigious and best-known women's fashion stores. On your left sits the Pollack-Blum furniture store.

Now you find yourself in the 200 block: to the left are Stieff Silver, Mano Swartz (furs), Jacobie's jewelry—and Awrach and Perl, luncheon headquarters for teenagers shopping downtown. The signature lunch there is the hot corned beef on rye with a chocolate soda.

On the right, approaching Lexington Street, stand some of the major department stores—Hutzler's, Hochschild, Kohn, and the May Company; on the left, Stewart's Department Store and Read's Drug Store.

Moving along toward Fayette, you see Thompson's, which, like Nates and Leon's, was one of Baltimore's leading all-night restaurants, a place you could count on getting breakfast at 5:00 in the morning.

■ CHRISTMAS DOWNTOWN In the Lexington Street windows of the Hochschild, Kohn Department Store, during every Christmas season in the 1950s, there was a popular and much-beloved (although mechanical) life-sized "Laughing Santa Claus." He belted out his "Ho, Ho, Ho!" with

The bustling Charles Street shopping district, viewed here looking north from Saratoga Street in April 1949, after the city had restored two-way traffic.

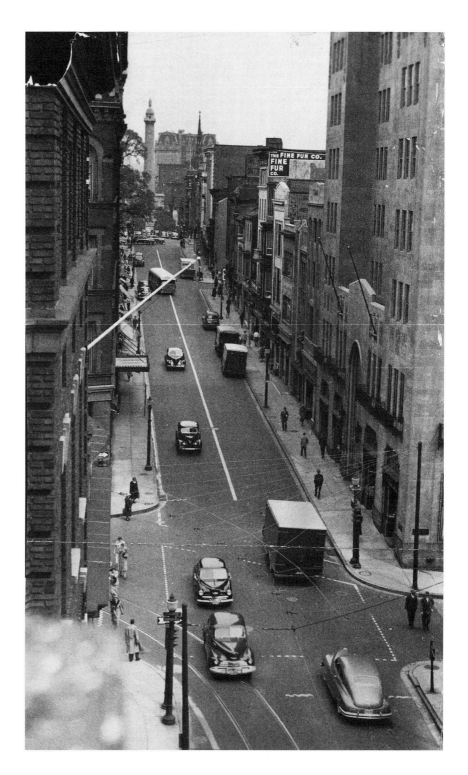

At the Tall Cedars of Lebanon benefit circus at Memorial Stadium in June 1950, Ann Roberts and Barbara Ann Burns enjoy an exciting (if a bit embarrassing) experience as two clowns join them in their seats.

Children pledge allegiance to the flag at the Carroll Mansion, November 1950.

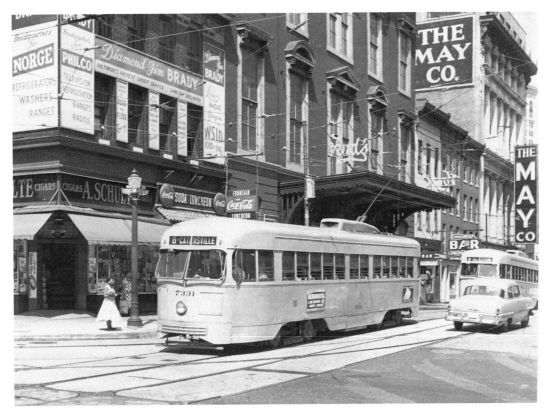

The No. 8 streetcar, headed for Catonsville on Fayette Street, passes the May Company, Ford's Theater, and an assortment of small shops in the early 1950s.

"The charm and beauty of old Baltimore will live again Tuesday," read a newspaper report from September 6, 1953, "when the May Co. opens its beautiful new restaurant, the Courtyard." The report went on to explain that the decor of the new restaurant would recreate "the atmosphere of old Aisquith Street and Orleans Street at the turn of the century."

The Courtyard

the MAY company

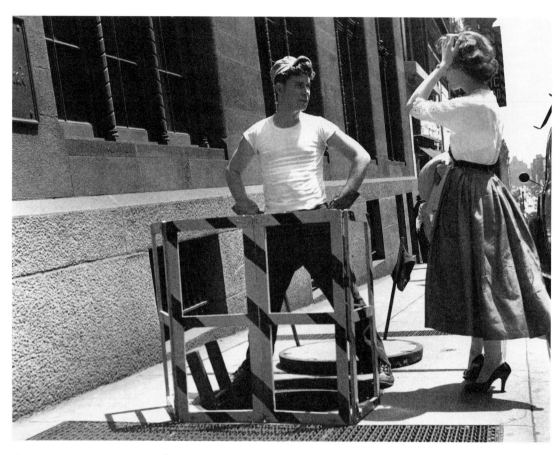

A momentary attraction on a delightful day in downtown Baltimore in the early 1950s. Courtesy of James P. Gallagher.

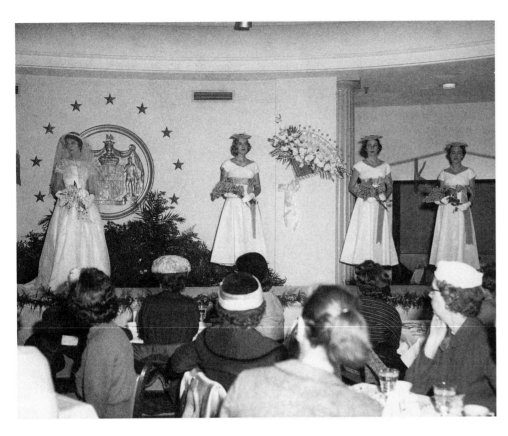

Above: *In the mid-1950s Hutzler's staged wedding fashion shows in the Tea Room.*

Right: *Samuel Kirk and Son, the nation's oldest silversmiths, opened for business on Baltimore Street in 1815 and in 1828 began producing distinguished silverware using the technique known in Europe as repoussé (meaning "raised high in relief") for the American markets. According to longtime employee Mil-ton Finch, "Kirk brought his special genius to design. He did flowers, figures, buildings, castles out of his imagination. Some people look at one of them and ask, 'What castle is that?' Well, there was no such cas-tle. It was all in Mr. Kirk's mind." Over the years, in addition to the store in Stewart's downtown, Kirk and Son established retail outlets in Edmondson Village, Towson Plaza, and Reisterstown Plaza.*

Mayor Tommy D'Alesandro Jr., also known as "Big Tommy," a patron of downtown revitalization, here strikes a Napoleonic pose. He won his first election in 1926 and thereafter ran up a remarkable streak, winning elections to become city councilman, delegate to Maryland General Assembly, congressman, and, in 1947, city mayor.

Nine years before he became mayor, his Democratic primary run to unseat the incumbent congressman, Vincent Palmisano, illustrated the texture of political life in Little Italy. "It was wild," Tommy recalled. "I went house to house. Whenever I saw a Palmisano sign in one window, I went inside and put a D'Alesandro sign in the other."

"He sent me into St. Leo's to pray to St. Anthony," said his sister, Jessica Granese. Prayer didn't hurt. That evening the Sun named him the unofficial winner, but by only forty-eight votes out of more than 25,000 cast. The tally seesawed thereafter, but the D'Alesandro forces could not contain themselves. As election officials continued their work, D'Alesandro's backers hoisted Tommy on their shoulders, departed the Emerson Hotel, and went on a victory march through downtown Baltimore to Little Italy—to taste, figuratively but also literally, the wine of victory. The next day, Tommy learned that his opponent led by one vote. D'Alesandro supporters continued to ignore the confusion. "There was dancing in the streets of Little Italy," newspapers reported. When the official count came in, Palmisano had won by seven votes. D'Alesandro petitioned for a recount. Three days later, yet another canvass gave the election to D'Alesandro—by fifty-eight votes. During the continued celebration in Little Italy (then in its sixth day) Tommy talked to reporters. "I think," he said, "I'll withdraw my request for a recount."

Even while serving in political office, D'Alesandro never really left the neighborhood. In the third story of his little row house at Fawn Street and Albemarle Street in the heart of Little Italy, he added lines to accommodate nine telephones. Every morning of his tenure as mayor, a chauffeured limousine called to take him to City Hall, and every night it brought him home to Fawn Street. He remained a neighbor and a family man. Every Sunday he went to mass at St. Leo's, the neighborhood church where he had been a choir boy and where he and his wife had been married. For his commitment to the neighborhood, voters in Little Italy gave him their ultimate gifts of loyalty and respect—despite their differences.

belly shaking, head rolling from side to side, and eyes glancing up and down. The electric-powered Santa became a sort of institution—and much later, as a memory, he served as a small and merry reminder of the running festival in downtown Baltimore during the holiday season, a very special part of which was the mechanized fairyland-come-to-life in the Christmas windows of Hochschild, Kohn.

Hochschild, Kohn is another immigrant's rags-to-riches story. Max Hochschild came to America in steerage, and by the late 1880s he owned a small store on Gay Street, which he opened in the morning and swept in the evening. Later, he pooled resources with Benno and Louis Kohn, and in 1897 Hochschild, Kohn moved to Howard and Lexington Streets. It prospered as a family business because of its attention to personal service—it offered generous credit, easy exchanges, and cheap deliveries (in black trucks sporting the Hochschild, Kohn signature centered within a yellow oval). After the war, Hochschild, Kohn opened the first suburban department stores, in Edmondson Village and at York and Belvedere; the company was the first to offer such innovations as an automatic telephone switchboard, revolving doors, a tea room, and a soda fountain. Unique among Baltimore's department stores, Hochschild, Kohn also maintained a major broadcast advertising presence. Rosa (Mrs. Martin) Kohn wrote the store's famous jingle, so often heard over WBAL as performed by disc jockey Bill Herson:

> When you buy, better try Hochschild, Kohn
> That's the store Baltimore calls its own.

But most Baltimoreans remember Hochschild, Kohn for its Christmas windows. A light snow was falling on downtown Baltimore the day before Christmas of 1953. In front of Hochschild, Kohn's windows, crowds stared in amazement at the Christmas displays within. A child, too small to see the window show, tugged at his mother's sleeve.

"What's it all about, Mommie?" he asked.

"Well," a parent happy to explain began, "it's like a play. It's called 'The Littlest Angel.'" And she lifted him up. What the child saw was an extravaganza of moving lights and mechanical wizardry. Angels floated about, flapping their wings, waving their wands, shaking their heads "yes" and "no" and carrying gift boxes, singing in unison: *"Hark the herald angels sing."*

"But what's 'The Littlest Angel?'" the child persisted, the way children persist at Christmas. The display ran in sequence through all eight windows of Hochschild's along Howard Street. Stewart's, the May Company, Hutzler's—all the department stores in the Howard and Lexington Streets area mounted similar display windows. It was street theater behind glass.

"Well," the mother explained as she moved along, window to window, struggling through the crowd. "Each of the angels is bringing a gift to the head angel. See? This one is a jewel box."

"But the head angel is saying, 'No,' right, Mom?"

"And here's another angel bringing a gift. It looks like a tiny sled. The head angel doesn't want that either."

"What's that little angel doing?"

"He's trying to get through all the bigger angels to bring his gift."

"What is it?"

"I can't see. It's a scroll with a word on it."

"Look, Mommy, the littlest angel finally got to the head angel. He's handing her his gift. She's taking his! I wonder what it is?"

"He's holding up the scroll," the mother exclaimed. "It says 'joy.' The littlest angel gave the gift of joy and it was accepted!"

The child took in the scene thoughtfully: the softly falling snow, the shouts of the street vendors, the Salvation Army ladies ringing their bells, the Santas on every corner huddled by their oil-drum fires, the magic of Baltimore's old Howard and Lexington Christmas. Then, he said wistfully, "The gift of joy. That's the best gift."

A child's Howard and Lexington Christmas—the gift of Hochschild, Kohn.

16 | True Sports

■ BLACK BASEBALL: "YOU STARTED, YOU FINISHED."

"ROMBY HURLS ELITES' OPENER" declared the sports page of the *Sun* on May 19, 1950. "The honor of hurling the Elite Giants' first game goes to Bob Romby on Sunday when the champions of the Negro American League meet the Philadelphia Stars."

Mention of that game stirred Bob Romby to reminisce about his days in black baseball in Baltimore. "I began with the Giants as a starting pitcher. We only had starting pitchers; you started, you finished. We played most of our games at Bugle Field, out on Edison Highway near Biddle. And we played good baseball! Henry Kimbro, the player-manager, was hitting .419, and Finney, .356, and Pee Wee Butts, .315. We even played against Satchel Paige. Satch threw everything—fastballs, curves, sinkers. He used to strike me out on three swings."

The ageless Paige may have humiliated Romby, but not first baseman

Fans watch the newly televised Friday-night fights at Mugs in Little Italy. Courtesy of Tom Scilipoti.

Hubert Simmons. "I remember one game," Simmons recalled, "we shelled him pretty good. I hit a single off of him myself."

We have to take the words of Romby, Simmons, and one-time owner Richard D. Powell for the firsthand story of the life and times of the Baltimore Elite Giants. Though Negro league baseball in Baltimore began with the Lord Hamiltons and the Orientals playing each other in South Baltimore as far back as 1874, few records document the earlier years and box scores did not show up in the daily paper until 1950.

Romby said he never went to see the major league Orioles play. When asked why, he said, "They make too many mistakes."

■ SPLINTER HEAVEN AT MUNICIPAL STADIUM It was a rip-roaring, bone-tingling "Gimme a 'C'!" in the late 1940s, booming like an erupting volcano out of the Municipal Stadium—true believers screaming their hearts out in a blood-curdling oath to their beloved Colts. As the popular history of the Colts makes so memorably clear, these true believers became a cult. Their home later became the multilevel Memorial Stadium on Thirty-third Street, complete with state-of-the-art escalators, twenty thousand covered seats, chairs with comfortable backs, lots of beer and hot dogs, and lithe and lovely cheerleaders.

It was not always thus. "In 1947," recalled Dr. Stanley Levy, who was

there in the early days, "the Colts played their first game in old Municipal Stadium, which is what the place used to be called. There were maybe twenty-seven thousand of us, sitting out in the open, often in the rain, sometimes in the snow. No cover of any kind. Primitive food service, and, to sit on, rough, wooden benches. We called it 'Splinter Heaven.'" This was the same Municipal Stadium where the Baltimore City Firemen played the Quantico Marines and where, in 1924, a record crowd of more than eighty thousand saw Army play Navy. Municipal Stadium's spartan accommodations did not discourage Levy and his merry band of true believers. While fledgling Colt players took bone-crushing blows on the field, fledgling Colt fans took splinters in their seats.

In 1951 the Colts were forfeited to the league and a still darkness settled over fans and stadium. But the true believers would never say die, and for two years, on the Sundays of the big games, many of them traveled to nearby cities where other teams in the league were playing. They marched in front of the stadiums along with the Colt Marching Band (which had not been forfeited with the team). They carried banners high, waving their demand, "Bring Back Our Colts." Their protests and their zeal paid off.

In 1953 the Colts returned to play at their new home, built on the site of the old Municipal Stadium. The place was known from 1949 on as

The Baltimore Zoo's new lion cubs—Amber, Catherine, and Cleopatra, dressed for the occasion—take a ride with Mrs. Ruth Watson and Mrs. Winifred Thompson in November 1951.

Memorial Stadium, a more commodious facility. Tiers went up, chair backs went up, escalators went up (and down); the beer and the cheerleaders appeared. And as every Baltimorean knows deep in his or her civic soul, the Baltimore Colts became the glory of their times. But, Dr. Levy said, "True believers will always feel the spirit of old Municipal Stadium in their hearts, and just a little further down, battle scars they suffered from the splinters up there in Splinter Heaven."

■ MR. BOH'S BEER No city loved its own beer more than Baltimore. National Bohemian beer can trace its origins through a tangled history back to the old Baltimore brewery known as Gottleib-Baurenschmidt-Straus ("GBS"), which flourished locally up until Prohibition began, in 1919. Beer then officially disappeared and did not reappear until Prohibition's repeal, in 1933. A few years earlier, around 1930 or 1931 (the deal was complicated and took a couple of years), undoubtedly anticipating repeal, Baltimore's Hoffberger family bought GBS and, along with it, the name and the product that got to be known as "National Boh."

Jerold C. "Jerry" Hoffberger, who later became chairman of the company, recalled that the firm brought on board brewmaster Karl Kreitler and hired Arthur Deute as president. "Deute," Hoffberger said, "was a marketing genius. It was he who created the one-eyed 'Mr. Boh' character that would become the star of so many television commercials and sing and dance his way into Baltimore history." But all of that was to come later.

National Bohemian started out as only one of half a dozen or so locally brewed beers competing for Baltimoreans' historic taste for suds. Local brewers had been at it since 1744, when breweries thrived in the Belair Road, West Baltimore, and Canton sections of town—early brands included Steil's, Bach's, Clagett's, and Staub's; later, Brehm's, Von der Horst, and Weissner's; and, still later, Free State, Gunther, American, and Arrow—names that would dominate the market into the 1940s. National had yet to make a serious challenge.

Fortuitously for Mr. Boh, the company was looking to expand the brand in the mid-1950s, just about the time that television, with its endless potential for entertaining and persuading, was exploding onto the media scene. "With imaginative guidance by the W. B. Doner advertising agency," Hoffberger said, "Mr. Boh became a fixture on Baltimore TV, largely through the presence of Chuck Thompson, Jim McManus, who later became 'Jim McKay' of ABC, and Bailey Goss." Boh also quickly jumped into sponsorship of the Baltimore Orioles, the Washington Senators, and the Baltimore Colts.

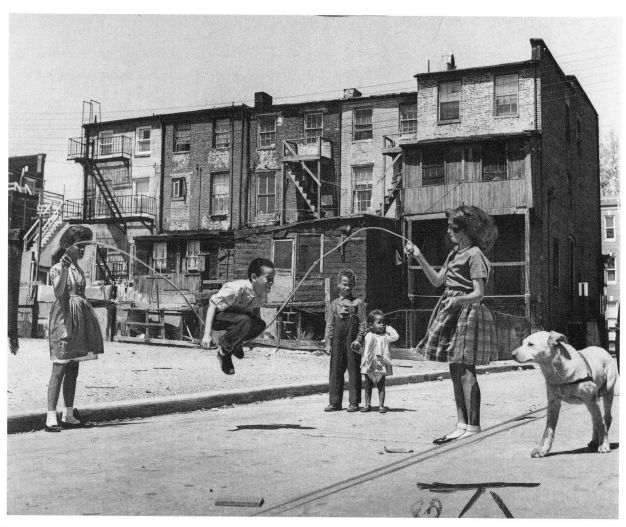

"Spring in the Inner City": A vacant lot across the street from their home, reportedly "flanked by crumbling dwellings," provides the daily playground for the children of Mrs. Willie Mae Bell on North Vincent Street.

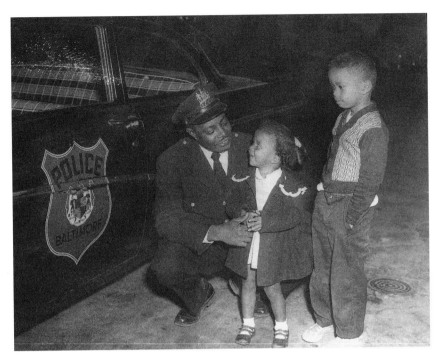

A police officer takes a moment to get to know two youngsters in a neighborhood on his beat. Courtesy of the I. Henry Phillips Collection.

The Dance Group of the Peabody Preparatory Program stage a May-pole celebration at Washington Place, May 11, 1955.

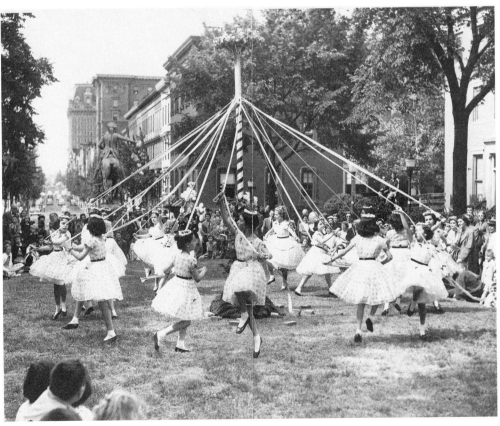

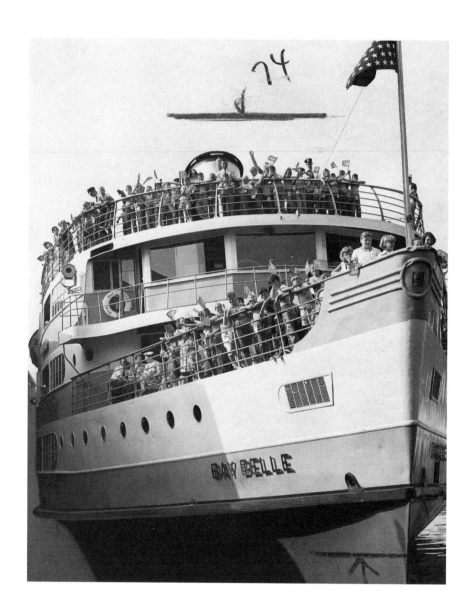

In the summer of 1956 the Retired Policeman's Association rented the Bay Belle and took orphans out for a day on the Bay.

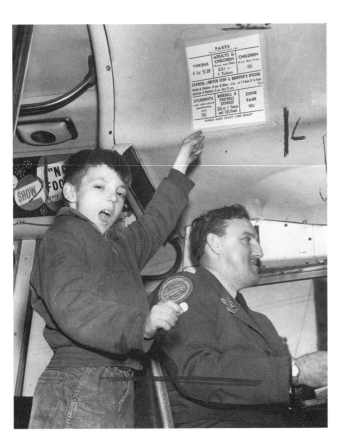

Young Clifton Birmingham voices approval of the fifteen-cent student fare while assisting bus driver Norbert Kecken. Fare for adults and children over twelve was twenty-five cents or one token. The sign reads, helpfully, "Tokens, 4 for $1.00."

Some children get help crossing the street in this vignette from a typical wage-earning neighborhood of the 1950s. Courtesy of James P. Gallagher.

Two employees of Stewart's Department Store on Howard Street demonstrate that, even in December 1960, window shoppers can browse in comfort thanks to the outdoor heating lamps Stewart's had installed.

In the cheap seats at—or near—Memorial Stadium, the clothing suggesting a football game. Courtesy of James P. Gallagher.

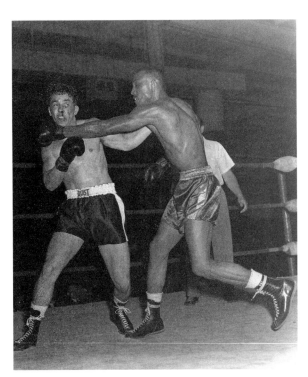

In this scene from local boxing in 1955, "Irish" Johnny Gilden takes a left hook from a fighter with considerably more reach. Courtesy of Tom Scilipoti.

In August 1957, the champs of the Maryland Amateur Baseball Association's sixteen-to-eighteen-year-old bracket, the Rosendale of Catonsville squad, hopped on a bus for the trip to Johnstown, Pennsylvania, and the All-America Amateur Tourney. Frank Svoboda, on the right, managed the team. The "pretty gal in the group," the News-Post *reported, "is Mary Callie Hill, 'Miss Baseball' for the past year."*

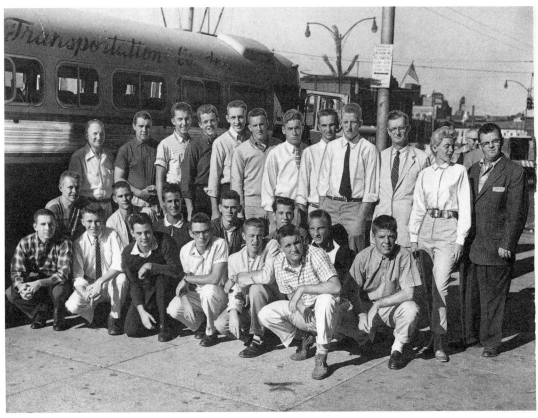

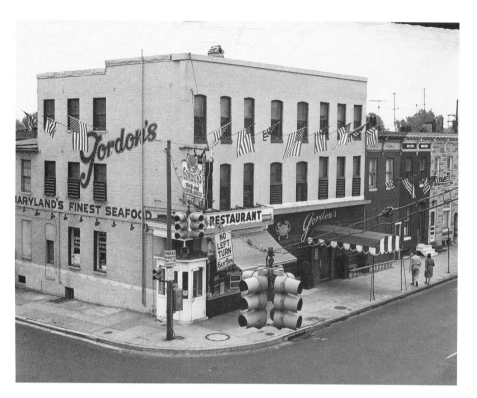

Gordon's, at Orleans Street and Patterson Park Avenue, took second to none among crab carry-out spots in the city and became the cause, on many hot and humid nights, of traffic tie-ups. One typical August night in 1955, cars were triple parked, horns were honking, crowds were churning, and the police were all over the place, trying to untangle the mess and get traffic moving. There was nothing unusual about this scene, it occurred almost every night in the hot weather months in Baltimore. What made this traffic jam different was that Traffic Commissioner Henry Barnes himself came to see just how bad it was. And it was bad.

The fracas was about crab cakes—Gordon's crab cakes. "Look, officer," drivers waiting in their cars explained to irate policemen, "we're waiting for our crab cakes. We always wait here for crab cakes. What are you trying to do, change things?" Frustrated, Commissioner Barnes asked a reporter, "What is there about crab cakes that make these people so crazy?"

After twelve years of it, Barnes left town. In his farewell speech, he took a parting shot: "The corner in front of Gordon's is the worst traffic mess in America. I don't get it." But Barnes was a Midwesterner who, so far as could be determined, had never eaten a crab cake in his life, much less one of Gordon's.

The Trevlac Pleasure Club takes to the road. "Some of the more than 1,000 Colt football fans who left today on a two-day excursion to New York to see the Colts try for their seventh straight victory in a clash with the Giants, are shown at Pennsylvania Station," the Sunday American *reported in November 1958. "The contingent will be followed by 3,600 more Baltimoreans who will leave early tomorrow morning, ready to cheer for the Colts in a crowd of about 70,000 at Yankee Stadium."*

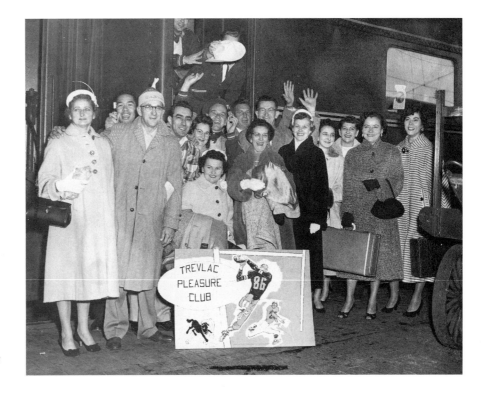

"Gimme a C!" The Colts cheerleaders rally fans at a standing-room-only game at Memorial Stadium.

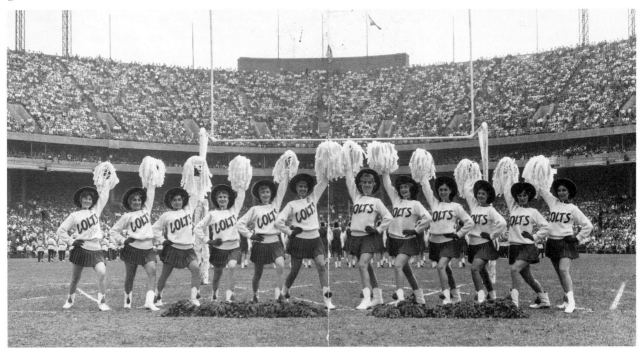

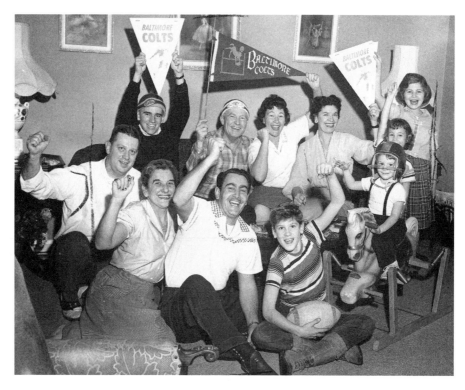

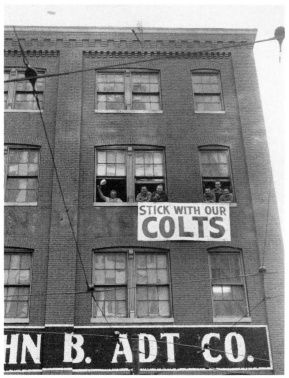

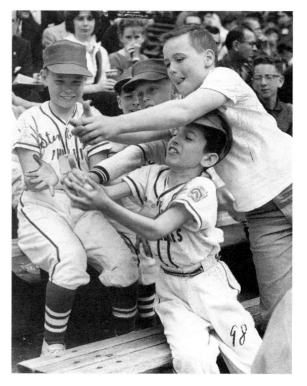

FACING PAGE:

Top: *Neighbors on Chinquapin Parkway, adults and children alike, celebrate a Colts victory over the Los Angeles Rams after watching the game on TV, December 1959.*

Bottom left: *Adt Company workers at 107 West Pratt Street hang it out for their Colts in 1960.*

Bottom right: *Little League Orioles fans scramble for a foul ball at Memorial Stadium in the spring of 1961. That year pitcher Milt Pappas won thirteen and lost nine; attendance climbed to almost a million.*

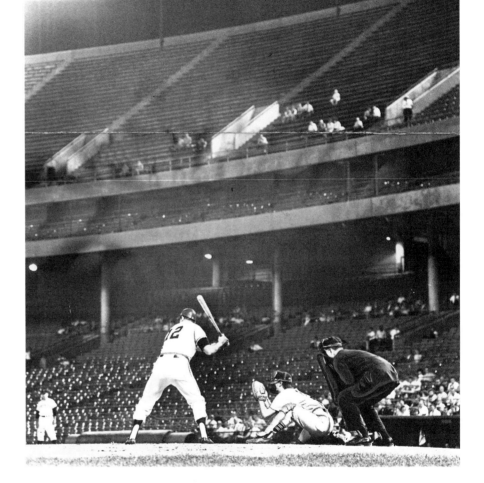

Orioles catcher John Orsino batting in late September 1963, when the Orioles and Senators played to an almost empty house at Memorial Stadium. Only 3,115 fans had turned the turnstiles. The Birds had nestled into fourth place; the Senators that night were losing their one-hundredth game.

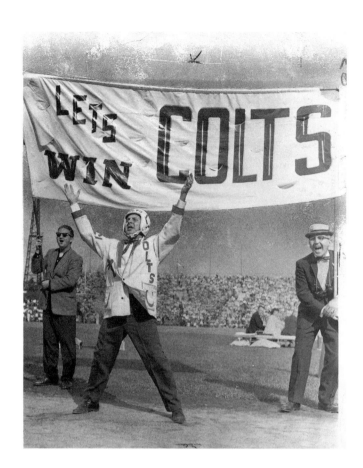

Bill Gattus Jr., Colts partisan and volunteer cheerleader, takes over at halftime in a 1964 home game.

At 6:00 A.M. on the morning of December 19, 1965, fans who may have been up all night celebrating stand outdoors at Friendship Airport to greet the returning Colts. The Colts had beaten the Los Angeles Rams the day before.

Orioles win! Paul Blair catches the last out in the 1966 World Series, a surprising four-game sweep over the mighty Los Angeles Dodgers, and the first fans clear the fence. Courtesy of Tom Scilipoti.

"Oh boy, what a beer!" Bailey Goss gives his all for National Bohemian beer on WMAR's The Bailey Goss Show. *Courtesy of Roger Goss.*

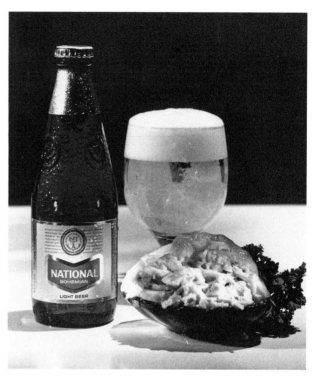

National "Boh" went famously with hot, steamed crabs—but any crab delicacy, including crab imperial, would do in the Land of Pleasant Living. Courtesy of Taddler/Baltimore.

The big breakthrough came unexpectedly, ten thousand feet in the air over the Chesapeake Bay. Hoffberger explained: "Early in the 1950s several executives—Dawson Farber, Sydney Marcus, and I, all of us from National Beer—and 'Brod' Doner and Herb Fried, from our advertising agency, had just taken off in a private plane. We were soaring high over the Bay and looking down on a brilliant, sunlit day. I said, 'What a gorgeous sight!' Doner picked up on that, and he said, 'This place is the land of pleasant living.'" That phrase, "land of pleasant living," became the National Beer slogan for the next thirty years.

The rest is history, as they say. From the 1950s well into the '60s, Baltimoreans happily conflated beer and civic pride. The Hoffberger machinery included "Commodore" Frank Hennessy, who piloted the good ship *Chester Peake* up and down Chesapeake Bay. While under way, Hennessy broadcasted live promotional squibs celebrating Baltimore, the state of Maryland, steamed crabs, oysters, the mountains of Western Maryland, the beaches of Ocean City, the Colts, the Orioles—all of it, five times a day, six days a week, all summer long.

Few companies in America used the newly emerging medium of television to create a brand image as effectively as did National Beer in the 1950s and 1960s. Its involvement in the *Bailey Goss National Sports Parade* show on WMAR (Channel 2) was an early example. Goss's son Roger recalled the excitement of Baltimore television in its infancy—the sheer day-to-day adventure of going on the air live every day and the omnipresence of National Bohemian beer. "From three o'clock in the afternoon until six, Dad sat at a desk with a camera trained on him, and all round him and never out of view of the camera were maybe half a dozen cans of National Beer.

"*National Sports Parade* was a variety show, and in those days, that meant pretty well anybody doing anything entertaining. Singing, dancing, playing a musical instrument. Matt Thomas was a local vocalist and a regular on the show. A young personality named Joanie Cole was part of the show, a woman comedienne in the style of Carol Burnett. It was like opening the West; there were no rules and there were no limits. There were always guests, sort of like the forerunner of the Johnny Carson style. Dad at his desk, guest seated nearby—always those cans of National Boh present. I recall his interviewing on camera Rocky Marciano and Mickey Rooney. Any star playing in town at the Hippodrome or the Club Charles usually appeared on what got to be known as the 'Bailey Goss Show.'"

Since the *Sun* then owned WMAR, the station's first studios were in the old *Sun* building at Sun Square, on the southwest corner of Baltimore and Charles Streets. All of the sports scores and news on the *National*

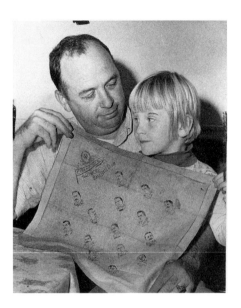

Heritage is passed down. Levin Thompson received this linen handkerchief, with inked likenesses of the 1894 championship Orioles, from his aunt in 1954. Here, twelve years later, he shows it to his five-year-old daughter Pattianne.

Sports Parade came directly from the *Sun* news departments, conveniently in the same building as the telecast. "The show got to be so popular," Goss said, "that National Beer took it on the road, telecasting rodeo from Eldersburg, the symphony from Mondawmin Mall on Reisterstown Road, wrestling from the Coliseum on Monroe Street, amateur shows from the Center Theater, at North Avenue and Charles Street.

"And intermittently, maybe every ten minutes or so, Dad would do a live commercial. He'd always end with his signature look and slogan: a sigh and a big smile of total satisfaction, holding up a can of National Boh, and emoting with total conviction, '*Oh, what a beer!*'" Soon that simple slogan was replaced by the jingle,

> National Beer, National Beer,
> We'll sing you the story of National Beer,
> And while I'm singing I'm proud to say
> It's brewed on the shores of the Chesapeake Bay,

which, for many, became an anthem for the times.

■ JOSIE HEARD Thirty-year-old Jehosie "Josie" Heard, a left-handed, five-foot, eight-inch, one-hundred-and-fifty-pound African American pitcher out of Nashville, came to Baltimore in 1954 as part of the old St. Louis Browns when that team became the Baltimore Orioles. Heard had played in the Negro leagues and had pitched for Victoria and Portland on the Pacific Coast.

Josie Heard is best remembered for one brief (an inning and a third), shining moment on a fine Saturday afternoon in Comiskey Park, Chicago, April 24, 1954. The sixth-place Orioles, with Jimmie Dykes managing, were playing the third-place White Sox in the young season. It was the ninth game of the season, and five Orioles, one of them Josie Heard, had worked their way into the lineup for the first time. In the sixth inning the Sox, leading 6 to 0, got four consecutive hits off Oriole pitcher Mike Blyzba. "Then," the story read the next day, "Jehosie Heard came on."

You won't find Heard in the pantheon of major league baseball. He pitched only one other time before being optioned to Portland, never to return (all told, in the majors he allowed six hits, walked three, and struck out two). And on that April day the White Sox crushed the Orioles, 14 to 4. But Josie Heard's debut was historic for the Baltimore Orioles. "The tiny Negro southpaw," the sports pages reported, "thus became the first member of his race ever to appear in an Oriole uniform in a regular season game. Heard's debut was a good one. He stayed for just four outs, but he didn't allow a hit,

before Dykes lifted him for a pinch hitter. Four bird chuckers were victimized by the Sox onslaught and only rookie Jehosie Heard showed credibility during a brief fling on the mound."

17 | Signs of the Times

■ **THE CLUB CHARLES** The Club Charles was easily Baltimore's best-known and most frequented night club, flourishing from 1941 through 1951, as Lou Baumel, former owner of the club, along with other former owners Tom Shaw, Milton Baumel, and Cy Bloom, loved to tell all who would listen.

"We had Ted Lewis and Sophie Tucker there several times," Baumel said. "We had a guy named Jerry Lewis and I paid him $125 a week. He had a partner, Dean Martin. I paid him $200 a week because he could sing a little. Tony Bennett, Jackie Gleason—we had shows at the Club Charles that made Baltimore a night club town right behind New York and Las Vegas, believe me. During World War II as many as four hundred people every night would dine and dance and watch the famous Club Charles shows. But in the early 1950s the Club's popularity began to fade. We just couldn't afford to bring all those big stars here. We served an imperial crab platter for $2.50. We couldn't charge what it was costing us. It was television. Television killed us."

■ **"IT WAS A FORTY-FIVE MINUTE TRIP, AND IN WINTER IT COULD GET BAD."** "Long before there was a Bay Bridge, thousands of us—businessmen, salesmen, families on vacation—crossed the Bay on the ferries," recalled John Hess. "It was quite a trip, at ten to twelve miles per hour!" The ferry ran between Annapolis (or, after 1941, Sandy Point) on the Western Shore and Matapeake on the Eastern Shore. Hess took it often in the 1940s and early 1950s on his journeys between Salisbury and Baltimore. "We'd wait for the ferry," he said, "the *Governor Harrington,* the *Herbert R. O'Conor,* the *John M. Dennis,* and the *Harry W. Nice.* They ran about an hour apart; often, sitting in your car, you'd wait for two or three ferries before you got aboard. It was a forty-five minute trip, and in winter it could get bad.

"One January night we were icebound in the middle of Chesapeake Bay. We had plenty of food but about 2:00 in the morning we lost heat. Talk about cold! It was daybreak before the Coast Guard cut us out and we could get through to the other shore." When word spread in the late 1940s that

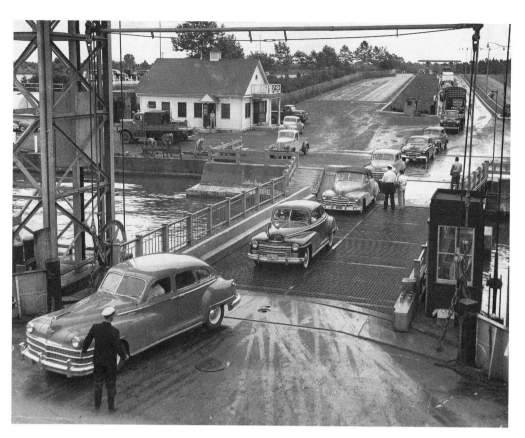

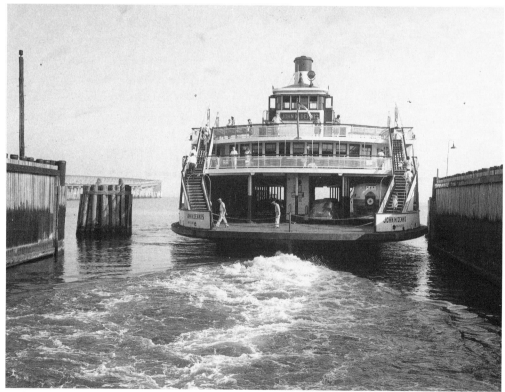

FACING PAGE:
The Chesapeake ferry John M. Dennis *makes its last run out of Sandy Point, bound for Matapeake, on July 30, 1952, bringing the Bay ferry service to an end. The newly opened Bay Bridge stands beyond the ferry, to the left.*

the Bay Bridge would be built, Hess recalled that he was "delirious" with the news.

Ferry service across the Bay ended on July 30, 1952. Still, for some, memories of ferrying linger—the satisfactions of being on the water, involved with sun and wind; the diesel fumes on deck and deep-fried greasy smell below; the bustle, punctuated with whistle blasts, as the ferry sloshes into its slip; the pure enjoyment of small adventure.

■ ROCKING AND CLOSING KEITH'S With television keeping viewers glued to their new sets and the suburbs draining business from downtown Baltimore, postwar attendance at the old downtown theaters waned dramatically. Late in 1955 the management at Keith's (at 114 West Lexington Street) decided to close, and they booked the wildly popular Bill Haley and the Comets for December 3, for one big, last night of the theater's operation. Haley played an ear-shattering, faintly insolent, electrically amplified, guitar-twanging new music getting to be known as rock and roll. "Rock Around the Clock" had been Haley's first hit recording. His audiences had earned a reputation for going berserk, collectively clapping and screaming to the loud guitars and heavy bass. At several of Haley's earlier shows, theater owners had called in police to shut things down midperformance.

On that last night at Keith's, the movie ended and the stage show began at about 8:30. The curtain rose to wild cheering, as bobbysoxers stood on their seats and screamed. Pandemonium reigned until, at 9:13, the curtain fell, and Haley and the Comets disappeared. The crowd had been loud but not unruly, and Keith's, which had entertained Baltimoreans for forty years, closed forever. The theater manager asked the rock star how it felt to be the last show to play Keith's. "We've shut down a lot of theaters for a single performance," Haley replied, "but this is the first time we've closed down a theater for good."

■ BALTIMORE'S FIRST, LAST, AND ONLY POETRY BROADCASTS "The sun has drawn its shade across the azure sky and night shrouds its veil about the earth"—you may remember what comes next if you were among the Baltimoreans who, between 1937 and 1957, tuned in to WCAO at midnight to listen to Nocturne. Those were the opening lines of a show that you didn't listen to so much as go to sleep to. A brainchild of Charles Purcell, John Ademy, and Roland Nuttrell, it was half an hour of soft organ music (songs like "Two Cigarettes in the Dark" or "Smoke Gets in Your Eyes") provided by Nuttrell, over which, ever so qui-

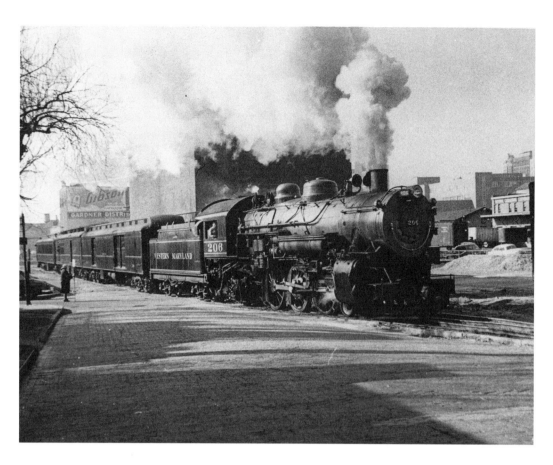

In May 1953 the Western Maryland Railroad ran its last passenger trains out of Hillen Station, ending commuter service on the line. Clearly, hauling coal produced heavier profits than hauling passengers, and in early 1956 the company placed an order for fifty new seventy-ton hopper cars. Demonstrating the advantages of roller bearings on the massive hoppers, Jackie White, Chris Roberts, and Jean Crowe pushed one, briefly to be sure, along a stretch of track at Port Covington.

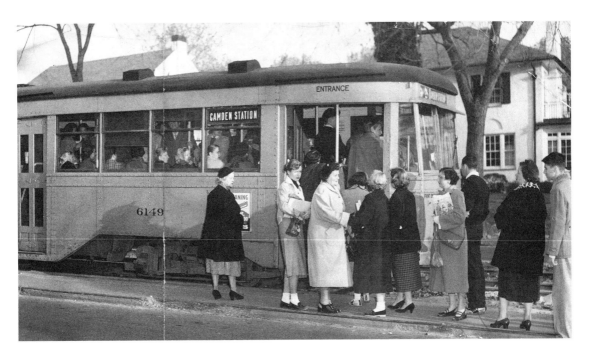

Crowds file onto the streetcar to Camden Station at Liberty Heights and Hilton Street, November 1953 (above). Passengers sit inside the sparsely filled No. 8 car, Fallsway/Hillen line, March 1956 (left). Whether it was complaints due to heavy ridership and consequent delays or complaints due to low ridership and apparent waste, streetcars suffered from bad press.

etly, Purcell would read the literature of love ("How do I love thee? Let me count the ways.").

Those poetry readings with organ accompaniment constituted a soporific that must have been the envy of sleeping-pill manufacturers. "Listeners loved it," recalled Purcell. "Letters poured in. During the war, while I was in China and Burma, I used to record the poetry readings in the Armed Forces Radio stations and send the discs to Roland. He would put them on the air and do organ accompaniment, just as if I were in Baltimore." When Purcell was there in Baltimore, the show originated, alternately, from the Century, the Valencia, and the Parkway Theaters.

The rest of the show's opening words went like this: "While the mystic, ribbonlike notes of the organ merge with the words of the poet."

The Plough Broadcasting Company of Memphis, Tennessee, bought WCAO in 1957 and closed the program. This is the way Charles Purcell bid farewell to his audience on that last show (over the music of "Brahm's Lullaby"): "Sleep on, dream on, and as the night shall fade away there comes a time for us to say, the song is through. The verse we close, so good night. Farewell; sweet repose."

■ THE DEPARTURE OF RIVERS CHAMBERS Rivers Chambers and his band continued to keep busy in Baltimore for most of the 1950s, becoming perennial favorites among people from all neighborhoods and social backgrounds. As a wealthy contractor who often ran as a Democrat for governor, George Mahoney threw many parties, and the pace picked up in election years. His friend Elmer Addison recalled that Rivers played every bash Mahoney ever gave.

Then, in May 1957, while playing the organ at Odd Fellows Hall on Fayette Street, Chambers suddenly died. At his funeral at Sharp Street Methodist Church on Etting Street, Leon Wilmore sang the words from Matthew:

Come blessed father,
Inherit the kingdom prepared for you.

Most of the congregation was black, but many of Chambers's white friends also came to pay their respects. Every person there had a private memory of Rivers Chambers. "I got my own memories of Rivers," Tee Coggins recalled. "I can see many a dance floor, crowded with couples, at white parties and black, clapping and stomping and singing, 'Oh, cut it down.'"

"After the funeral, Buster and I came back to my house on McKean Avenue," Elmer Addison later told friends, "and sat on the back porch. We talked long into the night. We could never finish with our memories of

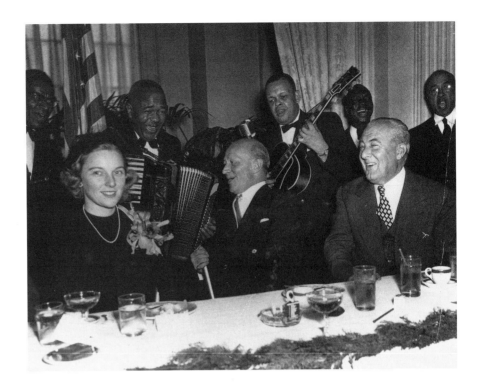

Rivers Chambers, center, and his orchestra play a gig toward the end of his career.

Rivers Chambers." Fellow musicians Brown and Addison took over the band.

■ TUNING IN As young people clamored for rock and roll music in the 1950s, WITH brought forth a galaxy of local celebrity disc jockeys—Fred Robbins, Ernie Simon, Howard Rudolph, Gil Kriegel, Al Stevens, Lee Case, and a southerner, "Buddy" Deane, who would go on to do the famous WAAM (WJZ) dance show bearing his name. Always a pioneer, WITH became the first white-owned radio station to air black personalities. Chuck Richards was on Sunday mornings; Maurice "Hot-Rod" Hulbert came on at 8:00 P.M. every Monday through Friday in the 1950s with his "Rocket Ship," opening with "Good googa mooga, here we go takin' off in our rocket ship from the Big B!"

Hot-Rod was no ordinary disc jockey, and this was no ordinary radio show. "The Rod," as he often called himself, was the first black disc jockey to host a prime-time popular music show in Baltimore. (The distinction of being the first black disc jockey on a white-owned station belongs to Chuck Richards, who debuted as early as 1945, but his was a gospel show on Sunday mornings.) "In the early 1950s," Robert "Jake" Embry, then station manager, recalled, "television was hurting nighttime radio. Nothing we could do seemed to get and hold a nighttime audience. We got the idea of

Stewart's opened a new store out on York Road, just across the line in Baltimore County, in 1955. Not every suburban store succeeded, but they all drew customers away from the Howard Street corridor.

getting a black disc jockey and a black music show and presented the idea to one of our larger advertisers, Gunther Beer. They liked it and sent us on the road to find the right man." The search led to Memphis, Tennessee, where Hot-Rod was burning up the rating charts with a show called *Sweet Talkin' Time.* Hulbert was persuaded to come to Baltimore to do the show. "He did his show well, too," Embry said. "We developed a good audience and a long list of satisfied advertisers." The show went off the air in 1960 but still stands out as pioneering black radio in Baltimore.

■ HOAX AT MILLER BROTHERS On the afternoon of Tuesday, August 22, 1961, at a time when blacks were routinely refused service in "white" restaurants, three "African diplomats," outfitted in full diplomatic attire (so press reports later had it) walked into Miller Brothers restaurant on West Fayette Street, sat down, ate, paid the check, and left—albeit much sooner than they had planned.

People of color seated in a downtown Baltimore restaurant during the early 1960s was a startling scene, one without precedent. And indeed there had been a series of incidents in which diplomats from the newly independent African nations had been refused service in restaurants along Route 40, east and west of Baltimore. The diplomats had complained to their embassies, which had filed formal complaints with the U.S. State De-

Ted McKeldin, moderate Republican, enjoys a soft drink. McKeldin won support from both sides of the party aisle and from both white and black voters, serving as city mayor from 1943 to 1947, as state governor, from 1951 to 1959, and then again as mayor for a term beginning in 1963. He led efforts to integrate the state government and national guard, and he also carried on old programs—as well as creating new ones—for urban redevelopment in downtown Baltimore. He loved people, and people loved him.

McKeldin recognized a kindred spirit in poet Ogden Nash, who late in life had moved back to New York only to return once more to Baltimore. Mayor McKeldin sent him a letter, welcoming him and Mrs. Nash back to town, and Nash responded with a typical sort of poem:

> *Dear Mr. Mayor,*
> *My spirits are gayer*
> *because of your letter of welcome.*
> *It rang like a clink of ice in a drink*
> *To one who has newly from hell come.*
> *Though others may falter*
> *And thrive in Manhattan*
> *I found it a verminous vault*
> *So I'm glad you don't shun*
> *This prodigal son*
> *Whose heart never wandered*
> *From Balt.*

The "diplomats" who presented their bogus credentials at Miller Brothers pose for this photo as they embark on the adventure. This image appeared much later in the Baltimore Sun *when one of the participants wrote a letter to the editor expanding on a piece the paper had published under "Baltimore Glimpses."*

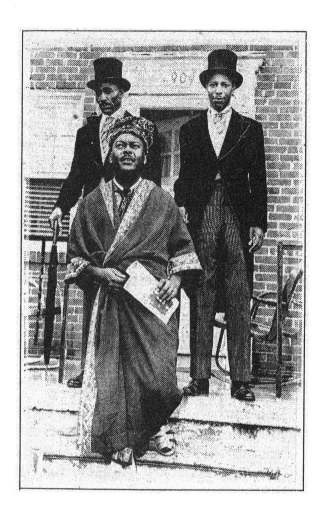

partment. Pressure, in turn, had then been applied to Governor Millard Tawes.

This particular visit of "diplomats" to Miller Brothers, however, was a hoax. The African diplomats were local black reporters with the *Afro-American* newspaper: George W. Collins, Herbert Mangrum, and Rufus Welles. They wanted to draw attention to what the *Afro-American* called "the senselessness of segregation" by forcing a confrontation in downtown Baltimore. And although no confrontation ensued, the incident, reported over the next several days in both the white and black press, thrust the problem of segregated restaurants into widespread public view. The battle for desegregation of Maryland's restaurants had been joined.

Collins recalled the incident: "We were initially denied entry to the dining room, but were eventually seated after a management executive interceded." A disturbance ensued and someone called the *Sun*, bringing *Evening Sun* reporter Richard Polack to the scene. Collins said, "Since he

knew Mangrum and me from our downtown beats, and because we were determined to keep the adventure secret and exclusively for the *Afro*, we abruptly ended our lunch." Mangrum and Wells scampered into a waiting limo, and Collins paid the check and rushed to join them—but not before Mr. Polack, as Collins put it, "began asking questions." "But thanks to my attire and phony accent," he continued, "Mr. Polack did not recognize me. We retreated into the limo provided by the Arlington Phillips Funeral Home, and made off."

Theodore Cook, headwaiter at Miller Brothers, told the *Sun* a slightly different version of what happened. He said, "The three 'diplomats' arrived around 3:30 in the afternoon and told us they were traveling through Baltimore and that they were hungry and asked if they could be served. In view of the difficulties that had taken place in Hagerstown, where an African diplomat had been refused service, and in light of Governor Tawes's request that Maryland's restaurateurs be particularly careful and courteous to foreign dignitaries, I seated them. I didn't want to embarrass the State Department or Maryland." He went on to say that a spokesman for the group told him that the robed man in the party was the finance minister of the new "African republic of Gabon" and that the party had just come from conferences at the State Department in Washington.

In Cook's account, the trio asked for soup and then ate what appeared to be a "token meal." They stayed less than a half an hour. As they were leaving, a *Sun* reporter arrived and asked the spokesman if they had had any trouble getting seated. He said they hadn't. The spokesman, the reporter said, talked "in what seemed like a feigned accent, one that sounded like Japanese, not African, and said the finance minister's name was 'Sorfa Diwab.'" (*Sorfa* spelled backwards is *Afros*.)

After spelling out the name of the alleged minister, the trio's spokesman said the party was in a great hurry to attend a meeting in New York and could be detained no longer. All three entered a 1961 Cadillac limousine parked at the curb in front of the restaurant, but not before an African American photographer on the sidewalk was able to take pictures.

The perpetrators never claimed that they worked too carefully pulling off the hoax. In Washington, protocol officials at the State Department soon noted that they had no record of any conference between the United States and Gabon being held there at the time. The Gabon embassy reported that the country's finance minister, François Meye, was in Gabon and that its diplomats drove their own cars. The limousine bore not diplomatic but Maryland plates. The Department of Motor Vehicles said the car belonged to Arlington Sylvester Phillips, a funeral director on North Monroe Street.

One can almost feel the gentle breeze on this quiet day at the foot of Broadway, May 1961.

With neither tracks nor fumes, a "trackless trolley" stands by the curb on Howard Street in the early 1960s. The sign on the front informs the public that "streetcars are alive and running at the Baltimore Streetcar Museum."

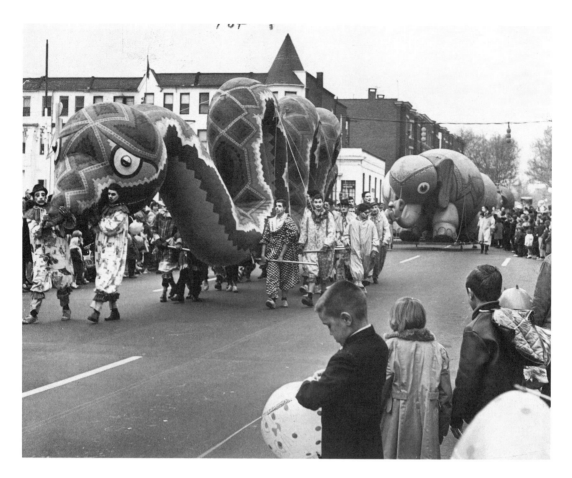

The Hochschild, Kohn Toytown Parade makes its way down Maryland Avenue in 1963, while Santa's letter carriers accept special deliveries along the route.

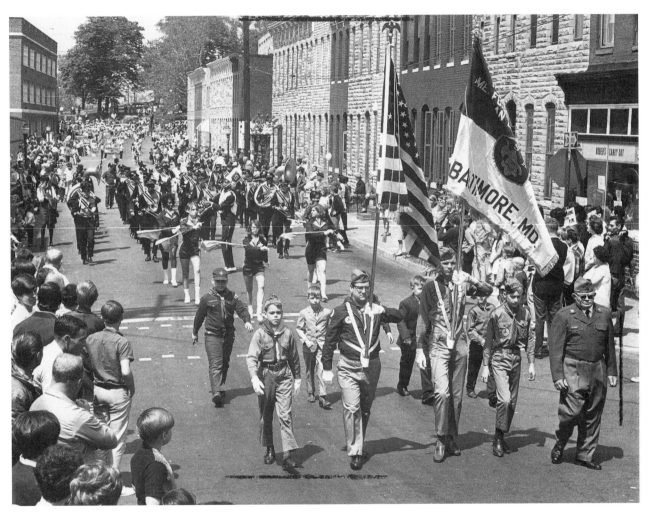

*Proud members of Boy Scout Troop
649 and the Southern High School
Marching Band mark the first day
of Little League baseball, April
1968.*

Offering the kind of service that was not to be long-lived, a Maryland & Pennsylvania (Ma & Pa) passenger train heads out of Baltimore on tracks that parallel Falls Road. The short line connected the city to York and other nearby points in Pennsylvania, running through territory so charming, hilly, and curvaceous as to make the trip seem like one through a model-train layout.

Meanwhile, a Mr. Charles Eckardt, assistant manger of A. T. Jones, the costume shop on North Howard Street, came forward and said that several days earlier a reporter from the *Afro-American* newspaper had called and ordered an African costume. The reporter, Herbert Mangrum, had come in and tried on the costume. He'd asked that the bill be sent to the *Afro-American*.

Only a few weeks after the hoax at Miller Brothers, a Nigerian diplomat driving with his wife and two sons on Route 40 from Washington to New York was refused service at the Cottage Inn on Pulaski Highway and Middle River Road. Predictably, word of the incident reached every official from the State House to the State Department, right on up to President John F. Kennedy. Quietly, word was sent back down the line: Serve the African diplomats.

Desegregation of public areas in Baltimore and other parts of Maryland would not prove easy. Before it would be realized, thousands would march and sit down in protest, and hundreds would be arrested. There

would be charges, countercharges, lawsuits, petitions. But the hoax at Miller Brothers on the afternoon of August 22, 1961, was a breakthrough, one among the many that finally made desegregation of public accommodations in Baltimore happen.

■ SWINGIN' ON THE AVENUE "If you wanted to hear good jazz in Baltimore in the 1950s and 1960s," Al Patacca said, "you went to the clubs on Pennsylvania Avenue on Saturday night. It didn't matter if you were black or white, the Avenue clubs were where the true jazz buffs went." Patacca (who is white) ought to know. He was playing trumpet in Tracy McCleary's famous Royal Theater band during those years, backing up the likes of Sarah Vaughan, Della Reese, and Nancy Wilson, and he knew the scene. He was talking about the dozen or so cocktail lounges that were clustered in and around the 1400 and 1500 blocks of Pennsylvania Avenue, the most famous of which were Gamby's, the Casino, the Comedy, the Frolic, the Avenue, the Sphinx, and the Alhambra. "Saturday night," he said, "it was people wall-to-wall inside, curb-to-curb outside, well-dressed and orderly, all come to hear good jazz. It was high-tone, and elegant, believe me."

Hiram Butler, a police detective with lots of reason to be on the Avenue, also recalled the scene: "That 'high-toned and elegant' part—that was true, yes, of the club area located above 'the Bottom.' 'The Bottom' was the lower part of Pennsylvania Avenue, a poor black neighborhood where whites rarely ventured. Dolphin Street was the dividing line. Below that, there was sometimes trouble. But above Dolphin, the finest people packed those clubs to listen to jazz."

Jazz musicians and Pennsylvania Avenue buffs saw and heard drummer Max Roach, who had played with Dizzy Gillespie; Gerry Mulligan, the baritone saxophonist who recorded with Gene Krupa; Louis Bellson, who played drums with Benny Goodman and recorded "Bugle Call Rag"; and the great Charlie Parker himself, wizard of the alto sax, whom contemporaries called "the creative force of modern jazz" or, more familiarly, just "Bird." These great players would spend hours improvising to such numbers as "How High the Moon," "Flyin' Home" and "Take the A Train."

Sigmund "Siggy" Shapiro, who followed jazz in Baltimore through the years wherever he and his friends found it, spent many a Saturday night in the Avenue clubs: "We had great times. I particularly remember one evening listening to Art Tatum. Back in the 1940s and 1950s, white jazz fans came regularly to those black clubs. People who liked jazz didn't care about color, they cared about *jazz.*"

Of the demise of the Pennsylvania Avenue clubs, trumpet player Pat-

acca lamented: "As for listening to all the great jazz musicians in the clubs on Saturday nights along Pennsylvania Avenue, changing times, as we say in jazz, wrapped it up."

■ DR. SPATZ'S FIVE-MINUTE COMMENTARY Any weekday morning at 7:35, from the early 1960s into the 1980s, people in five states listened in to WBAL radio in Baltimore. After the news, one heard the voice of Don Spatz; following the broadcast, if the pattern held, as many as fifty people would write a letter to Mr. Spatz. His few minutes on the air each day moved listeners to respond with thousands of letters each year. Who was Don Spatz, and how did he strike such a chord?

A former radio drama writer, music critic, and public relations director for the Peabody Conservatory, Spatz began broadcasting his daily five-minute program of anecdotes and commentary over WBAL beginning on October 16, 1960. To the astonishment of the station management (which had seen commentary shows come and go in a matter of a few years or, more often, months), the Spatz show would run for thirty years. His comments in the tumultuous 1960s, when the city and nation were restitching the American social fabric, had a quiet, reassuring, and redeeming quality. He sifted through the long record of human experience and picked out some of the inspiring moments. In a period often characterized by coarse behavior, he spoke about civility. In the "me" years, he focused on the unselfishness, on the "we," what he called "the noble instinct people have that unites them and lifts their spirits."

Spatz spoke of "character," which he defined as "what you are when no one is looking." His heroes included the mail carrier who turned a dusty roadbed into a garden by planting flower seeds along his route every day; a truck driver who volunteered his services one day each week to destitute farmers; the boxer who prayed before each fight that no one would be hurt. He liked to tell the story of the young stranger who stopped to help a black man struggling with a heavy load on a cold winter's day. The stranger turned out to be Theodore Roosevelt, the black man Booker T. Washington. Pure Spatz.

■ THE FAMOUS BALLROOM Louis Shecter had a dream that if he built it, they would come—a place like New York's famous Roseland, but in Baltimore, a place where guys and girls who were growing up in Baltimore during the 1940s and 1950s would come to dance cheek-to-cheek. He dreamed that these couples holding tight and dancing to slow music would make the place a Baltimore institution, celebrating in three-quarter time

In 1963 during the Easter Parade, the 3100 block of Charles Street was totally deserted; "balloon vendors," according to the paper, "said it was the worst year they had ever experienced."

the joys of the waltz, foxtrot, rumba, and so on. So in 1947 he opened the Famous Ballroom at 1717 North Charles Street, in what had been a bowling alley. In the 1950s, the dream unfolded as sweetly as a Guy Lombardo waltz. Every Thursday, Friday, and Saturday night, as well as Sunday afternoons, as many as six hundred couples danced to the music of Sammy Kaye, Billy Butterfield, and Tommy and Jimmy Dorsey. It was all happening the way Shecter had hoped it would.

Then, in the mid-1960s, Shecter made a decision: the enterprise had gotten too big for him to handle, and so he leased it to Bernie Allen, also an impresario but one with his own band. The formula of Bernie Allen and his band, and ballroom dancing, worked. The crowds came, and they danced. Among the groups they danced to, beginning in 1966, were those brought in by the Left Bank Jazz Society.

Something else happened: without attracting attention, the crowds that took in the Left Bank Jazz Society's Sunday afternoon concerts became racially mixed. Jazz buffs being color-blind, a special kind of camaraderie took shape at the concerts, at a time when most Baltimoreans did not look kindly on the mixing of races in any setting. The Sunday afternoon concerts grew not only into large and memorable events but also into historic ones. For years, on Sunday afternoons from 5:00 P.M. to 8:00 P.M., the Left Bank Jazz Society entertained with the biggest names in the business: John Coltrane, Miles Davis, Count Basie (who arrived during the April 1968 disturbances, with police stopping his bus), Dizzy Gillespie, Duke Ellington, and Earl (Fatha) Hines.

"The place strikes us as a cross between a concert hall, a night club and a church circle," a *Sun* entertainment critic wrote at the time. "After all, how often can one find first-rate music, barbecue and beer, and a well-dressed audience, all under one starry roof?" He meant that "starry roof" reference literally. The ballroom's ceiling was painted with stars.

18 | Fond Farewells

■ THE EASTER FLOP OF 1959 The biggest disappointment of 1959 was certainly not the championship Colts and not even the Orioles, who finished sixth despite Gus Triandos's two grand slammers. For years, going back nobody-knows-how-far, the parade on Charles Street on Easter Sunday afternoon, starting at the Washington Monument and winding up at University Parkway, was where you went to see and be seen on that holiday.

It was a never-ending "stroller's parade" of ladies in sequined gowns and gentlemen in tail coats and top hats, of people who were in Baltimore society's blue book and of people who never heard of it.

Through the years, observers outdid themselves with their rave reviews of the scene: the crowds, the fashions, the balloon vendors, and the inevitable exhibitionists who showed up dressed to various extremes. But in the late 1950s the character of the parade changed. The lovely models boasting fashions out of the fine Charles Street fashion shops gave way to models out of Detroit's assembly lines. Muslin and crinoline yielded to chrome and steel. In 1958 a police sergeant on the scene remarked, "They're running four cars wide across Charles. I'd say we're handling four thousand cars an hour, bumper-to-bumper." By electing to come to the parade in cars, the sightseers forced the very strollers they came to see off the street. "It just can't go on like this," the sergeant added.

The next year, 1959, on Easter Sunday, Lieutenant Charles Reiss stood in the middle of Charles Street at about Thirty-third. His view took in the scattered few strollers (some, it appeared by their dress, were obviously unmindful that there even was a parade), the solitary vendors (with a few lonely balloons), and the long, barren stretch of Charles Street all the way to Wyman Park. "This isn't an Easter parade," he said. "It's a supervised walk for thirty people."

Few people remember the Charles Street Easter parade of that year because few people were at the flop of 1959.

■ LAST FLIGHT OF THE RUXTON ROCKET In June 1959, a sign posted over the door of the Calvert Street station at Centre and Calvert Streets, southern terminus of the Pennsylvania Railroad's Baltimore-to-Harrisburg run, read: "By authority order 54046 April 29 Public Service Commission, trains operating between Baltimore and Parkton will be discontinued." This terse announcement marked the end of the beloved Parkton Local (also known as the "Ruxton Rocket"), an improbable commuter train that ran north and south between downtown Baltimore (Calvert and Centre Streets) and Parkton in northern Baltimore County, meandering through the rural Jones Falls Valley. Heading into town, the train that left Parkton at 8:55 in the morning usually made it to Timonium at 9:30, Lutherville at 9:33, Ruxton at 9:38, Mt. Washington at 9:45, and the Calvert Street station at 10:00.

John Redwood rode the train almost every day, morning and evening, from 1910 to the end. "You knew everybody on it," he said. "When some-

The Parkton Local (known as the
"Ruxton Rocket") prepares to chug
up the Jones Falls Valley.

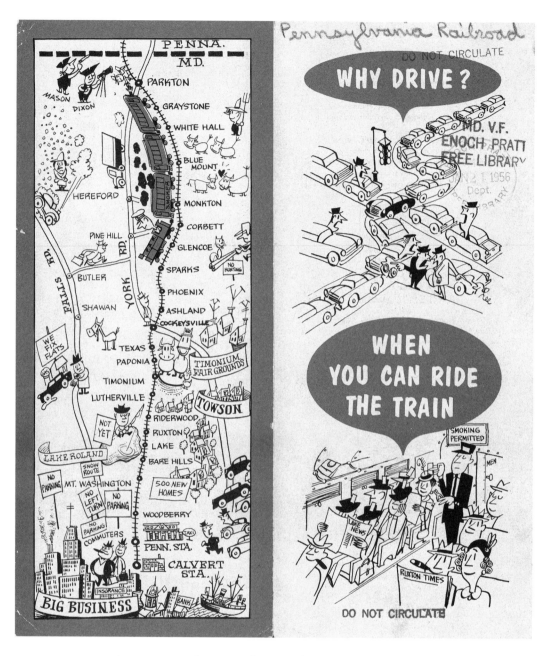

At one point in the 1950s, the Pennsylvania Railroad, owner of the Rocket, hired cartoonist Richard Q. Yardley to help publicize the benefits of train travel over automobiles. He had some artistic fun with the subject, editorializing the male commuter culture. Courtesy of the Maryland Room, Enoch Pratt Free Library.

body new came aboard you just had to meet him. It was a beautiful ride. In the fall as you passed Lake Roland, you watched the foliage changing colors in the water. In winter you could see children ice skating."

"The Parkton Local was no ordinary train," said Russell Mellinger, a conductor on the run. "Tradition had made it a sort of traveling club. We all knew each other, and very well, too. Why, if a passenger left a package on the train, nobody would touch it. We knew the passenger who left it would be back on the train the next day and pick it up. If a new person came aboard, everybody, including me, would introduce himself. That kind of a train."

With the dramatic increase in automobile use came a decline in the number of passengers riding the Parkton Local. "You could see the end coming," Redwood mused. Trouble surfaced in the fall of 1958. The Pennsylvania Railroad asked the Public Service Commission for permission to end the service. The majority granted the request; Public Service Commissioner Albert Sklar dissented. "Financial return," he said, "is not the only issue in the matter."

Nevertheless, the train's fate was sealed; the last ride was scheduled for no later than June 1959, a round-trip out of Calvert Street station. People who had never ridden the train climbed aboard to say goodbye to a Baltimore tradition, bringing along cameras and looking for souvenirs. As the train pulled out of Lutherville, there was a bouquet of roses on its front light. And so on she went, stopping at Texas, Cockeysville, Ashland, Phoenix, Sparks, Glencoe, Corbett, Monkton, Blue Mount, White Hall, Graystone, and into Parkton—about a one-and-a-half-hour trip from downtown.

In its glory days, the railroad offered nine locals each way to Parkton, five each way to Cockeysville, and four each way as far as Hollins (branch to Garrison by way of Greenspring Valley). A late morning train served a group the line referred to as "women shoppers"; an evening train got you to the Lyric in time to be seated for the symphony's first number and home by midnight.

Redwood was a passenger that last day, Saturday, June 27. "When, on its last trip south out of Parkton, we got to the Calvert Street station, I asked the conductor, the brakeman and the engineer to step on the platform. I took their picture, then we all shook hands and said goodbye. That was it."

■ THE BURNING OF BAUM'S It started out as just another Saturday night in downtown Baltimore in the 1960s. The streets were busy and the crowds that would soon be emptying out of the late movies—at the

Stanley, the Hippodrome, Keith's, or the New Theater—could be expected to start finding their way into the restaurants for an evening snack. But on this one Saturday night, January 30, 1960, these crowds were in for a surprise. Coming out of the movies, they heard sirens screeching and saw fire engines racing through the smoke-filled streets and streetcars blocking traffic in both directions. To the frenzied question everyone was asking, "What happened?," came the answer, "Baum's is on fire!"

That news was a huge blow. Baum's restaurant, at 320 West Saratoga Street, traced its beginnings back to 1890 and had become, by its later days, one of the most popular dining spots for the downtown movie and theater crowd. In 1939 the job of host fell to owner-operator Dave Schwartz, and in no time Baum's was the darling of the restaurant critics. "The food in Baum's is so well prepared," declared Frederick Philip Stieff, a leading critic of the day, in the high-toned *Gardens, Houses and People*, "that I join the repeaters several times a week. This applies to both the sixty-five and eighty-five cent lunches. Dishes in season are available the year around. Shad and shad roe in the spring, broiled rock during the summer, crab most of the year. Diamondback terrapin is on the menu for $1.75 a serving, and Watertown goose is served from Thanksgiving through the balance of the year. The geese, raised in Watertown, Wisconsin, are shipped to Baum's ready for the oven. My compliments to Baum's host Dave Schwartz. He never disappoints."

On the night of the blaze, the crowds couldn't get out of downtown until well after midnight, hours after the fire had been brought under control. Dave Schwartz said later that the inside of the building would have to be completely rebuilt before the restaurant could ever reopen. It never did.

■ SLATTED BENCHES AND ROCKING CHAIRS "There's something about these railroad stations," Benjamin Scheinberg, stationmaster of the Western Maryland Railroad's old Hillen Street station, said in 1954 as he delivered the eulogy for the beloved train station where he'd worked. Mr. Scheinberg, informed of the imminent demise of that once-bustling depot at Hillen Street, Fallsway, and Exeter Street, mused wistfully about the thousands of commuters who regularly used Baltimore's many railroad stations in those days for business or pleasure.

Hillen Street station once had been the gathering point for Baltimore society as they set off to Blue Ridge Mountain resorts ("the place of perpetual breezes"). Meanwhile, the Pennsylvania Railroad's Biddle Street station, near Gay Street, served mostly commuters and was so little known that when its closing was announced and reporters sought details, the railroad's

information bureau claimed the railroad had no Biddle Street station. Then there was the tiny station at Pennsylvania Avenue and Wilson Street, recalled by its patrons as "no more than a break in the Wilson Street tunnel."

Western Maryland's station on Garrison Avenue (Arlington station), near Reisterstown Road, became a coal warehouse; Hollins station on Lake Roland "just went to sleep," those who knew it recalled. Stations on the Northern Central between Calvert Street station, at Guilford Avenue and Centre Street, and points north included Woodberry, Mt. Washington, Ruxton, and Riderwood; others in Anne Arundel County along the WB&A included Harman's and English Consul.

Some of the stations were no more than concrete platforms; others boasted freestanding buildings with steeples, dormers, and mansard roofs right out of Norman Rockwell.

The Baltimore and Ohio's Mount Royal Station, down in the grassy hollow where Mount Royal Avenue meets Cathedral Street, never wanted to be a railroad station in the first place. Had she been able, she would have told anybody listening that urban railroading was not for her. From the day the station opened in 1896, with its Romanesque design and red-tile roof right out of Hansel and Gretel, she was considered old-fashioned and took on a resolve of her own, trying to be everything but a railroad station. To begin with, she was host to fewer trains than Camden Station or Penn Station. The only excitement came late in the afternoon, when the Royal Blue departed for New York. A porter who worked there complained: "Standing around doing nothing got on my nerves."

For passengers awaiting trains, the ambiance was that of a mountain lodge after dinner—positively soporific. Fires burned in fireplaces at either end of the station. A gramophone played soothing music. Art exhibits turned the station into a gallery; four rocking chairs made it seem like an old front porch. (Once, in 1943, the chairs suddenly disappeared. Citizen outcry was so vociferous that management hastily explained that the chairs were only being repaired and would be back soon. They were.) Outside, the slopes became an amphitheater for various events, and crowds would gather on them for carnival-like celebrations. From the grassy inclines they cheered Cardinal Gibbons, President Herbert Hoover, Governor Al Smith, President Woodrow Wilson, the Queen of Romania, and Governor Albert C. Ritchie.

By the early 1960s, the passenger trains had stopped coming to Mount Royal Station altogether. The art came down, the rocking chairs disappeared, celebrities neither arrived nor departed, and the outdoor amphitheater grew silent. The embers in the fireplaces grew cold at last in

1964. The Maryland Institute College of Art bought the station and turned it into classrooms and exhibition galleries. Mt. Royal Station finally got her wish to be something else.

But back to Benjamin Scheinberg, getting the news in 1954 that the Hillen Street station was to close. "Close the station?" Scheinberg asked in disbelief. "Times won't be the same."

They were not. And memories of them include slatted benches, printed timetables snug in ancient racks, the smell of heat in winter and dank coolness trapped by a high ceiling in summer, the wait on the platform alongside the big-wheeled baggage carts, and the conductor's "All ab-o-o-oar-r-rd" fading into the era's end.

■ FINAL CRUISE TO NORFOLK Boarding one of the Old Bay Line's steamers for the overnight trip to Norfolk was only the first step in a thirty-six-hour ritual, one that since 1870 had been among the truly pleasant features of Chesapeake life. By 7:00 P.M. the *City of Norfolk* (or the *City of Richmond*) would be downstream, passing Fort McHenry. "When the fort came into view," recalled Bernie Shofer, leader of the steamer's dance band, "we always played 'The Star Spangled Banner.' By 7:30 everyone was in the dining room for crab cocktail, Norfolk spot, and corncakes, Maryland corn and tomatoes, green apple pie, and coffee."

Another traveler aboard wrote, "After dinner, you went out on deck. Darkness had fallen. The lights of both shores twinkled. Overhead, the stars were out; sometimes, a moon. It was balmy, lovely. Sooner or later you retired to your stateroom for a good night's sleep."

At 6:00 A.M. the *City of Norfolk* was at Old Point Comfort; by 7:00 A.M., she was in Norfolk, where guests disembarked to spend the day shopping or on the beaches. That same night the *City of Norfolk* would head back, and by dawn she would be nosing her way back into the Light Street dock, her passengers still talking about the delights of sun, moonlight, music, soft breezes, sound sleep, fine food, and flawless service.

On April 11, 1962, the ritual had a different feel. The few people in line waiting to board knew that this trip would be a farewell voyage; there would be no overnight boat to Norfolk or to anywhere else out of Baltimore's inner harbor in the foreseeable future. This evening, as the *City of Norfolk* backed out of her slip, she gave three long whistles, the last of which was a mournful dirge. Aboard were Captain Patrick Parker, a few guests, and a skeleton crew. The captain was heard to murmur sadly, "I am going to the funeral of an old friend."

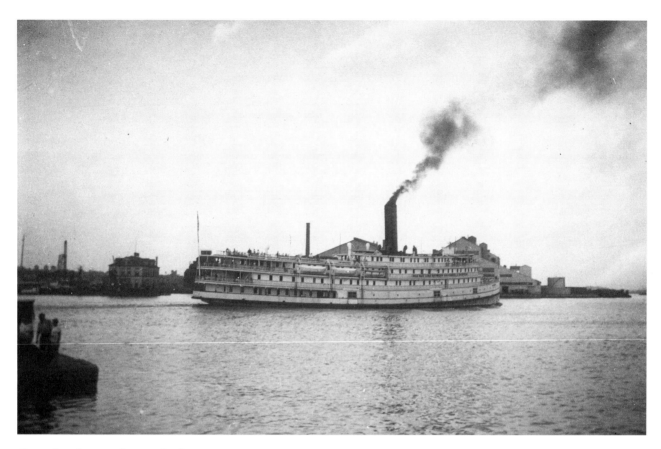

From the 1840s until 1962, for those who could make the trip, boarding the Old Bay Line's City of Norfolk *for the cruise to Norfolk was a most enjoyable experience. Courtesy of the Maryland Historical Society.*

When the *City of Norfolk* returned to Baltimore, Captain Parker's son and daughter-in-law were at the dock. They boarded, and, in the empty dining room, the three of them had a long farewell breakfast.

■ LAST RIDE OF THE NO. 8 At precisely 4:40 on the morning of November 4, 1963, the No. 8 streetcar (Towson to Catonsville) lumbered along Frederick Road. Suddenly, a passenger got out of his seat and began to remove the advertising cards from their frames, one by one. Then another passenger got up, and, encouraged by such aggression, cut a length of signal-bell cord. Moments later, still another passenger began to unscrew the overhead ceiling-light frames. These were no routine acts of vandalism, and this was no routine Towson-to-Catonsville run for the old No. 8 through West Baltimore.

These souvenir hunters were riding the No. 8 on its last regularly scheduled run—also the last for any streetcar in Baltimore, the end of a 104-year history. The passengers were caught up in an emotional high. One woman was crying. A minister, Henry Schell, took down the advertising sign

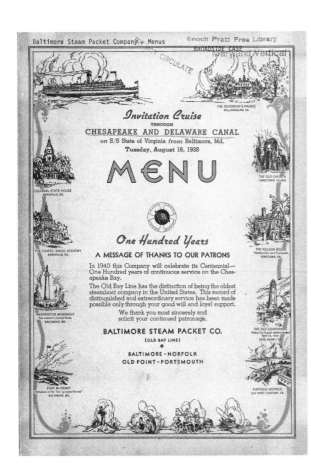

This menu cover for the dining room of the Old Bay Line was from the line's "invitational cruise" on the S.S. Virginia, *August 16, 1938*. Courtesy of the Maryland Room, Enoch Pratt Free Library.

Die-hard streetcar buffs take the last ride of the No. 8, November 4, 1963—Towson to Catonsville. The ride marked the end of the line for streetcar service in Baltimore after 104 years. Courtesy of James Spears.

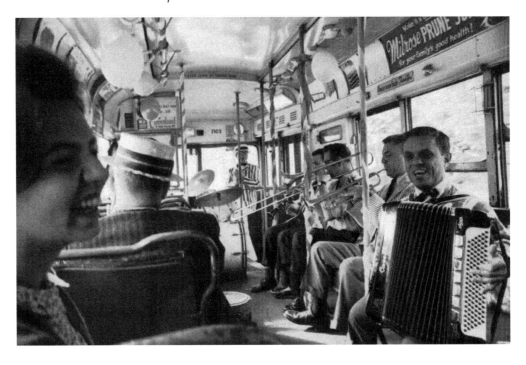

that read, "Go to the church of your choice." ("This sign," he said, "must be saved!")

Many had come in from New York and Washington to share in these heady moments. Soon the souvenir-hunters had taken all of the signal cords, three window frames, six light fixtures, and the cloth roll that listed destinations. One ambitious soul had loosened a complete seat (legs, braces, and all) and was prepared to move it out the door when the car came to its final stop. When the car did get to the Irvington car house at 5:25 A.M. (two minutes behind schedule), the motorman, Thomas Jackson, reached toward the fifteen buttons on his dashboard and pulled them to "off." Then he cranked his hand brake and got out of the car.

He reached over to the front wheel to get the chock, a triangular wooded wedge routinely placed snugly under the wheel to ensure that the unmanned car didn't move. That should have been the last official act, putting a formal end to streetcar service in Baltimore. But when Jackson reached for the chock, he found it missing; a souvenir-hunter had made off with it too.

■ "THERE'S ROSEMARY, THAT'S FOR REMEMBRANCE"
Fayette Street (the north side) between Eutaw and Howard Streets—here lies hallowed ground. Here Ford's theater flourished, Alfred Lunt played opposite Lynn Fontanne in *Elizabeth the Queen,* Tallulah Bankhead played in *The Skin of Our Teeth,* and Humphrey Bogart and Judith Anderson played in *Saturday's Children.* Here, too, Julie Harris, Rosalind Russell, and Melvyn Douglas gave memorable performances.

Four years after Lincoln was assassinated in Ford's Theater in Washington, the U.S. government ordered the edifice destroyed. Baltimorean and owner-operator of the historic theater, John T. Ford Sr., then opened a second Ford's, this one in his native city of Baltimore. Newspaper accounts observed that the "theater's presence enriched that part of Baltimore's downtown."

The grand opening of Ford's in Baltimore was October 2, 1871, with Shakespeare's *As You Like It.* Legitimate theater would continue to flourish at Ford's for ninety-three years. Because many people in New York theater circles considered Baltimore audiences to be excellent judges of performances, Ford's got be a very good trial-run theater for Broadway-bound shows. Impresario David Belasco once commented that he would only try out his shows at Ford's in Baltimore.

John T. Ford Sr. died in 1894. After his death, his sons, Charles E. and John T. Jr., carried on the management and operation of the playhouse. It

When the No. 8 pulled into Irvington at 5:25 in the morning, Baltimore's streetcar service officially ended. Courtesy of James Spears.

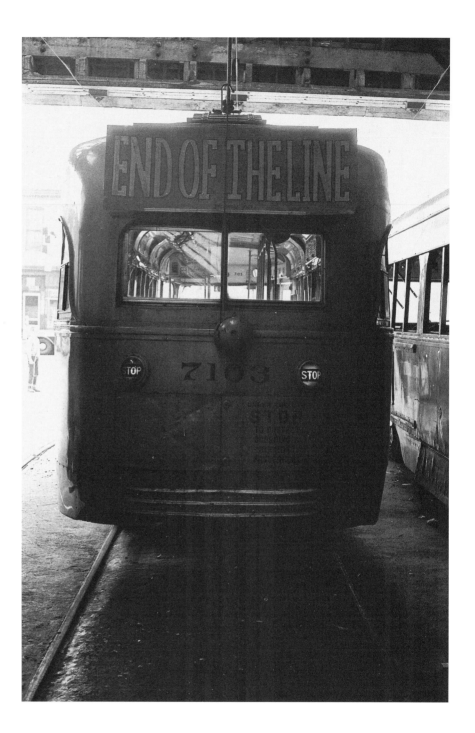

remained in the hands of the family until 1929, when it was sold to the Er-langer chain of theaters. In April 1942, Ford's Theater was again sold, this time to Morris Mechanic. Baltimore's "Temple of Drama," as it was called in earlier days, flourished from the 1920s into the early 1960s as Baltimore's leading venue for legitimate theater, the splendid progenitor of the Mechanic.

The last night Ford's entertained audiences was February 2, 1964—a night to remember. The show was *A Funny Thing Happened on the Way to the Forum,* starring Jerry Lester, supported by Arnold Stang and Edward Everett Horton. Everybody on both sides of the footlights knew this was the last show. At intermission, Mayor Theodore R. McKeldin said, "I refuse to say farewell!" He promised a "rebirth of theater in Baltimore."

After the curtain came down the final time, Lester came stage front and coaxed the audience to silence. He began in a light mood but he would not end in one. He said, "Ladies and gentlemen, in order to get the demolition off to a good start, the management would like you to take your seats home with you. The legitimate stage was once described as 'the fabulous invalid.' Tonight, ladies and gentlemen, we have lost the patient." (He could have added that the patient was ninety-three.) He brought the audience to its feet and led it in a chorus of "Auld Lang Syne." With the dying strains, the crowd slowly made its way to the exits.

Then, a funny thing happened. Those departing ran into another crowd—souvenir-hunters rushing into Ford's entrances to grab everything that wasn't nailed down (and much that was): strips of curtains and carpet and molding, knobs, light bulbs, door hinges One man came equipped with a screwdriver and was seen removing lamps, wall ornaments, and anything else screwed down.

When both crowds had dispersed, Governor J. Millard Tawes joined Dorothy Lamour, who was then a member of the Civic Center Commission, at a black-tie party in the lobby.

Yet one more melodramatic scene marked the closing. The Monday morning after Lester's poignant farewell, a wrecker's ball smashed into the Fayette Street wall, leaving a pile of rubble where Ford's had stood since 1871. Around noon, two women—Saile Gavin and May Richardson, grand-daughters of the founder—made their way carefully over the pile. As did Ophelia in *Hamlet,* commemorating the grave of Polonius ("There's rosemary, that's for remembrance; pray love, remember"), they sprinkled rosemary on the grave of Ford's. "It was May's idea," Gavin recalled. "She's very sentimental. She called me up and said she wanted to do it, and would I go

along? I said I would. We sprinkled the rosemary and said a few private good-byes and walked off. It was a very cold day."

It must have been.

■ PLAYING AT A THEATER NEAR YOU Downtown, the movie houses were referred to as "movie palaces," and with good reason. Their architecture and decor were always elegant (and sometimes overdone), in variations of rococo, art deco, and gingerbread. Bob Rappaport, whose family owned the Hippodrome, explained. "In the 1940s and the 1950s, a movie theater was thought to be part of the Hollywood dream. It put you into another world, fanciful and unreal, different from the world outside. They used the word *palaces* because it helped define the storybook role of the movie theater in the lives of the patrons."

One of the more dramatic examples of the splendor of Baltimore's movie theaters was the Stanley, at Howard and Centre Streets. When the wreckers tore down the place, Susan Garten made it a point to salvage some of its artifacts. Among her tokens were parts of the massive brass railings that led up the stairwell to the second-floor balcony seating, ornate, finely worked wrought iron trim from around the entrance to the mezzanine, and marble that adorned the walls.

From 1921 until the Charles Center project came into being, in 1962, the Century was an ornate movie palace on the north side of Lexington Street between Charles and Liberty. The main feature in 1940 might have been *Love Finds Andy Hardy* or any other film of the time; but, routinely, when the picture ended and the theater went dark, there was the hush of anticipation. Suddenly, from high above, a pencil of pink light broke out, landing on a spot in front of and just below the stage. There, a huge Wurlitzer console rose slowly on a hidden platform. Seated at it, his hands roving the keyboard, was Harvey Hammond. At once, Harvey would launch into one of Baltimore's most memorable and popular showbiz acts, the "Sing-a-long with Harvey Hammond." The audience sang the words as they appeared on the screen, led in rhythm and accent by the all too familiar "bouncing ball." Now, as the words appear on the screen and Harvey accompanies on the Wurlitzer, the audience is belting out "Tippi-Tippi-Tin" and "Boo-Hoo," taking their cue from the bouncing ball, syllable by syllable. Half an hour later, console and organist are lowered out of sight into somewhere below, the spotlight fades, the pencil of pink light gives way again to darkness, and the sugarplum world of Harvey Hammond ends, until next time.

Those performances went on for twenty years, from about 1935 to

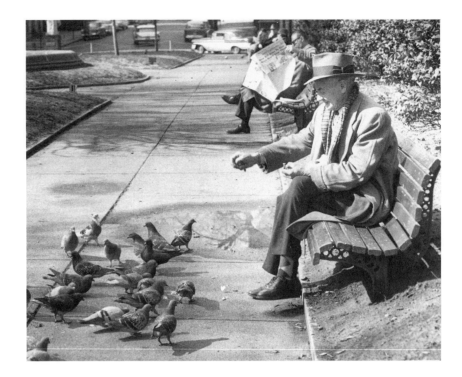

Some things never change: feeding the pigeons on Mt. Vernon Place in the 1960s.

1955 (with time out for Hammond to serve during World War II on the carrier U.S.S. *Bonhomme Richard,* on which he was, of course, ship's organist!). Then Harvey, like the Century and all of the other motion picture theaters of those days, began losing his audience to television.

The Valencia, built above the Century, in the lost block of Lexington Street between Charles and Liberty, was a bizarre example of the Baltimore movie palace. Its ceiling simulated the night sky, full of twinkling stars (blinking lights) and billowing clouds moving silently across the sky. The effect was wondrous. You sat in a fairyland, bathed in soft light as you watched a fairy tale of a movie.

On York Road, the Senator opened in 1939 as a neighborhood theater in Govans, showing, as its opening feature, *Stanley and Livingston.* Patrons welcomed its comfortable seating, and, with a curved, glass-bricked facade lighted from behind by yellow, green, and pink neon, an oval foyer with terrazzo floor, and a thirty-five-foot-high auditorium ceiling, the building emerged as an art deco showplace. In the early 1960s the Senator began to show first-run movies—the first was *Irma la Douce.*

Through the early 1960s, the neighborhood theater was where neighbors met neighbors. In earlier years, before home air-conditioning, whole families walked to the movies to cool off. Saturdays were for kids, and the day would begin at 10:30 A.M. Some kids would bring lunch, sit through two

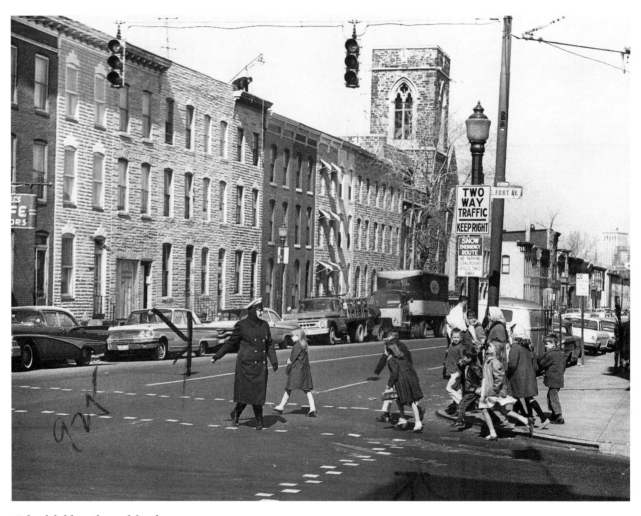

*Schoolchildren, braced for the
brisk March wind, scamper across
Charles Street at Fort Avenue in
1965. The area remained heavily
Formstoned.*

shows, and not get home until maybe 7:30 that night. A typical show would include two newsreels, a travel short, two or three cartoons, and one or two cowboy serials.

Movie palaces on a smaller scale were common to the neighborhoods. Marian Marcus, whose family once owned the Brooklyn, in southeast Baltimore, recalled, "There were fine tapestries on the walls, thick carpets on the floors, and richly detailed wall treatments, using paneling, muted lighting and wall coverings. Even for a neighborhood theater, the decor was elegant." William Goodman remembered the Ideal, in Hampden, which his family owned and operated. "The decor? It was *gorgeous!* We had beautiful tapestries on the walls, heavy draperies on either side of the screen. The richness of the decor made going to the movies more fun." The State featured interior walls and ceiling done in techstone and polychrome, green carpeting and velour hangings trimmed in burnt orange, and crystal chandeliers.

By the end of the 1960s, Baltimore's downtown and neighborhood movie houses (except for the Senator), one by one, all went dark. Among them were the Pimlico, 5132 Park Heights Avenue (closed in 1952; last show, *The Redhead and the Cowboy*); the Ideal, 903 West Thirty-sixth Street, in Hampden (closed in 1963; last show, *P.T. 109*); the Forest, 3300 Garrison Boulevard (closed in 1961; last show, *On the Waterfront*); the Edgewood, 3500 Edmondson Avenue (closed in 1961; last show, *Foxhole in Cairo*); the State, 2045 East Monument Street (closed in 1963; last show, *Phantom Planet*); the Ambassador, 4604 Liberty Heights Avenue (closed in 1968; last show, *The Fox*).

With the curtain down on these theaters, the whole memorable era at long last came to "The End."

■ THE CHARLES STREET OPEN-AIR PRODUCE MARKET Just about a mile south of the prestigious shops along the 300 to 500 blocks of North Charles Street was Baltimore's infamous and unloved open-air fruit, vegetable, and poultry market. This bazaar took over the 200 to 400 blocks of *South* Charles Street, crowding Camden, Lombard, and Pratt Streets. Few had anything good to say about it.

In 1952 a report of the Maryland Vegetable Growers made these observations: "The ancient buildings are rat-gnawed. Hundreds of trucks jam the streets in the dark hours of the early morning, discharging their fruits and vegetables on the sidewalks and into the streets. Horse and wagons mill about, adding to the congestion." In literature promoting an alternate site for the market, it was described this way: "Scattered along the sidewalks and

in the dingy dilapidated buildings along South Charles Street, it is a festering, unsanitary eyesore, where damaged and overripe fruit litter the gutters, and winos and rats pick through the leavings, leisurely."

Andrew Fava, who was practically raised in the family's store and stall at 218 to 222 South Charles Street, right in the heart of the market, remembered: "Restaurant people, Lexington Market stall owners, fruit store men—they all came down here regularly to buy from the most well-known fruit and vegetable families in Baltimore. Families like Lanasa, Holloway, Lewis [poultry dealers], Smelkinson [egg dealers], and Stevens. We are only a few blocks away from the Pratt Street wharves, where the boats from the Eastern Shore would come in, loaded with fruits and vegetables and poultry. Stevedores would load the stuff onto horse-drawn wagons and trucks. They made several trips from the wharves to here every day, and starting very early in the morning, too."

In the late 1960s all of the merchants, 140 of them, were given notice that they would have to move out of downtown to make way for the inner harbor renewal and the new hotels planned on the same site. Some tried Pulaski Highway for a while, but the location did not work out. The merchants were then encouraged to move to a new facility in Jessup, Maryland. In terms of amenities that supported the merchants, the new market was said to be one of only three of its kind in the world, along with a similar facility in Paris and another in Philadelphia.

Leaving South Charles Street, the produce and poultry wholesalers left behind what was once a fixture of small-town Baltimore—part Arab bazaar, part Idaho country fair. A reporter recalled it without sympathy: "I had all I could do to thread my way through the towering piles of baskets of tomatoes, cages of chickens, crates of eggs complete with droppings, their yolks spilling out of their shells into the streets, cartons of trash. And through the slow moving and often stalled trucks, scattered and rotting vegetables and sleeping bums."

A passerby on the scene that day added: "And very healthy horses."

■ "SINGIN' THE BLUES FOR A BEAUTIFUL LADY" "This song, ladies and gentlemen . . . if this old ricky-tick piano holds up and I can see you all through this smoke . . . hey, are you out there? Lemme hear you!" (Loud applause from the audience.) "This song is a blues song," the speaker intones, as a light piano melody begins. "A beautiful lady has left my life and yours, and, oh, how we miss her! I'm talking about the Royal Theater, at 1329 Pennsylvania Avenue."

The Royal opened as the Douglass in 1921, and the biggest names in

A Fells Point window provides this view of the harbor in January 1967.

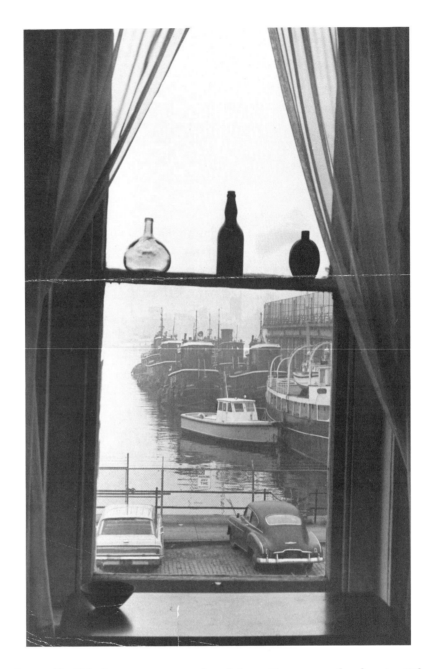

the world of black entertainment played there. Fans remember hearing Billie Holiday—she grew up in Baltimore—singing "I've Found a New Baby," and Cab Calloway belting out "Minnie the Moocher." Pearl Bailey, who went on to become a big star, was only in the chorus line at her first performance at the Royal. Sarah Vaugan and Dinah Washington both played there too.

In the late 1950s and early 1960s the Royal was showing signs of fading. The whites-only rule was breaking down all over town and blacks were

going wherever they chose to go for their entertainment. Meanwhile, television was getting bigger and stealing the audience. And of course, the big bands themselves were disappearing from the scene, one by one.

In its glory days, the Royal ranked with the world-famous Apollo in New York. And if you weren't very good, you couldn't survive your first night at the Royal. The crowds would boo lesser acts right off the stage! Albert "Diz" Russell and the Orioles played there in the 1950s, and they were a hit. Tracy McCleary and his Kentuckians were the Royal's house band for twenty years.

On the night of January 6, 1965, Count Basie himself was playing. As the curtain went up, the Count and the boys were already into "Sent for You Yesterday (Here You Come Today)" and the house was going crazy. Then the Count went into "Jumpin' at the Woodside" and it seemed the joint went berserk, digging that Basie style. Big piano tinkling after the brilliant brass barrage! The evening moved on. It was time for the last number, and everybody knew that it was going to be "One O'Clock Jump." The band gave it everything it had. Some of the kids were dancing in the aisles. The curtain came down and the applause died out and everyone left the theater. It was all over.

Funny thing, though, nobody knew this was the end, that it would be among the last times any of the big-name stars would ever play the Royal stage. The management never announced it. So the audience stood and applauded just as if the great Royal stage shows were going to go on forever. They weren't, though. After the Count finished this one-week gig, the Royal showed mostly movies.

The soul of Baltimore's famous Royal died in those last notes of Count Basie's "One O'Clock Jump." The theater showed double-feature movies until 1971 and then closed for good. "And that's all there is to say about the old Royal theater. A beautiful lady has left us. I told you this was going to be a blues song . . ."

■ HOW BLAZE GAVE US THE SLIP Late in the evening of Saturday, October 21, 1972, Blaze Starr, easily Baltimore's most popular and colorful exotic dancer of her day, strutted down the spotlighted runway of the famous 2 O'Clock Club at 414 East Baltimore Street. To the accompaniment of heavy blues music, wearing her signature mink coat and flashing her long cigarette holder, she slithered and wisecracked her way through the crowd of gawkers. Underneath the lively banter she had to be vaguely sad; she knew what the audience didn't—that this night would be the very last night she would perform in Baltimore.

Born Bella Fleming in the coal-mining town of Wilsondale, deep in the hill country of West Virginia, she had come to town by a circuitous route in 1950, at age eighteen. At fourteen, bored and restless with small-town life and having finished with school, she went to the largest nearby town, Logan, West Virginia, where she worked as a car-hop, and then moved on to Washington, D.C., where she worked as a waitress. Perhaps it was the mystic hand of destiny, but, for whatever reason, her first date took her to see a strip act. She told friends in later years that she'd known in a second she had more going for her than the stripper she saw that night. Someone told her that if she wanted to learn the business, she should go see 2 O'Clock Club owner Solly Goodman in Baltimore. She recalled her first meeting with Goodman: "He looked at me and said, 'Is that all you?'"

Seeing her winning ways, Goodman sent her on the road playing Washington, Philadelphia, New York, Boston, Cleveland—and New Orleans. There, in the late 1950s, her life took an unexpected turn. The idiosyncratic Louisiana Governor Earl Long, brother of the even more bizarre Louisiana Senator Huey Long, saw her act. He asked her to dinner; she turned him down, prompting the governor to say, "Damn! But I am attracted to strong-willed women." The hotter the liaison appeared, the more the couple was denounced from the pulpits of Louisiana. But the lurid romance got Blaze something she must have loved—national publicity, including a full feature in the pages of the popular, nationally circulating *LIFE* magazine.

Blaze always said that the first time she walked into the 2 O'Clock Club she told herself, "Someday I'm gonna own this place." As this Cinderella story unfolds, she did get to own it. In 1968 the business was valued at $65,000, and she had accumulated enough money to swing the deal. She was thirty-six years old. Even as the club owner, she continued as the star stripper. "I know the crowds get pretty disappointed if they are out there waiting in line and don't get in to see me," she told a reporter from *Baltimore Magazine.* "So I go on as soon as the place fills up—as often as five times a night." This night in late October was one of them.

In the morning, passersby stared in disbelief at the "Closed" sign on the door of the club. Blaze Starr's 2 O'Clock closed? The club had been in business since 1936. A reporter asked Ms. Starr how she felt about the closing. "Don't worry honey," she told him. "I'll be back."

Five years after she'd closed the club she came out of retirement and hit the strip circuit—Miami, Detroit, San Francisco, and Washington: Always the heavy blues music, wearing her signature mink coat, flashing a long cigarette holder. As promised, Blaze was back!

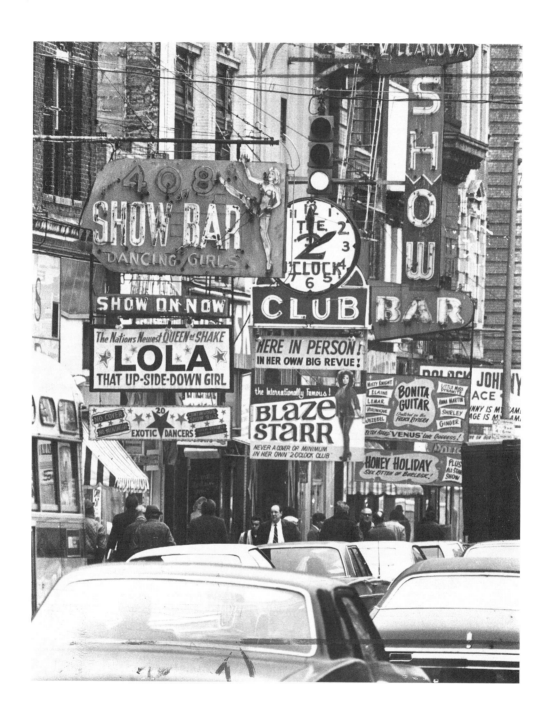

Signs vie for space on the Block in the 1960s and early 1970s (far left) when Patti Wayne, "A Dame with a Flame," starred at the Copa and Blaze Starr performed at the 2 O'Clock Club. Eventually Starr even did her bit at charity events. Portrait of Ms. Starr (above left) courtesy of Tadder/Baltimore.

■ ALL THE GRAHAM CRACKERS YOU COULD EAT "Pop" Standiford was having a bad day. Pop was known downtown as the "Sage of the Soda Fountain," and in the 1940s he was a counterman at Thomas and Thompson's drug store, which had been doing business at the southeast corner of Baltimore and Light Streets since 1912. It was October 1942, and Pop was in the September of his years. And feeling it, too. A regular at the counter noticed on this particular day that Pop seemed sullen and moody, and so he asked Pop about it. Pop went on with the business of making milkshakes and serving them to patrons, and then he turned to the visitor and, in a lowered voice, said, "I've watched the customers change from bankers and mayors and governors and executives, to these crummy-looking war workers in dirty overalls. I've seen the management close the place three nights a week at nine instead of midnight. I've seen women being allowed at this counter. *Women!* But worst of all," Pop went on in obvious pain, *"they have taken away the big bowl of free graham crackers! That bowl's been on the counter thirty years!"*

Many Baltimoreans, most of them men of a certain age and stage of life, will never forget that bowl of graham crackers on the counter at Thomas and Thompson's. One patron commented to another when the place closed years later, "Like so many other men in those dark days, I was broke, out of a job, down on my luck. I spent the morning walking around downtown, looking for a job, and at lunch time I'd go into Thomas and Thompson's and buy a single glass of milk, and eat twenty graham crackers—they were free! Lots of men did. And many a famous and wealthy business executive or lawyer or banker will tell you he did, too. We were sort of a secret society, gathered around that bowl of graham crackers: broke, hungry, and meeting everyday at the same time, and for the same sad reason. I think of those men, the poor who have become rich, the unknowns who have become famous, down and out around that bowl of graham crackers."

■ CLOSING CLASSY EATERIES "As is and where is and without recourse against the United States."

So chanted John Ercole, an auctioneer in January 1974, as he called for bids to pay off taxes owed Uncle Sam by the Oyster Bay Restaurant. This was the original Oyster Bay that opened in the late years of World War II and went on to become one of the largest and most luxurious restaurants in pre-Renaissance Baltimore. It seated four hundred, and there was always a wait to get in. The decor was very nautical, of course, and what John Ercole was auctioning off, as he stood in the center of the empty and cavernous restaurant, was a nine-foot mounted marlin.

Women share their delight at the
Flower Mart, 1969.

Just beyond the city line to the southeast—bound by Wilkens Avenue, Rolling Road, and Washington Boulevard—Arbutus developed a pride of country and community that helped to account for its renowned Sailorettes, an all-girls precision marching and baton-twirling unit that took part in as many as thirty parades a summer. It paid its own way to all of them and also to national competitions, which it frequently won. The girls would go house to house selling things like cookies and raffle tickets; the saying was that you didn't live in Arbutus until you had answered the door and bought something from a Sailorette. This photo caught the color guard on a beautiful day in May 1969. "As much a part of Arbutus as the flagpole in the center of town," as the paper said in a later salute to the Sailorettes.

By this time, late in the auction, the bar, the chairs, the tables, the silverware, and even the liquor license had all been sold. "Now let's hear an opening bid for this marlin," Ercole pleaded. "For $500. She's a real beaut." Maybe Ercole thought so, but the buyers apparently didn't share his ideas and kept their silence. "It's a shame," commented Dora Siedor, part-time manager and cashier of the Oyster Bay. "If only people would have come downtown we wouldn't be here selling off this place. And the Civic Center across the street—that didn't help. All it brought were people interested in roller-skating shows. Those were not the people who would come into the Oyster Bay for a leisurely meal."

Nor, she might have added, would that crowd have appreciated that kind of grand style of dining: a huge wine list, a wide choice of Chesapeake Bay seafood dishes, red-carpeted ambience, tuxedoed waiters who were attentive without being intrusive. "Those waiters," Siedor said, "they were so dedicated. Most of them had worked at Miller Brothers and the old Southern Hotel. You don't find them like that anymore."

Ercole was showing signs of nervousness. Here he was, down to the final minutes in this auction, and he could not sell this one last item, this stuffed and mounted nine-foot-long marlin. "Somebody, please, make a bid," he pleaded. "Any bid. Somebody!" Somebody did, for $180. "Sold!" Mr. Ercole said, his relief showing, "to that gentleman there." "That gentleman" was George Marmaras. "Used to work here," Marmaras said. "I always admired that marlin." Marmaras said at the time that he was going to mount the marlin at the Golden Seas, a new restaurant he planned to open on Belair Road. But a search for the Golden Seas Restaurant shows that neither it nor the nine-foot mounted marlin ever surfaced.

UPON A STARCHED WHITE LINEN TABLECLOTH, using gleaming silverware, you are dining on Maryland crab soup, boned shad, and strawberry shortcake. You have chosen this fare from a menu of four or five appetizers, eight entrees, eleven vegetables (all fresh, not frozen), six desserts—including pies and hot breads freshly baked on the premises—and perhaps a dozen salads. Jack Lederer's orchestra is playing soft dining music from the balcony. From this entirely civilized dining experience, you would think we were in one of Baltimore's more expensive restaurants. In fact, though, we are in one of Baltimore's least expensive restaurants, the Oriole Cafeteria—there were several in Baltimore from year to year.

For more than half a century, eating at the Oriole was quintessential Baltimore; on Sundays the after-church crowd was overflowing. "The Oriole Cafeteria was the very first cafeteria in Baltimore," recalled John Dun-

nock, son of founder Reginald Dunnock. "My father heard of a self-service restaurant in California and he decided to try it in Baltimore. He opened the first Oriole at 32 South Calvert Street in 1922," a location that was later the site of a long-gone night club, Johnson's Mecca. "He was so successful he later had to move to larger spaces nearby at 22 Light Street."

Over the years, John Dunnock expanded to open Oriole Cafeterias at 306 North Howard Street, North Avenue and Charles Street, 17 East Baltimore Street, 5100 York Road, and, the last one, at 7011 York Road. He closed the last Oriole in 1975 because there was no one in the family to take over the business. "And," Dunnock added, "it turned out in those later years, people seemed happy with only hamburgers, colas, and French fries and the faster they could eat and drive away the better. So the end came. The Oriole just didn't seem to fit in anymore."

■ THE RISE AND FALL OF FORMSTONE Over the years Baltimoreans have fought (and will fight, as the tradition continues) a great many things that they perceive to be new and different because they might compromise the familiarity of the world around them—plans to build the Orleans Street viaduct, a bridge across the Bay, a subway system, ideas about altering street patterns or building a beltway. Whenever such ideas first surfaced, citizens fought them passionately and only accepted them kicking and screaming. The one exception was Formstone, the catnip of Baltimore during the 1950s.

For a hundred years, Baltimore was revered for its charming row houses, all characterized by red brick exteriors and white steps. The people who lived in these red brick row houses loved them; they kept them clean and, where they could, put out plants and benches beside the steps to take in the passing parade. Red brick row houses with white steps were quintessential small-town Baltimore. Then, in 1950 or so, some enterprising home improvement companies suddenly saw those red brick houses as one vast market for a new product they were pushing: Formstone.

Formstone was a cementlike mixture of reds and greens and yellows and blues, all blended together and set in a wire mesh grating. The whole mess was then slapped against, and affixed to, the brick, then formed into stonelike shapes. "It'll make your home warmer," the Formstone salesmen would tell homeowners. "Yes," another company's salesmen would say (there was also Permastone, Romanstone, and Fieldstone), "the sculptured look is in." Or, "Aren't you tired of that same old red brick?" Or, "It's the modern trend. Everybody's doing it." Many Baltimoreans listened, believed in the trend, and paid out hard-earned money to have the red brick fronts

In action at Memorial Stadium, Frank Robinson slides in safe, scoring the winning run in the bottom of the ninth inning against the Detroit Tigers on April 10, 1971, as Oriole catcher Andy Etchebarren cheers him on. These heroics were not unusual for Robinson. His hitting and fielding had measurably helped the Orioles win the World Series the preceding year; his gutsy manner and leadership on and off the field epitomized the "Oriole way" in the minds of fans.

of their houses covered with the mix. "Beautiful!" the salesmen said, and went down the block, house to house, signing up neighbor after neighbor. "And keeps the house warmer, too," one neighbor who just bought would tell another.

In a matter of a few years, all of those rows of red brick houses were rows of Formstone-covered houses. The city took on the look of one huge, disparate collection of weirdly colored (but "sculptured") faux-stone houses. "Makes our houses warmer," the neighbors said. "Like the salesman said, we were tired of the same old red brick."

And then in the late 1960s a mystic force began to move through Baltimore—"the Baltimore Renaissance." Part of it led to the development of the Charles Center and the transformation of the Inner Harbor, where a toy town of glass and glitter took shape. With this renaissance, another impulse found its way into the neighborhoods where many of those once-red brick houses had been Formstoned into a multicolored blur. At this point, sensing new market opportunities, the same home improvement companies that had touted Formstone as a panacea went around the same neighborhoods asking homeowners, "What's all this fake cement doing on all these historic old Baltimore brick row houses? Let us remove this ugly stuff and restore your house to its original, lovely red brick. We'll take it all off—at reason-

able prices, too." "Besides," the salesmen would say, "this stuff attracts bugs, they build nests underneath." "Right," chirped up the neighbors. "Take off this gunk. Restore our homes to their original old-time historical Baltimore look."

And so in some, if not all, neighborhoods, houses were stripped of their Formstone. "Beautiful," the neighbors said. "Historic!" "Gets rid of bugs!"

NOTED IN PASSING

A rough chronology of Baltimore airports: Logan Field flourished from 1921 into the mid-1940s. Municipal Airport, later the site of Dundalk Marine Terminal, stayed busy from 1941 to 1950, when the city and state opened Friendship Airport—eventually renamed Baltimore-Washington International (BWI)—in Anne Arundel County.

The end for the Charles Street double-decker buses came in 1942, when the federal government, citing what gas-eaters they were, insisted that they disappear from the streets of Baltimore. They did, never to return.

Late in the afternoon on Tuesday, October 25, 1949, Harry Straus, by this time rich and renowned, was flying from LaGuardia Airport in a twin-engine Beechcraft headed for Baltimore's Municipal Airport. Shortly after 6:00, a truck farmer was sitting down to supper in his home in Craigtown, a mile north of the Susquehanna River in Cecil County. "I saw a flash and thought it was lightning," he later told reporters. "I got up and walked outside and saw flames coming out of the woods." The plane had crashed, and there were no survivors.

By 1950 not a single vendor in all of downtown Baltimore sold roasted chestnuts. Castina's turned out to be the last.

At the end of the day on August 5, 1951, when Officer Raymond Miles stepped out of his kiosk and wheeled it over to the curb, the era of Baltimore traffic kiosks came to an end.

Black baseball, and the famous Elite Giants, went out of business in Baltimore with the end of the 1950 season.

Sometime in the early 1950s, the Druid Hill boat lake became a waterfowl sanctuary.

The Guilford Avenue "El" came down in the early 1950s.

The end of the line for Baltimore & Annapolis Railroad came in 1950.

The marquee of the Famous Ballroom advertises the space is available for rent.

The No. 13 streetcar made its last run along North Avenue in January 1954.

By the mid-1950s, *This Week in Baltimore,* the bible of local nightlife, no longer mentioned either the Club Charles or the Chanticleer.

The last circus parade in Baltimore took place in 1956, when it wended its way through downtown Baltimore to Eastern Avenue and its final tent raising.

On April 28, 1958, George Nixon stepped off the Royal Blue in Camden Station, patted its blue and gold steel body affectionately, and said, "Goodbye, old girl, goodbye." He bade farewell for all Baltimore to that famous run, which in retrospect was less like a railroad (as passenger rail service later evolved) than the Good Ship Lollipop.

Both the Pennsylvania Avenue Easter parade and the Charm Center were out of business by the 1960s. Nobody can remember which went first. But everybody who remembers those parades seems to think that the demise of one had something to do with the demise of the other.

The last *Bay Belle* moonlighter sailed down the river to nowhere and back on a late summer night in 1960. No one noted whether there was a moon out.

Mrs. Marie Bauernschmidt died in 1962, aged eighty-four. Former

mayor Thomas D'Alesandro Jr., asked to recall his bouts with her, said only, with rare restraint, "Marie Bauernschmidt? May she rest in peace."

Miller Brothers closed in 1963 to make way for the Charles Center. A Miller Brothers with the same menu opened in the Statler Hilton, the hotel that rose on the original site of Miller Brothers, but it never quite managed to bring back the Miller Brothers of fond recollection, and it, too, closed after a few years.

Hochschild, Kohn installed its last Christmas windows in 1965.

Captain Emerson of the police vice squad died in 1969. The Emerson Hotel, sold at auction in 1969, was demolished shortly afterward.

If you were in the audience at the Gayety on Saturday night, December 21, 1969, watching the late show (8:30 P.M. to 11:30 P.M.), you are a part of Baltimore history. Five-and-a-half hours after the featured stripper, Texas Jezebel, did her number and the curtain came down, fire broke out under the stage of the theater, destroying the building and bringing an end to big-time baggy-pants burlesque in Baltimore.

The Baltimore-inspired poet Ogden Nash died on May 20, 1971, at Johns Hopkins Hospital, age sixty-eight. His funeral was at the chapel of the Church of the Redeemer, 5600 North Charles Street. His wife and two daughters, Mrs. J. Marshall Smith of Sparks and Mrs. Frederick Eeberstadt

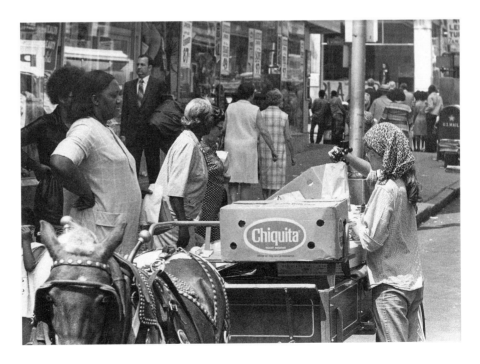

A young white woman in the 1970s serves a patient customer, plying a trade traditionally practiced by black men—"A-rabbing," selling fruits and vegetables from a horse-drawn cart.

Welcome to Jimmy Wu's New China Inn! In March 1974, waiters Ren Hang, Albert Lee, and Wally Lee pose in the elaborate main dining room.

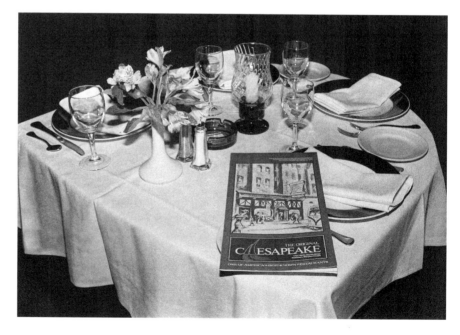

A finely set table beckons the patron at the Chesapeake Restaurant, 1701 North Charles Street, the menu design inspired by the restaurant's glory days.

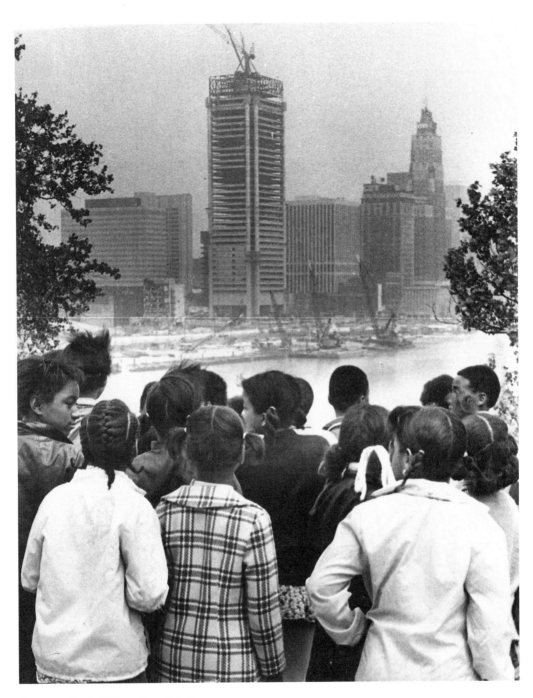

In 1972 schoolchildren from P.S. 85 view the Inner Harbor in the making, the nearly completed USF&G Building visible in the distance.

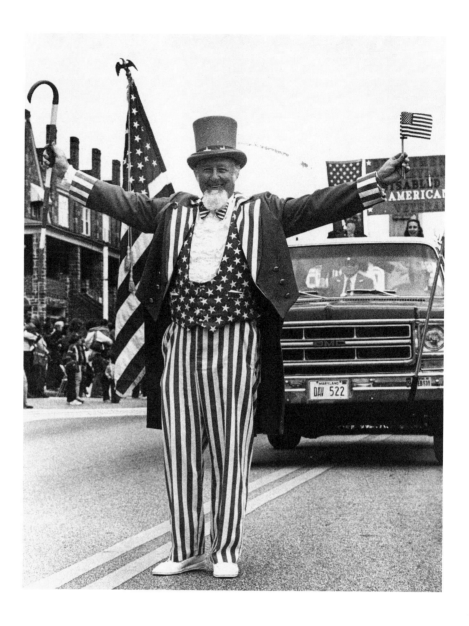

A cheerful and welcoming Uncle Sam (Ken England) leads the annual Columbus Day parade in Hamilton, 1981.

of New York, survived him, along with five grandchildren. Nash's sister, Mrs. Eleanor Arnette Nash, columnist for the *Evening Sun*, had died in 1969.

Thomas and Thompson's closed its doors in 1973.

Rice's Bakery flourished until the early 1970s; it closed in 1974.

Horn and Horn announced its closing abruptly on the morning of January 25, 1977, posting a "Closed" sign in the window. On the sidewalk outside, the mourners—the guys and the dolls, the politicians, the high-rollers, and the buttoned-down bankers—read it reflectively. A reporter on the scene overheard one nattily dressed sports type address a similarly dressed friend. He asked gravely, "My God, where we gonna go now?"

In 1980 the Baltimore Museum of Art purchased Pocahontas, the wooden Indian that had stood so proudly in front of Hopper, McGaw for so many years. At least it can be said that she never left Charles Street.

Schellhase's restaurant fell from popular favor during the 1970s, and in July 1980, Otto Schellhase, son of the founder, announced that he was closing the place. "It's time," he said.

Don Spatz broadcast his last show the morning of March 1, 1981. Jeff Beauchamp, who at the time was station manager of WBAL radio, recalled how the end came. "We made the decision together. We all recognized that the radio audience was changing and the station format would be changing, too, and that the time had come to end the show. On that very last show Don thanked his listeners and said good-bye." It had been twenty years.

Jimmy Wu announced in March 1983 that, because he had no sons or daughters to take over his restaurant, he had sold it to Paul Chao and would retain only a small interest. Wu died the next year.

The Famous Ballroom closed in 1984.

A fire closed the Chesapeake Restaurant in 1974. It opened again a few months later. Sidney Friedman retired in 1976, but he kept the restaurant in the family until 1986. It then closed again and reopened under new management, surviving for less than a year, into 1987.

McCormick & Company closed its downtown plant in the late 1980s, removing the aroma of spices from the Inner Harbor. The *Sun* immediately editorialized that the company, move or no move, should figure out a way to keep piping the scent into downtown Baltimore. It never happened.

Abe Sherman's new newsstand was dedicated on Veterans Day, 1964. He himself stayed at it until 1970, when he became ill and could no longer work. His doctor said it was pneumonia. "The hell it was," Sherman told a customer. "It was the smog downtown. I couldn't stand it!" So in 1971, after half a century, Sherman left the Battle Monument and migrated to a small store at Park Avenue and Mulberry Street. He died in 1985; the store closed a few years later.

Siegfried Weisberger retired in 1957 and sold his Peabody Book Shop to Baltimore advertising executive Maurice Azrael, who promised with the best of intentions to carry on the Weisberger tradition. He could not keep his promise for long, however, and in the early 1960s the place went to Rose Boyjian Smith. The shop finally closed, following her death, in 1988. The architectural firm of Cochran, Stephen & Donkervoet occupied the nearby property at 901 North Charles Street and in 1989 purchased the building in order to expand its offices. In the early 1990s the firm decided to abandon both the shop and its offices on Charles. Richard Donkervoet was the per-

fect person to keep a death watch on the old bookstore. As a young man in the army, he had spent many a lighthearted hour in it. "The place was still a musty cellar," he reported not long before the building came down, "still crowded with rafters, smelling of old books." That would have been fine with Siegfried Weisberger.

Cab Calloway died in a nursing home on October 18, 1994, in Hockessin, Delaware. Coppin State University acquired many of his papers.

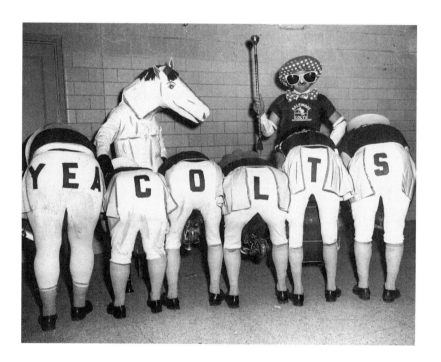

INDEX

Italic page numbers indicate illustrations.

SMALL TOWN BALTIMORE
An Album of Memories

Gilbert Sandler

Designed by Kathleen Szawiola, set by the designer
in New Caledonia, and printed by The Maple Press.

Library of Congress Cataloging-in-Publication Data

Sandler, Gilbert
Small town Baltimore : an album of memories /
Gilbert Sandler.
 p. cm.
Includes index.
ISBN 0-8018-7069-0 (acid-free paper)
 1. Baltimore (Md.)—History—Anecdotes. 2. Baltimore
(Md.)—Social life and customs—Anecdotes. 3. City and town
life—Maryland—Baltimore—Anecdotes. I. Title.
F189.B14 S36 2002
975.2'6043—dc21 2002003875